Chasing ORDINARY

Chasing ORDINARY

A Memoir

PRISSY ELROD

LLP

LEATHERLEAF
PUBLISHING

ISBN 978-0-9912420-9-2 (Paperback Edition)
ISBN 978-0-9912420-8-5 (Hardcover Edition)
ISBN 978-1-7329664-0-6 (Ebook Edition)
ISBN 978-1-7329664-1-3 (Audible Edition)

For inquiries about volume orders, please contact:
Leather Leaf Publishing
548 High Oaks Court
Tallahassee, FL 32312
bulksales@leatherleafpublishing.com

Cover design by Katie Campbell
Book design by Vinnie Kinsella; Indigo: Editing, Design, and More
Author photograph by Katrice Howell

Printed by Thompson Shore Inc., in the United States of America
First printing February 2019

www.prissyelrod.com

For Dale,
who helped me discover the left-handed version
of my right-handed self

Hardships often prepare ordinary people
for an extraordinary destiny.

—*C. S. Lewis*

Contents

Literary Disclaimer

EVERYONE HAS THEIR OWN perspective, and what you read in this book is told from mine and may differ from another. I have tried to recreate events and conversations from my memories of them. I have changed some of the names but not all of them. Also, I have attempted to preserve anonymity by altering some identifying details in certain cases.

Chapter One

Lost in the Right Direction

To be honest, all I really wanted was to go back to folding laundry on a regular Tuesday afternoon. Back to that day when my life was simple and ordinary. But as I sat on the ornate sofa inside the lobby of the Peabody in Memphis, Tennessee, nothing was ordinary anymore.

Boone, my husband, had been dead sixteen months. Don't you hate the word *dead*? Passed? Departed? Vowels and consonants strung together as synonyms for *suck*.

It was July. The weather was hot, humid, and stinking miserable in Memphis. A man I'd come to meet sat opposite me in a fancy, gilded chair and looked nothing like I'd expected. But then, I really had no idea what to expect. After all, I hadn't seen the guy—my college boyfriend—in years.

His hair was still brown but now peppered with gray around his temples. His beard was well groomed and matched his hair color. He looked scholarly.

The top buttons of his untucked shirt were open at the neck. I was relieved to see no gold chains. His two-toned loafers without socks peeked from beneath his black silk trousers. He had an appealing city look, as though he'd stepped off the cover of *GQ* magazine. A beautiful smile—the one I remembered from our past—beamed from his tanned face. But it was his ocean-blue eyes that captivated me. They always had.

I watched him watching me. He leaned forward, an elbow on each knee, rhythmically tapping his fingertips together, then stilled them in a tepee formation. The heel of his right foot started rocking up and down. I could tell he was nervous. Maybe more than I was.

I studied his oversized hands, remembering how they once felt gliding over my body. In our silence, his smile broadened. We both stared and waited, neither one of us saying a word. I couldn't. It was so uncharacteristic of me not to be babbling. But seeing him again was surreal.

I picked up the tasseled pillow next to me on the couch and tucked it behind the small of my back. I cushioned against it and yanked my polka-dot dress over my bony knees. I glanced back up to see his blue eyes boring into me. *Oh God!* I hoped I looked calmer than my fast-beating heart felt.

A few months earlier, Dale—that's his name—sent me a condolence letter. I answered, and our writing began. First a letter or two, then emailing. We would write every few days and share stories of family, friends, and work. Soon our email exchange became more frequent. Then it progressed to every day. Before we knew it, we were emailing each other several times a day.

We never once talked on the phone or exchanged pictures. So, technically, one could say we were strangers.

As I read his emails, nostalgia filled my heart. I was transformed to the young girl he once knew. The one who believed—with innocent naïveté—bad things happened to others. In those days I was sheltered by a physician father and housewife mother. I believed life was safe, wonderful, and certain, as only a tenderfoot would, before the brutality of life knocked me flat.

Thoughts of Dale transported me back to the days when anything seemed possible. And since I had no idea how he looked, my brain pictured the boy's same face, physique, and manner, even though

I was communicating with someone much older. The brain, well, it's a funny thing.

After three months of writing, he suggested we meet in person somewhere between our two cities—Indianapolis and Tallahassee—and try to pick each other from a crowd. It would be fun, especially since we had no idea what the other looked like.

A cat-and-mouse game ensued, with clues and guesses, teases and temptations. Each day he emailed a hint about where our reunion would take place.

I flew to Memphis from Tallahassee, Florida, to meet the boy I once loved, having no idea what awaited. It didn't matter. I was stepping out of my comfort zone and taking a chance.

<center>❧</center>

My heart raced as I walked off the elevator and looked around the spacious mezzanine level. It was vacant and quiet. There was not a soul on the floor where I stood. As I leaned over the brass railing, I could see over a hundred people below me.

I watched a flock of ducks, hens, and drakes splashing and skimming the fountain water.

I studied the tops of the men's heads. They were short and tall, skinny and fat, and so many nationalities. No one looked like the boy I remembered.

I felt a tap on my shoulder and turned around to find his smiling eyes. We stood motionless, his blue eyes melding with mine. A jazz band was playing the Miles Davis version of "Some Day My Prince Will Come."

We had both slipped down to the mezzanine level early in hopes of spotting the other first, neither of us wanting to wait thirty minutes longer. After all, it had already been thirty years.

The waiter interrupted and placed a bowl of nuts on the coffee table.

"What can I get you guys to drink?" he asked.

"I'll have a cosmopolitan, Ketel One and Grand Marnier, not triple sec, extra cold…and bruised, please," I half stuttered, blurting my order like a crazed alcoholic. I sounded like visiting a bar was something I did often. It wasn't. The waiter pulled a pencil from his short apron and wrote down my order.

"I'll have a beer…um, any kind is fine," Dale said.

The young waiter chuckled as he walked away.

"What was that?" Dale asked.

"A martini."

"Never heard of that kind."

If he didn't care what kind of beer he drank, it was no wonder. I started to say so but bit my tongue. As we waited for our drinks, we made nervous conversation. It took me two martinis to relax.

"Hope it's okay I made reservations for us over there." He pointed to the restaurant to our left.

Inside I could see waiters in tuxedos scurrying around the French décor. The name above the door read Chez Philippe, a Forbes Four-Star, AAA Four-Diamond designation on the glass window. If he wanted to impress me, he did. Well, aside from ordering that no-name beer.

During our dinner, the conversation was nonstop. On my end anyway. He listened. I was reminded how quiet he was during the years we'd dated. Our romance was germinating over flickering candlelight as we ate filets mignons. I didn't even like red meat.

"Have you ever seen Beale Street?" he asked.

"Beale Street, no, where's that?" I hadn't left our hotel, so I hadn't educated myself on Memphis. I'd been too busy readying myself to meet him. He had arrived two days before me, so I assumed he had his bearings and our activities planned.

"Let's go check it out. Go change into jeans."

I was wearing my brown dress with yellow polka dots and was embarrassed to say I hadn't packed jeans. Truth be told, I didn't even own them. Well, I did have one pair, but they were uncomfortable and decorated with rhinestones. I had buried them in my closet with all the other things I never wore.

"I forgot to pack jeans," I told him.

We left the restaurant and walked along South B. B. King Boulevard toward Handy Park. I was way overdressed, but the blues music coming from all the clubs—not to mention, my martini consumption—made me not care one iota.

The smell of barbecue filled the air. My hand was swallowed inside his as we strolled Beale Street. His hands were so much larger than my husband Boone's. I was comparing, thinking, remembering as he let go and slid his arm around my shoulder, pulling me even closer.

We walked farther, sharing the curtained memories of our years together and stories of the years apart. I was studying his blue eyes, his laugh, and his smile in those first hours. He radiated warmth. I observed his mannerisms, his sense of humor, and his interest in the most ordinary things. I was so grateful to be attracted to him.

Dale had planned everything with one exception—his rental car. At least that was what he told me as I climbed into a maroon-colored Buick sedan.

"This looks like an old person's car," I said. The words popped out of my mouth before I could stop them. But I was expecting something sportier, a convertible, anything. I sat so low I could hardly see out the windshield.

"I forgot to reserve one, so it's all they had," he told me.

I was embarrassed for a nanosecond. "Where to now?" I asked.

"How about an art gallery?" I couldn't believe he was offering to take me to an art gallery without my asking. Apparently, this man remembered how much I loved art from my emails.

We arrived at the Dixon Gallery & Gardens, the former residence of the Dixon family. Inside we walked around, studying painting after painting, all collections devoted to French American Impressionists and Postimpressionists. Two hours passed before I knew it. But I could tell he wasn't as enthused. I suggested we head out for something different, maybe something he might like more.

"How about Graceland?" he asked.

"Yes, fun, I'd love it," I said, and we climbed back inside his Buick. But what were we thinking…a Saturday at Graceland? The line was as twisted as a stick of licorice, and just as we were about to get out and get in that line, it started raining. So instead of Graceland, we spent hours sitting inside the car, talking. When my stomach growled, I realized the day was almost over.

The weekend exceeded our expectations in every way. We backslid to how it was during college when we couldn't keep our hands off each other. In those days I always worried what my parents would think. In Memphis I worried what my daughters would think. The circularity of life is downright funny.

Sunday crept in too fast. We were like lovesick teenagers again. We both wanted to stay longer, but it was impossible. I was flying to London two days later, and he had a company to run.

As we sat at the gate, awaiting my boarding call, I was wondering what to say, how to end the weekend. The thousand-mile distance made things impossible. What was I thinking when I agreed to meet this man again?

"We'll make it work, Prissy," he said, reading my mind.

"How?"

"Just leave it to me, don't worry about it."

After the final boarding call, I pulled out my carry-on lever and walked into his arms. Without a second thought, I stood on my tiptoes and whispered in his ear.

"You should dust off your passport and come to London."

Chapter Two

The Pencil Marks of Life

EIGHT HOURS AFTER I got home to Tallahassee from my whirlwind weekend (I only slept four of those eight hours), I pulled myself out of bed, longing for a cup of espresso. As soon as I walked into the living room, I saw him. Well, not him, per se, but the large gold-framed photo taken three summers earlier. Boone.

He wore his favorite denim shirt, starched jeans, and the familiar crooked smile. The creases in his forehead—from years of worrying—stood out. I ignored his stare and turned on the stereo. I dialed up the volume to Kenny Chesney singing "You Had Me from Hello."

It was barely eight a.m., and I was already exhausted, with no idea where to start to get myself organized. It was hard to make decisions after Boone died.

I sang a duet with Kenny and wrestled with the coffee machine. By my second cup, I was energized. But not inspired to do what needed to be done. So, I decided to clean and grabbed some supplies, then headed for the glass-top table in the living room. It was ridiculous, or rather I was. The table was already clean; anyone could see that.

I scooped up my stack of unread magazines, the decorative picture frames with my daughters' smiling faces, and the new rose-scented

candle I'd yet to burn. I circled around the table and sprayed and wiped the glass with my Windex-saturated cloth. I felt Boone's eyes watching me as I arranged everything back on the table in a different order. I studied my new version then switched everything back.

I scanned the living room for another item to steal my time and occupy my mind. I was a discombobulated mess and had no idea how to fix myself.

There were two opened suitcases on the floor in my bedroom—one needed unpacking; the other needed packing. And yet, there I was *cleaning*. It was so stupid, especially since I was leaving the next day. And the next day was right around the corner.

What's wrong with me?

The phone rang and startled my guilty heart, sending it racing. Without looking at Boone, I hurried past the photo and answered on the fourth ring.

"Good, you got home okay," he said.

I eased down on the kitchen chair next to my desk. His voice sounded strange coming through the receiver. I hadn't heard it through a telephone receiver in decades.

"Yeah, it was late, around midnight, when I pulled in."

"Wow, I bet you're tired." I sensed his nervousness by the crack in his voice.

"I am, but more awake after four shots of espresso." The conversation seemed polite, uncomfortable, then followed by an awkward silence.

"God, what can I say, Prissy? Seeing you again…" I waited for him to finish his sentence. He didn't.

I tried to change the subject. "Your voice sounds so different on the phone."

"Were you serious?" he asked.

"Serious? Serious about what?"

"About me dusting off my passport and meeting you in London."

I was stunned, speechless, really. I tried to wrap my brain around the question, or rather my answer to his question. I remained silent—overstimulated with caffeine—but my brain was still foggy.

"Did you hear me?" he asked.

"Yeah, oh sorry, I heard you." A nervous laugh slipped out of me.

"Are you considering it?"

"Maybe. That's why I called, to see if you really meant it."

I hesitated a moment longer, trying to think what to say, weighing his question.

"Sure." I wasn't sure of anything.

"Good. Well, okay, I might make it happen. I'll get back to you."

I hung up and stared out the kitchen window, trying to process what had just happened.

Dear Lord! What have I done?

I grabbed a glass from the cabinet, filled it with water, and gulped. My mouth was bone-dry, and I had the caffeine shakes. I toasted a piece of rye bread and squirted some local honey on top, pondering my shortsighted invitation. *What the hell, Prissy?*

The whole time I was cleaning up my breakfast dishes, I was worrying, wondering, and wrestling with how I would handle this new twist. I should have known my snap decision to invite Dale to join me had unexpected consequences. I would just unpack my bags and figure it all out while I did.

I raced from the kitchen toward my bedroom but stopped in my tracks. I walked over to the piano and lifted the frame. I stared into Boone's squinted hazel eyes. Rubbing my finger along his hairline, I cradled his face against my breast and let my tears fall. I wiped my cheeks.

No more, I'm sorry, but no more!

My head knew what my heart didn't. When one person dies, two people shouldn't. I had to move on.

It was so random and unfair. Boone was a healthy, active fifty-year-old man who died in the prime of his life. He had been

diagnosed with a glioblastoma multiforme, a deadly malignant brain tumor. After a craniotomy to remove the tumor, he was given a year to live. I'd adamantly ignored his prognosis and refused to accept it.

Literally, I'd spent the last months of his life chasing the cure and trying to save him. All for nothing. I couldn't, and neither could anyone else. I stole the remaining months of his life. He could have shared that time with our daughters. The best doctors in the country told me it was hopeless. I refused to listen.

Damn it, stop crying.

I was talking to myself more and more, not to mention the ghost of Boone following me around the house.

I had to move on. I just had to. And I would. Once again, my head ordered my heart to believe this truth. I was done. I wanted to be.

I placed the picture back where it had sat for the last sixteen months and headed to the bedroom. On to the business of finding my new life.

I was unpacking my Memphis suitcase when the phone rang again. I held the receiver with my head cocked and my arms full of clothes.

"Well…?" I heard my daughter Garrett's excitement on the other end of the line.

"Morning, honey."

"Tell me, how was he?" she asked.

"He was nice, cute."

"Tell me more than that, Mom."

"We had a great time. I liked him."

"What did you do all weekend?"

I felt my face blush remembering what we did. "Let me wake up, and I'll call you back, okay?" I had to spin my story, and it was way too early.

Before I could unload my armful of clothes, the phone rang *again*. This time it was my other daughter, the younger one, Sara Britton.

"Mom, I want every single detail. Is he fabulous?"

"He's pretty cool."

"I knew it! I'm so excited. He sounded like it on the phone." She'd called while Dale and I were having lunch and, after a moment, asked to speak to him. I had handed over the phone, wondering—worrying—what in the world she was saying to a man she'd never met.

He had started chuckling as his eyes wandered around the dining room and away from me. When he looked back, his eyes were watering as he smiled.

I still didn't know what she said to him, but deep down, I knew her. She had welcomed him into her heart after only one phone call. Before she'd even met the man.

Sara Britton was like that. She and I believed everyone was our friend until they gave us a reason not to be. It had to be a very good reason too. Garrett was more like her dad—reserved and cautious. She wanted to get to know someone first then make her decision. She would be a great juror. Sara Britton and I would be horrible, or great, depending on which side polled us.

Finally, my Memphis suitcase was unpacked and emptied. I zipped it up and carried it back to my closet, knowing it was way too big to haul overseas. I concentrated my effort on packing a smaller one and sorted through the remaining clothes stacked on my bed.

The phone rang. Everyone wanted a minute-by-minute description of my two days with Dale. It had started with Garrett and Sara Britton, then my sisters, my close friends, and finally my mother. My tongue was tired, and my body ached. My early-morning flight was fast approaching, and my clothes, shoes, makeup, and jewelry were still clustered in piles.

I was in the middle of putting stamps on a stack of bills I'd paid. That alone had me second-guessing what in the world I was doing. Why in God's name was I spending money on a vacation?

Especially since my friends had husbands with jobs paying their way, and I had neither.

I wasn't sure who I was anymore. I was trying to be the old me, the Prissy who was married to a successful lawyer. The secure woman in her once-sheltered world. But that was over. He was gone, and nothing felt safe. What remained was a widow living on her own. I couldn't even say the word. It didn't belong in front of me or behind. The *widow*, Prissy. Prissy, the *widow*. That happened to older women. Not to me.

But it had. It did. I was.

I answered the ringing phone.

"Okay, I'm coming, it's done!" Dale said, sounding manic.

"No way…really?"

It was eleven thirty p.m. on Monday, and my flight was leaving at eight the next morning for London. I sat down at my messy desk and felt panic in my gut.

"I'll get there Friday, a little after ten p.m."

"What, at night? That's not right."

My previous work in the travel industry made me question his nighttime arrival. In the past years, I had planned, executed, and escorted clients on overseas trips, and we always arrived in the early-morning hours.

"What time does the flight leave Indy?" I asked with authority as I clipped the July bill payment receipts, filing them alphabetically in my desk drawer. I was listening, getting ready to show off my travel knowledge.

"Two p.m., that's when it looks like I depart from Indianapolis." I could tell he was reading something.

"Nope, that can't be right, you can't be getting there at ten the same night. It must say ten a.m.—it's the next morning. You have a layover somewhere, a long layover." I was beginning to think the man didn't have a lick of sense.

"No, I'm looking at my itinerary, Prissy. It's Friday night at ten p.m."

I argued my point, bragging how I knew the industry, suggesting he call to confirm. I was sure it was a misprint, and I would need his correct flight arrival before I left on my flight the next morning.

He was quiet as he listened to my instructions. Finally, in the middle of my sentence, he interrupted.

"I'm flying the Concorde, Prissy—it only takes three hours."

It was one of the few times in my life I was speechless. Especially since I was using my poor dead husband's remaining frequent-flier miles. My flight was going to take countless hours and multiple flight segments to get me to the very same place.

"Well...that's pretty cool." Seriously, what else could I say? Back when we'd dated, he lived in a small camper trailer he pulled behind his '57 Chevrolet. Now, he was flying to Europe on the Concorde.

We talked a few minutes longer. I yawned, sighed, and realized my end of the conversation had lulled.

"Go to bed, don't worry," he said. "I'll send you an email with all my information and any requests."

I finished straightening my desk, washed my face, set the alarm, crawled into bed, and pulled the cotton sheet over my worn-out body. I was almost asleep when I remembered his last comment... *"any requests."* I worried a few seconds longer and fell asleep.

Chapter Three

Sense of Occasion

ONLY HOURS AFTER MY friends and I landed in London, I managed to slip away. I knew they would be unpacking and settling into the apartment where we were staying.

I headed for the student center in search of Wi-Fi, my heavy laptop stuffed inside my backpack. I found an empty spot in the corner, settled in, and started searching.

I scrolled one hotel after another, looking for the specific type Dale had requested: quiet, secluded, small, and charming. It took me more than an hour to find one that qualified: hotel Number Sixteen, located in the heart of South Kensington. It was described as "cosmopolitan."

The photographs showed a tree-filled private garden, a reflecting pond, and a beautiful fountain surrounded by lush foliage. The rooms were decorated with an eclectic flavor, a merging of antique, modern, and funky décor. It looked perfect.

It was a quaint, mid-Victorian building surrounded by some of London's greatest bars, restaurants, and cafés and only steps away from London's major museums and, best of all, Harrods. I called immediately and booked the room.

I repacked my laptop and headed back to my friends. I knew they were waiting, probably wondering what happened to me. I had to get

ready for the day's plans. Plus, I had some rehearsing to do. I wondered if my secret would be noticeable. I had a hard time keeping secrets.

We had arrived in London early that morning and were staying in a three-bedroom flat. Patti, the one who had invited us, kept it during summer months. She was head of the Florida State University exchange program, so the apartment was located at the complex where the students and faculty resided. We planned to be in the city four days then travel to the countryside. We had reservations at a small country inn.

When I walked into the apartment, I skirted around the question as to why I had been gone so long. I felt my face flush as my white lie weaved itself inside my brain.

"Sorry, I was calling my girls," I said.

"How were they?" MaryAnn asked.

"Who?" I had already forgotten the conversation.

"Your girls."

"Oh, um, they were fine." I climbed the stairs to shower with two fingers crossed against my heart.

◆

On Thursday, the six of us sat around a scarred table inside a London pub. It took me only one quick glance to realize nobody in London went to pubs for wine. The waiter came back carrying another round of beer. My damp hand was wrapped around the one I had ordered thirty minutes earlier. It was still full, only now, stinking warm. After years of trying, I never acquired the taste for beer.

We'd chosen one of the more popular local sights, hoping to appear less touristy. Our American—not to mention, Southern—accents gave us away the minute we ordered.

A horde of professionals happy to be out of the office crowded the pub. The tables were full, and patrons were packed three layers

thick against the antique mahogany bar. Ancient beveled mirrors as tall as the ceiling lined the wall behind the bar, making the small space seem much larger. Polished brass railings adorned the edges of the bar. The scent of cigarette smoke mingled with furniture polish, giving an aromatic flavor to the bar's setting.

"Tomorrow we'll go to the Victoria and Albert Museum," Julie yelled over the noisy crowd. MaryAnn waved to our waiter, urging him back over as Linda laughed at something Lyn had said. None of them noticed my silence among the chatter, beer, and laughter.

Everyone was talking at the same time, each louder than the next. The acoustics inside the pub made conversation almost inaudible, but it didn't matter to me. My friends had no idea how nervous I was. They couldn't know I wasn't listening to a single word they said about the next day's adventure or the play we had tickets for. I'd spent the last hour mentally rehearsing my revelation and any explanation I could muster up for my new plans.

After years of escorting women on trips to New York, China, and Europe, I learned that women and men have different mentalities when it comes to travel. Most women don't mind sharing rooms to save a dollar. They will divide a restaurant bill to the penny even in foreign currency.

As I would calculate the tab for something not included for my tour group, invariably a female client would approach and say, "Wait, Prissy, I'm paying too much. I only had one drink."

Okay, maybe I rounded the bill and divided by the number of women at the table. It was much easier. We're talking one drink of varying prices times twenty-five clients.

Nope. It had to be exact. I would repunch my calculator, even worse, my conversion calculator. I had to make sure it was fair and square to the last dollar, euro, or yuan. I get it. Nobody wants to pay for heavy drinkers—I understand that. But I hated wasting valuable traveling time on math, especially division, and in a foreign currency.

Men, I argue, worry less about dividing restaurant bills or anything else.

My point: I planned this trip with friends who counted on me. Now I was putting a hiccup in their mathematical division: hotel room splits, transportation, food, and everything else. Tickets had been purchased for plays and prepaid tours. Inviting Dale to join me was unfair to my friends in the game of division. And that was the least of my problems. How was I going to tell them I was going off with a man they'd never heard of? What would they think of me, even if I was a grown woman?

I finished my beer and ordered another. This time I swallowed in gulps, not sips. When my mug was almost empty and the room was spinning, I couldn't wait another second. Before I knew what happened, I was spilling my guts in the middle of Patti's sentence.

"I'm leaving tomorrow!" I took another sip. "Someone, well, my college boyfriend, he's flying, coming, he's coming to see me," I stammered.

Their expressions said it all. I spent the next hour trying to explain Dale, our Memphis reunion, and his pending arrival. We finished several more rounds. By the night's end, I still hated beer.

⁓

I wasn't brave enough to take a taxi alone to the airport so late at night. I knew nothing about London, so I hired a driver recommended by the hotel concierge, even though it was triple the cost of a taxi.

I spent the entire ride chatting with the driver after he politely asked, "What takes you to the airport so late at night, young lady?"

That question afforded me an opportunity to share way too much. By the time we pulled into Heathrow, he'd heard every detail of my European rendezvous. But he wanted to know more about

the man I was picking up. Thankfully, we pulled into the terminal before I could elaborate.

He pointed to where he would be waiting for us. I jumped out of the car before he could open my door. I was halfway inside when he yelled in his adorable British accent, "Did you hear? I'll be over there."

I looked where he pointed, nodded, and gave him a thumbs-up.

It was after ten p.m., so the lounge was almost empty. An eerie quietness shadowed me as I admired the polished floor sweeping the corridor. My eyes were tired, heavy, and dry. My hands felt clammy and damp. I rubbed each one down the sides of my black jersey dress.

Being alone at night inside Heathrow Airport was completely out of character for me. I felt like I was role-playing. In truth, some might think I'd been auditioning since I started dating again. But never for something like this. It felt like I'd been given the leading role in a Hollywood drama and handed an unread, unrehearsed script, and the camera guy slammed the clapperboard and said, "Action."

I was unnerved.

My entire adult life thus far had been lived in the Southern arena of the Junior League, Garden Club, and PTA. Irish nuns had schooled me with strong moral fiber even as a small child. I'd married Boone, a conventional, Brooks Brothers–type lawyer, who sheltered and overprotected me for decades.

That conservative woman wouldn't be standing here. Never. She wouldn't be waiting on a man to step off a plane at her invitation. Yet, here she was—here I was—doing just that.

I was on cruise control with my new self and lost the steering to my old self. I was headed for—well, who even knew where. Nobody would believe it. Hell, I couldn't believe it. And yet it was true.

And the man was coming as fast as he could…on the Concorde, for heaven's sake.

I was rethinking my impulsive invitation as I awaited his flight. I would be with him day and night, and for almost two weeks. And

after only two days together in Memphis. We hadn't been "sleeping together" then. I mean, after all, I did have my own room when we were in Memphis. What was I thinking? What was I doing abandoning my friends and our plans?

I tried to justify my behavior. I wanted—no, I needed to take this chance. I knew the arc of life was filled with "what if," "could have," and "should be" opportunities, all synonyms for *regret*. I was on a treasure hunt for happiness. I had no intention of collecting any more regrets. I had plenty. The painful journey over the last two years had provided a unique life perspective, and I longed for happiness and prayed for joy in my life again.

I heard the announcement on the intercom that his flight was about to land. I realized I had to pee and looked around for the closest restroom. I ran. The moment I closed the stall door and lifted my dress, I knew.

No! No! No!

I had no panties to pull down. None. There was nothing under my black jersey dress. No panties…where were my panties? I flashed back to jumping off the bed when I saw my panty line showing under my dress in the hotel mirror. I remembered digging in my suitcase for a thong. Why was I not wearing it?

Oh God! That man from the front desk had called to say my driver had arrived. I must have, I did—I forgot to put the thong on! Clearly, my nerves had sabotaged my judgment and any frigging sense I had.

Sharing the tiny stall with my chills, panic, and embarrassment, I realized there were probably no shops still open. And if they were, they wouldn't sell underwear. I pulled my jersey fabric down as far as it would stretch past my knees. It wasn't far enough to make me feel any better.

I went to the sink and splashed water under my bloodshot eyes. I wanted to cry but had no time. Still berating myself, I hurried

out just in time to see Dale exiting the private gated area. He was looking around, left to right. He spotted me, and his grin grew.

He looked very European in his all-black ensemble: pants, shirt, shoes, and no tie. He carried a leather briefcase with a small carry-on bag strapped across his body. I waved with my left hand, pulling my dress farther down with my right. Then he reached me, and I slipped into his outstretched arms. My face was the color of a blistered college kid at the beach on spring break.

As we exited the terminal, my driver was parked closer than the spot he had pointed to earlier. He was standing next to his dark sedan, looking like an FBI agent, staring at us, his grin gone.

"Good evening, sir. I hope you had a good flight." He reached for Dale's bag and opened our back door. That was the extent of the conversation from my chatty driver, the one who'd been so friendly earlier. His eyes watched Dale through the rearview mirror the entire ride back to our hotel. And I was busy pulling my dress over my knees.

Clearly, he was worried about my new roommate. But not as worried as my girlfriends I'd left behind. I had appeased them with a "cross my heart" promise. I was taking Dale to meet them the very next day.

Poor Dale. He had no idea about my friends or my missing panties. Well, that was until we backslid to our Memphis steps. And I don't mean dancing.

Chapter Four

Shining in the Starlight

DALE AGREED TO MEET my friends the next afternoon for tea at the Savoy Hotel. As we readied ourselves to leave, he knew he was going to be checked out by them but seemed not to care.

"Prissy, I get it, they're worried about you. I'll meet them, let 'em see I'm safe. Even better, that you're safe with me."

"Are you sure? I mean...tea, do you even drink tea?"

"It's not about the tea, Prissy. It's about you."

They were sitting on a big velvet couch in the lobby when we walked in. I could see the worry in their eyes through their welcoming smiles.

Dale was dressed much like the night before, wearing his black sports jacket over a silk T-shirt and slim-cut jeans. He beamed a smile as he reached his hand to clasp theirs, one by one, and introduced himself. He repeated the name of each friend back to them then dispensed a compliment.

"Hi, Lyn, nice to meet you. I like your necklace."

Portraits of famous people who once frequented the Savoy hung from the walls surrounding us. Magnificent floral arrangements were displayed on tables everywhere. The large, historical room was infused with a delicate perfumed scent.

I heard piano music streaming and looked over to see a pianist playing in the oversized lobby. He was playing my favorite classical song, *Canon in D Major.* My heart skipped. I had walked down the aisle to marry Boone to the same song. What were the odds it would be playing now?

Dale sat on one of the large armchairs and slid in closer to the couch where my friends were sitting. The smell of fresh baked scones and pastries sifted through the lobby and merged with the glorious scented flowers. Servers poured a variety of tea selections in exquisite china teacups. I was enamored with the history of this iconic library, knowing Winston Churchill, Frank Sinatra, and Christian Dior had graced the space I now was occupying.

Dale attempted to slip his index finger inside the small teacup handle, an impossible feat with his too-large finger. Finally, he just wrapped his hand around the entire delicate cup and camouflaged the exotic painted flowers. When he took his first sip, I composed my laughter at the sight of his big hand and that tiny, fragile cup. He looked ridiculous.

MaryAnn, Patti, Lyn, Linda, and Julie peppered him with questions. I watched silently on the sidelines and was surprised how comfortable he was during "the interview."

Dale asked questions too. "How do you know Prissy? How long have you known her?"

When it was time to leave, I knew he had captured their approval. More important, he had reinforced mine.

We spent our first days in London strolling the Mayfair district and sharing even more stories of our thirty years separated, things we hadn't talked about in Memphis.

Every evening we stopped at the same little bistro. We met Ricardo Curbelo, a cellist, the first night at the café. He moved his instrument right next to our table and serenaded us, dedicating song after song, night after night, to us.

"I see love," he said one night.

Dale smiled then shared our story with him. Three nights later, after having drunk a little too much wine, I mentioned to Dale that I wished Ricardo could play in Tallahassee so all my friends could enjoy his amazing talent.

"Hey, Ricardo, you want to fly to Tallahassee for this beautiful lady and play for her friends?" Dale jumped up and asked in the middle of his tune.

"Where this Tallahassee? Is in America?" he asked in his broken English. His fingers moved quickly as he plucked the chords and sounded the cello tune "The Cavaliers of La Mancha." (We bought his CD with the original song on our last night. I still listen to it to this day.)

"Yes, Florida, in America," I shouted over the café noise. "You should come, please, please, please!"

"Oh yes, I love go to Florida," Ricardo said, grinning and plucking.

Day after day, night after night, Dale and I learned more about each other. We shared our deepest truths and personal stories. I talked about trying to save Boone, sharing my regrets, my guilt. He remained quiet, never once interrupting. He seemed interested in every word I said. I felt comfortable, safe, relaxed.

It's funny how human senses—sight, smell, touch, taste, and sound—are sharpened with surrounding newness. As we walked past the brownstones lining the Mayfair district, I listened to the changing gears of the red double-decker buses, my senses acute. I inhaled the intoxicating, sweet smell of the blooming linden trees. The creamy-yellow flowers were a blend of scented honey and lemon peel beneath the pale-green branches. They were luscious and everywhere. We discovered cafés on hidden side streets and feasted on their foreign food.

But what sparked my senses the most was the man who walked next to me. After years apart, being with him again made me feel

as though I were someone else. A different me entirely. I was more comfortable being the person he remembered, not the stranger he reunited with. He once knew a young and free-spirited Prissy. The woman thirty years later was new to him. The longer we were together, I could almost sense the shift within my being, my personality and thought process changing. In some strange way, I felt more relaxed, liberated, perhaps even transformed without knowing when, how, or why.

Our London strolls, café dinners, serenades from Ricardo, and conversations never staled. It was as though a wizard had transported us back in some time capsule. I would linger behind him, watching his familiar gait, the bounce of his hips, the swing of his arms, remembering the boy I had loved so long ago. His blondish-gray hair glowed from the sun's glare.

I couldn't remember the last time I felt so happy. His devoted interest drew me in more and more. I realized I didn't have to be talking. We sat in still quietness, the absence of words our conversation. I let my guard down and felt the relaxed state I had forgotten. Or maybe one I never knew.

When I had received Dale's itinerary and realized he was staying in Europe until I left, I thought I would surprise him, so I purchased two tickets on the Eurostar train for Paris. After our week in London, we checked out of the Number Sixteen and hailed a taxi to St. Pancras, the gorgeous train station in London dating back to 1868. The ornate glass-and-steel train shed had a high arch and beautiful Victorian façade.

As we traveled from England I admired the farmland, green countryside, and the villages of Kent and northern France that speckled the landscape. After only two hours and fifteen minutes, we arrived at the Paris Gare du Nord, another stunning historic station. It was impossible to believe I was in France so quickly. We grabbed our bags, hailed a cab, and climbed inside.

"Quels sont vos objectifs?" the driver asked as Dale shut the door. "I'm sorry, we don't speak French. Yikes, do you speak English?" I asked the driver.

"Oui, I speak English. Where you go?" the driver asked.

"Oh good, thank you so much. We are going to the Hôtel de Crillon."

Dale remained silent. He had nothing to do with our reservation, no idea where we were staying. I had made all the arrangements, or rather I had asked the concierge in London where he suggested we should stay in Paris. I had gotten to know him from visiting the desk before Dale arrived from the states. I remember him clicking his computer as I hung near.

"I know just the place," he'd said, handing the confirmation paper over to me with a big smile. "You will love Paris and this hotel."

When our driver pulled onto the Place de la Concorde, in front of Hôtel de Crillon, we stared in awe. The hotel was located at the foot of the Champs-Élysées and only steps away from the Arc de Triomphe. It was spectacular from the front, the grandest hotel I had ever seen.

"Is this where you made our reservation, Prissy?"

"I didn't make it. The concierge at Number Sixteen did. He thought it would be perfect."

I worried what this place was going to cost. I should have asked Dale what he wanted to spend on a hotel in Paris. Too late. Poor Dale. Literally.

I asked our driver everything about the hotel before I even climbed out. In his French accent, he shared the history of Hôtel de Crillon, which was housed in a building dating back to 1758. He described how it had opened in 1909 and withstood three centuries of history, through two French kings, the French Revolution, the Napoleonic empire, and the birth of the League of Nations.

We found the pace of Paris to be much faster than London's. I was like a squirrel on meth, dragging Dale along with me to museums, relishing the history, culture, and delicious French cuisine.

On our last day in Paris, exhausted after another long tour, we returned to the hotel to decompress. Both of us had changed our departing airport from London to Paris, and I needed to pack for my return flight home. Dale poured each of us a glass of Chardonnay. I propped my tired feet up on the coffee table, his feet next to mine, our toes touching.

"So, what's going on when you get back home, between all your facials, exercise, and massage appointments?" He laughed and clicked his glass to mine. I swallowed the Chardonnay, swirling it in my mouth, and felt my heat rise.

"What did you say?" My head turned toward him, and I sat straight up.

His smile faded. "I was just kidding, making a joke."

"Yeah, well, who's laughing? Did you really just ask me that?" My rage reared its ugly head. "I took care of my dying husband, never took a single day off. You have the nerve to ask me that. As though I'm only a person who sits around being pampered, entitled, and maintained!" I jumped up, headed for the bathroom, and turned my head back, expecting an angry rebuttal. He was as white as a ghost.

Soaking in overfilled bathtubs was my therapy. When Boone was sick, it was my only escape. I would soak until my fingers and toes were wrinkled beyond recognition. There were times I could barely pull myself out. I would watch the water drain as I air-dried, wishing I could slip inside the drain and evaporate.

Reflections of pain resonate inside a soul for life. You can shuffle, rearrange, and attempt to camouflage painful memories, but discarding is impossible.

Dale was still sitting in the same chair when I came back into the living room. My wet hair was wrapped in a towel with an air of anger trailing behind.

"I'm sorry. I swear, I didn't mean anything, Prissy," he said. "I was trying to be funny. I never thought—I don't think of you that way. You should do nothing if that's what you want. You deserve to do nothing."

"I'm not planning to do nothing. I'm still trying to find my way, and comments like that don't help. I'm consumed with guilt just being here with you."

"I'm sorry. I am. What can I do, say?"

I knew he didn't mean anything, and as much as it seemed we knew each other, we were still strangers.

"Forget it. It's okay," I said and wrapped my arms around him.

❧

The next morning, we were having a late breakfast. My flight was scheduled to depart in a few hours. I was still trying to accept the fact that he was leaving hours after me and arriving home hours before. But he was flying the Concorde, and I was flying like every other ordinary person I knew.

"What'd you spend on that ticket?" I asked.

"More than you." He buttered his toast and took a bite as he grinned.

"I flew free," I said, throwing in a touch of sarcasm to make my point.

We both knew our thousand-mile distance was an issue. We just chose not to talk about it, though it was all either of us thought about. His next question didn't take me by surprise.

"When will I see you again?"

"I don't know, we need to figure it out." I slipped a strawberry into my mouth. I felt him studying me as I reached for jelly and slathered some on toast.

"How 'bout I fly to Tallahassee this weekend?" he asked. That was only four days away. I needed to prepare my daughters. Well, frankly, Garrett. I knew I needed time before he came.

"Maybe the following week. That way I'll get myself unpacked and organized. Plus, imagine all the work waiting for you back in Indy."

"I'm not thinking work. I'm only thinking you."

"Let's just get back home and decide, how's that?" I slathered another spoonful of marmalade on the same piece of toast and avoided his eyes.

Chapter Five

Blue Eyes and Blue Skies

DURING MY ENTIRE FLIGHT from Paris, I worried. I didn't sleep a wink on the plane. I had sent an email to my daughters when I was in Paris, fearing they might get wind from someone else about my changed itinerary and that Dale had flown over and met me.

After he met my friends at the Savoy, I decided to play offense, not defense. I also knew it was easier to beg forgiveness than ask permission. Not that I needed to ask anyone's permission about Dale. But still.

Nothing stays quiet for long in Tallahassee, a capital city with small-town charm. As silly as it sounded, I didn't want to be judged for traveling with a man no one had heard of. It would be difficult for everyone who knew me to digest.

Garrett and Sara Britton would want details. We were a tight trio, especially after our tragic journey together during Boone's last year. But I was their mother and not a girlfriend. I needed to remember that, though my personality might make it difficult.

Don't share too much, Prissy, I told myself.

I decided to play it down, only giving them the most basic outline of what had happened. They didn't need to know I was crazy about someone they'd never met. Besides, after just two weeks, I couldn't be. That was insane. I was insane.

The air outside the Tallahassee airport was stagnant and nasty hot. I couldn't imagine Dale wanting to visit during August, the worst month of the year. But he called twice and asked if he could come the next weekend. I knew it wouldn't work with Garrett. She made it clear it was wrong of me to abandon my friends after they had planned on me. Clearly, Garrett was not in favor of her mother's new romance. Not by a long shot.

I told Dale I would be out of town and he shouldn't come.

A few months earlier, before I had reconnected with Dale, I had offered to help my good friends Bobby and Beverly Burleson at their annual Florida Transportation Builders' Association (FTBA) convention. It was being held at Amelia Island, a three-hour drive from Tallahassee. Bobby was president of the association, and Beverly planned the event every year. It was huge, a thousand attendees. I thought it would be fun to work the registration table and chat with people from all over the Sunshine State.

It was Tuesday as Beverly and I sat inside Bella Bella restaurant for lunch. We were wrapping up the details for their upcoming convention. I shared a few tiny pieces of information about Dale, the Memphis reunion, and our trip to London.

"Why don't you invite him to the convention? We could meet him. I think there's even a direct flight from Indianapolis to Jacksonville. We're having a costume party and a band on the beach. It might even be cooler there than Tallahassee."

I listened as I ate my salad. I wasn't quite ready to introduce him to more people. But almost everyone at the convention would be a stranger. The pros and cons floated around my brain.

"What's the costume theme?" I asked. I was never one for a costume party but didn't want to burst her bubble.

"It can be anything you want, so long as it starts with the letter *H*."

"I don't understand…*H*?"

"Every year we pick the next letter of the alphabet. We started with *A* eight years ago. Now we're up to *H*. So, it's an *H* party."

Everything about Beverly was fun, so I knew the party would be too. I decided to call Dale that night and invite him. He was excited to fly to Jacksonville. I elected to keep the news of his visit a secret until…well, until I couldn't.

I had no idea what to wear to their *H* costume party. I was thinking through some ideas as I headed out for some errands. I slowed down, looked to the left of North Monroe Street, and turned on my left blinker. I had found my *H*.

I parked in the parking lot of the restaurant. It was almost vacant, still too early for the lunch crowd. I reapplied my bronze lipstick and studied myself in the mirror to make sure I had outlined my lips properly, then licked them moist. I jumped out of the Jeep, pulling confidence along with me.

I was greeted with the smell of beer and fried food the minute I walked inside. An attractive waitress wearing a smile welcomed me.

"Lunch for one?" she asked.

"Oh, no thanks. I'm not eating. I'd just like to talk to someone about renting or borrowing a uniform like yours."

She looked at me like I had two heads. Her name tag said Marilyn. "Excuse me, borrow my uniform? We don't loan out uniforms."

"Is the manager here? I'd like to talk to him, please. I know it sounds weird."

So, Marilyn went into the kitchen and came out with Vern, who was covered in sweat. His apron was soiled from the kitchen work he must have been performing when she interrupted him.

"Yes, ma'am, can I help you?" he asked as he wiped his hands on the dirty apron.

"Yes, hello. I hate to bother you—I can see you're very busy. This may sound strange, I know, but…I'd love to rent, maybe even buy, one of your uniforms."

Vern cocked his head as I pointed to Marilyn's uniform. "Do you need work, ma'am? You want a job?"

I gave him a big smile, bordering on a laugh. "You are so sweet. No, I would be a terrible waitress. But if I were looking, I sure would want to work for you." If he only knew how uncoordinated I was, he would have little interest in hiring me. Even so, I slathered him with compliments. "No, actually, I need it for a business event."

"I'm sorry, ma'am, we don't rent, loan, or sell no uniforms."

It took some swaying, more flattering, and a large order of French fries. But twenty minutes later, I walked out of Hooters with my uniform. I think they call this kind of persuasion brownnosing in my neck of the woods.

❧

The Hooters girl picked up her Hoosier man at the Jacksonville airport three days later. We headed to Amelia Island for the weekend.

I introduced Dale to the small circle of friends I knew. He met ten or fifteen at the FTBA convention, and he knew the five from the Savoy. The number of Tallahassee people he'd met had grown to almost two dozen and was still growing.

The Hooters outfit was a huge success. No one believed I could acquire it without an employee contract. "Who says I didn't sign an employee contract?" I said to each person who asked.

To my surprise, Dale had booked his return flight to Indianapolis from Tallahassee, not Jacksonville. "I want to meet your daughters, see your mother and sisters again," he said.

We left Amelia Island that hot August day for Tallahassee. Despite the ninety-nine-degree heat outside, my body was covered in goose bumps. My daughters had no idea Dale was coming to meet them.

Chapter Six

State of Being

As I DROVE ALONG the panhandle toward Tallahassee, the traffic was so snarly it made me even more white-knuckled than usual. The semitrucks and speeders challenged my mental state. I loathed interstates, but today I was anxious to get home and knew it was the fastest way to make it happen.

Dale seemed quiet. I looked over and saw his head bob then fall. He was asleep. I switched the radio from my soft rock station to some classical music and lowered the volume. A crazy speeder cut in front of me. I slowed down, giving him plenty of room, then glanced over at Dale again.

The hot sun shone on his head, his blond hair pressed against the passenger window. I observed his muscular thighs through his lightweight slacks and his broad, relaxed shoulders. It was still hard to comprehend he was in the seat next to me, traveling on the interstate to my city, my home. My emotions zigzagged between excitement and dread.

I felt Tallahassee might change the dynamics of my new carefree romance. We weren't gallivanting here, there, and yonder without a care in the world. The reality was I had two daughters who still missed their father and mother as a unit—the family.

I wasn't sure Dale would be welcomed by Garrett. She had not liked anyone I had dated since her father's death. And this was more than just a date. She knew Dale had flown to Europe to meet me. She also knew he had come to Amelia Island for the weekend. And now he was coming into her territory, into her town, and worse, into her childhood home.

Her mother was carrying on with a new romance, dragging it across the threshold of her loss, pain, and memories. I knew it. But I couldn't stop myself. It was unlike me. I wanted to please, not cause pain. But it felt so good to be happy again.

I turned onto the black asphalt driveway and drove inside the carport of my low-country home. The house where I had built my life with Boone and where he'd taken his last breath.

"This is where you live?" Dale asked, sitting up, half-asleep.

I put the car in park and reached for the door handle. "Yep, home sweet home."

"It looks like a bank," I heard him mumble.

We walked past the manicured boxwoods, every leaf trimmed with the precision of a surgeon. It was Boone's passion, so I tried to keep it the way he liked.

We went in through the downstairs side door. It opened into a large playroom that led into Boone's study. Everything was exactly as it had been when he died seventeen months earlier. He was a game hunter, so the stuffed heads of various animals lined the hunter-green walls. Dale looked up but said nothing. He didn't have to. His expression said it all.

Behind the study were three bedrooms. We walked down the hall toward the rooms. I flipped on the light to the first bedroom on the left and turned around and looked at him.

"This can be your room," I said, surprising myself.

He stared at me, still holding his small bag. His skin turned pale as his questioning eyes searched mine. I couldn't explain something I didn't understand myself. He dropped his bag to the floor.

"Where's your room?" he asked.

"Upstairs, my room's upstairs." My voice sounded hoarse, like I was about to cry.

The downstairs and upstairs were equally divided in square footage. Three bedrooms were downstairs and two bedrooms upstairs. Well, there *were* two bedrooms upstairs, but I had redesigned the upstairs, converting the room where Boone had died into my office and adjoining it to the master suite. I'd thought it might spare me the reminder. It was an expensive lesson in ignorance.

I climbed the stairs to the second floor with Dale following me. When he walked into the family room, his eyes fixed on the large portrait of Boone sitting front and center atop the baby grand piano. I met his eyes when they looked from Boone to me. I showed him the rest of the upstairs in silence.

The moment Dale walked inside my house, everything changed. I was cold and formal, making him feel like an intruder. I couldn't change my behavior. He left me upstairs and went downstairs without saying a word. I didn't see him again until the next morning.

I slept little. I tried to make sense of myself, to peel back my layers of emotions. Grief and joy shared equal space in my heart, all tangled up together. My home was a reminder of all my pain, struggle, and loss. Dale had no place in the space that belonged to Boone, the girls, and me. I had brought another man into our sanctuary, and it felt wrong. And if I felt like that, surely my daughters would.

I woke up early, laden with shame. Who invites a guest into their home and abandons them? I hadn't offered him dinner or wine or even checked to see if he had towels. I had put him as far away from me inside that house as possible—the bedroom beneath mine. I made fresh croissants as a peace offering and went downstairs to see if he was even there.

He sat on the sofa in the playroom, staring into space. He looked as though he'd never gone to bed. His eyes looked pained, confused,

and disappointed in equal division. "What's going on with you?" he asked.

"Honestly, I don't know. I'm sorry. It just feels wrong having you here."

"Do you want me to leave?" He looked like he was about to cry, and I knew I was.

It was so difficult to explain something I didn't understand myself. But I knew I should try. And I did. I tried. Only later would I discover there was a name for my emotional muddle. It's called survivor's guilt.

I talked. He listened. I talked more. Dale was patient and understanding. I apologized over and over for my behavior. My reaction as we walked together into my home, our home, Boone's and mine, was a complete surprise to me.

"You can't force something that needs time and attention, Prissy. We'll just take it slow. No worry. Go get yourself ready, okay? You have daughters in this town I came to meet."

I went upstairs and called my girls to let them know we were coming over, then showered and threw on some jeans and a white T-shirt.

As we drove the six short miles, I prayed in silence. I was a total mess. Knots in my stomach and the mental strain were competing to disarm me. And both were the winners.

The Good Heart

As I PULLED INTO the girls' driveway, I could see Sara Britton's nose through the curtain of her bedroom window. I was sure Garrett was lurking behind, both wanting a view of their mama's new love interest.

In one of my crazier moments, I gave Sara Britton a standard poodle for Christmas. It was a few months after Boone died, a few days before our first Christmas without him. I hadn't shopped and had nothing special for her. Garrett suggested another poodle to go with the two teacups we already had. I know, right? Crazy. But I truly was half-insane, so it was easier than shopping at the mall with last-minute folks. Hence, we had Belle—that was her name—the one now running around in circles in the middle of their yard. She was being treated for hyperkinesis, a dog version of ADHD. It wasn't working.

"Sara Britton, please find a home for that nutcase. She needs land to run around," I pleaded to her deaf ear every time I saw the dog spinning.

I honked the horn to let them know we'd arrived. I also wanted them to know I saw them spying on us.

I had purchased the small house for them to share during college at Florida State University, where they were enrolled. It was a serious fixer-upper, and I had no plans to ever fix it up.

There was no sidewalk from the driveway, so we walked through the lawn to get to the front-porch steps. Dale and I zigzagged across the grass, attempting to avoid piles of dog poop scattered everywhere like grenades.

It was close to one hundred degrees with the August sun radiating down on us. The perspiration already dotted the front of my fresh T-shirt. I had almost reached the porch steps when my right shoe slipped on a sunbaked pile of dog poop.

"Damn it…there's crap all over my shoe!" I yelled. The girls came running with paper towels and apologies. It wasn't a good start.

Here's a truth for anyone who cares: three dogs plus two college girls equals a pile of dump. My dog, Puddles, stayed with them when I traveled. And my sweet little boarder created one more pooper for my girls. This wasn't the first time nastiness hitchhiked on the soles of my shoes at that house.

Once I stopped whining, the polite conversation began. Dale asked all the right questions, inquiring about their friends, boyfriends, school, and life. He was genuine, thoughtful, and kind, just like he had been at the Savoy Hotel with my girlfriends.

"Your mother and I are so excited we found each other," he said. I knew that was the wrong thing to say when I saw Garrett's eyes dart away and focus on something in the dining room. But Sara Britton was engaged, smiling, and listening.

"I'm excited, I am," Sara Britton said. They were like two friends visiting. He answered one question, and she would ask another—job, friends, and Indianapolis. Garrett and I listened to them in silence, her eyes focused on the floor, my eyes focused on her. Sara Britton did have an advantage over Garrett. She had called and talked to him on the phone in Memphis. He wasn't a perfect stranger.

"So, how do you like business school, Garrett?" he asked.

She looked up. "Fine," she answered.

Unlike Sara Britton and me, Garrett was shy. Chitchat was never

her forte. Even so, it was crystal clear she wanted that man to fly back to Indianapolis. The sooner the better. I hoped it wasn't as obvious to Dale.

The poodles had been crawling all over me, and suddenly Puddles and Pooh settled on my lap. Their drool and hot fur made me start to sweat. They felt like two heating pads. I threw them both off my lap and pushed Belle and her panting tongue away. I jumped up from the couch.

"Dale, let's go," I said. "Mama's waiting."

The anxiety festering inside my gut was gobbling me up. I hugged each of the girls and waited for Dale on the front porch. He lingered inside longer. I flinched when I heard him ask, "How about we pick you girls up for dinner?" I walked back inside and was relieved to hear them both say they had plans.

Sara Britton wrapped Dale in a hug as Garrett watched from across the room. But Dale walked over and put his arm around Garrett's shoulder. "It was great to finally meet you, Garrett," he said. "Your mom never stops talking about the two of you."

She returned his hug with one arm, the other arm hanging beside her. In her defense, it's her standard hug. But he wouldn't have known that.

On the drive to my mother's house, I broke the silence. "I'm sorry Garrett wasn't too friendly; she's having a tough time with everything."

"It's no big deal, Prissy. She was fine, give her time. She'll come around. She just doesn't know me yet." He patted my arm. "You'll see."

I looked over at him and smiled. He had no idea how my stomach churned underneath that smile.

As we drove, I reflected on my behavior with him the previous night. Just how much more would he take? If it were me, I would have left. I wanted to ask how he felt but decided not to worsen matters. Besides, I already knew. At least I could count on my mother and sisters to welcome him.

He had a grand reunion with my mother, sisters, and brothers-in-law. After all, they knew him from when we had dated. They talked about things that had happened years earlier, correcting stories shared back and forth and recapturing memorable tales of my daddy, who, of course, Dale had known. This made him special in ways other men I'd dated could never be.

He flew home early the next morning. We had moved into a very different relationship, but it was still a thousand miles apart.

It was Wednesday, and we had been apart for a few days. I answered his regular eight p.m. phone call. "Can you fly up this weekend?" he asked.

"What, why?"

"I told my family about us. They want to see you. Come, will you? Please."

"I don't know. For how long?" My brain was working through the scenario of telling anyone I was flying up to Indianapolis. Especially Garrett. She'd wasted no time sharing what she thought of my fast-moving relationship.

"What do you even know about him, Mom? I mean, what are you doing?" she'd asked over dinner the night after he flew home.

"Garrett, we're dating, that's it. And I know him! My gosh, we went together three years. I knew his family, visited them in Indianapolis. Give me some credit here."

It was no use. She wouldn't budge.

I remained silent on the phone as he kept talking. I was wavering, thinking, *Go. Don't go.* Both thoughts spinning in my head.

"Okay, yes. I'll come." I decided to put Dale first, or maybe me. I flew to Indianapolis just four weeks after reuniting with him in Memphis. Only this time I was going to meet his people.

Prissy, what are you doing? I asked myself over and over. I had no idea.

Chapter Eight

Warm and Welcome

LOOKING THROUGH THE WINDOW of the aircraft, I saw nothing but plains and flatlands. I didn't see any rolling hills, large trees, or bodies of water. I pressed my face against the window. Only fields of corn and soybeans dotted the landscape. I closed my eyes, remembering my previous visit to the Midwest.

It had been in May of my senior year in high school. It was also the season for the Indianapolis 500. I knew nothing about cars and zero about racing. But Dale's father was involved in the racing industry and happened to be driving one of the pace cars. Dale was driving his 1957 Chevrolet up from my hometown, where he attended junior college, to see the race.

The restored old car, with its polished cherry exterior and tan leather interior, had been a chick magnet for him and had a definite rebel appeal for this Southern high school girl. When his mother and daddy invited me to the race and suggested I ride up with him, I was excited, even though his car had no radio or air conditioner.

I lobbied, whined, and begged my daddy to let me go. He was the strict one. He refused. But I gave the poor man no peace. Teenage girls are gifted in that way, I later learned.

He finally caved, but he had one stipulation. We had to drive through La Fayette, Alabama, and spend the night with his spinster

sisters, my aunts Maymie and Tutter. They had lived together all their lives. We did just what he asked. We also made out on the sofa the second they turned their backs.

I sweated like a pig the entire thousand-mile road trip. Not to mention all the times Dale pulled off the road for us to make out—the last time sitting under a sign that read "Welcome to Indiana: Crossroads of America."

I was ashamed to admit I wasn't even sure where Indiana was on the map. Geography and math were my least favorite subjects. I was more a science and English type of girl.

The plane dipped with turbulence, and I bolted upright. I had dozed off. I picked up the dog-eared book from under my purse and started reading again. The night before my departure, I'd gone to Books-A-Million and bought a travel book on Indiana. I was trying to educate myself on the state before I saw his family again.

I learned Indianapolis was the twelfth-largest city in the United States, and I was reminded again it was the Crossroads of America. Now I knew why. It was because five interstates crossed through the city of Indianapolis. It seemed irrelevant, an uninteresting fact to someone like me, who wasn't geographically inclined. But then I put the book down, closed my eyes, and reflected on why nuggets of information like that mattered.

Lake City, the charming little town nestled in northern Florida where I was born and raised, is known as "the Gateway to Florida." That's an important piece of trivia I should have known and didn't. Until I learned the hard way when I was seventeen years old, and not from Google or Wikipedia. It was during a beauty pageant in Fernandina Beach, Florida. My mother, Sylvia LeBlanc Landrum, a former model, decided I might like the pageant scene. Spoiler alert—she was wrong.

I had never been exposed to a beauty pageant, much less trained as a contestant. In no way, shape, or form was I aware of the skills

needed. I'd never had a lesson in standing with my shoulders erect, breasts poking out, and my lips fixed in a fake grin and smeared with petroleum jelly, nor had I been enlightened on ways to use Preparation H for anything other than hemorrhoids. Worse, I had no idea how to strut a runway in a single line, one foot in front of the other.

My mother just filled out the forms and mailed them in with my picture. She then hauled my fanny from Lake City to the front door of that auditorium ninety miles away. I cringed, remembering the brightly lit stage, my wobbling in five-inch heels, and my fire-red bathing suit. I was a foot shorter than the two contestants on either side of me. And that was despite my spiky beehive teased and crowned atop my head.

"Now, Miss Prissy Landrum, here is your question," said the squirmy little man with bad breath. "Can you tell us why Lake City, Florida, is called the Gateway to Florida?"

I could hear the *Jeopardy!* theme playing in my head as I concealed my panic.

"Um…I think…um…is it because we have the Lake City Junior College and Forest Ranger School?" I stuttered.

He burst out laughing, along with everyone else in the auditorium. I didn't win. I came in third, last, since there were only three contestants left standing. But I never forgot Lake City, the town I came from, is the Gateway to Florida because two major interstates meet there: I-10 and I-75. Who knew? More important, who cared? Well, I did after that. Interstate information apparently is relevant enough to get linked to cities and states as subtitles.

I returned to my book and read some more. We were cleared for landing as I discovered an interesting fact. The peony was Indiana's state flower, and that happened to be my favorite flower. Was it a sign?

As I exited the plane, I saw Dale's smiling blue eyes.

"I didn't think you'd ever get here," he whispered in my ear, his arms wrapped tightly around me.

"It's only been five days," I said.

"It felt like five weeks to me."

His infectious love for the city of Indianapolis revealed itself the moment he closed my car door and I buckled my seat belt.

He took the driver's seat on my ten-day Midwest excursion. I was still trying to believe we had reunited only a month earlier, yet here I was coming to see his family.

We merged onto I-70 and headed east toward the Indianapolis skyline. I attempted to let go of my nervousness, but the crowded road and the speeding cars almost unraveled me. Every single car exceeded the well-defined speed limit. Dale seemed not to notice my lack of chitchat or the color of my pallor. He weaved through four lanes of cars like all the other drivers. Finally, he merged onto the exit toward Illinois Street. It was only when the speed limit sign read 25 mph that my heart rate returned to a normal beat.

The downtown district in Indianapolis was a cultural, electric, and beautifully landscaped haven. On every street corner were violets, geraniums, and begonias in full bloom. The colors purple, yellow, and red were arranged in hanging baskets and large concrete containers everywhere I looked. The city had a European feel with the strolling pedestrians and café tables spilling onto the sidewalks.

Our first stop was Palomino, a cosmopolitan, upscale restaurant with a Euro-American cuisine, situated off West Maryland Street, across from the Circle Centre Mall. I looked out the window and saw Nordstrom wrapped around the entire city corner. That discovery whetted my appetite more than the delicious choices on the menu. After lunch, we rode around as Dale familiarized me with the city layout. I learned it had the only grid modeled after Washington, DC—another piece of trivia that might come in handy one day.

Dale kept a corporate apartment downtown, only steps away from Nordstrom. I'm ashamed to say nothing about his tour excited me more than that discovery. When we arrived at his apartment, it was pristine, especially for a bachelor. I suspected he'd had it professionally cleaned before my arrival.

It wasn't designer inspired, though I could tell he had not scrimped on his furnishings. The décor reflected a minimalist approach in style. Dale had probably chosen everything in one sweep, at one store, in one hour. I based this assumption on the palette, fabrics, and textures.

There were no pictures on the walls or anywhere else. There were no throw pillows on the sofa, no knickknacks on the end tables. A two-month-old business magazine lay on the otherwise empty coffee table. The color scheme was beige, brown, and navy, my three least favorite colors. But it *was* in the heart of downtown Indianapolis and walking distance to Nordstrom. And that alone colored my world brighter.

I was exhausted from my early departure and the flight delay in Atlanta. The two glasses of Chardonnay I drank at lunch didn't help, not to mention Dale's two-hour car tour of Indianapolis.

"Go take a nap. I've got some things to take care of at the office," he said.

"I did get up at four a.m. I'm kinda beat." The thought of napping sounded lame, but I was too tired to say much else.

He showed me where everything was in his apartment, then pulled out fresh towels in the bathroom and pointed to snacks and beverages in the tight kitchen before he left. I unpacked a few things and grabbed some empty hangers from his closet. I lingered a few minutes longer and studied his wardrobe. I tried to imagine Dale without a woman to approve or disapprove of what he wore. I had never known a lifelong bachelor.

Who says he didn't have a woman, Prissy? The thought popped in my head from nowhere and caught me off guard.

I realized how little I knew about Dale's previous love life. He didn't volunteer much in our emails. I curled up on the queen-size bed and thought about some questions I would ask him later. As I was about to drift off to sleep, I remembered a conversation I overheard between my brother-in-law Chip and Dale when he visited my mother's house in Tallahassee.

"How in the world did you stay single all these years?" Chip laughed through his question.

"Well, I *was* a foot soldier in the sexual revolution."

Chip had slapped Dale on the back and laughed out loud.

I felt a twinge of jealousy as I drifted to sleep. I didn't wake up for three hours.

When I opened my eyes, it took me a second to remember where I was. I slipped out of bed and strolled to the living room and found him watching the evening news.

"Wow, I feel drugged. When did you get back?"

I was wearing an old T-shirt and pair of boxer shorts I'd found rummaging through his dresser drawers. Mascara bled beneath my eyes, and my hair was knotted. He laughed at the state of me.

"About six. It's six thirty now. By the way, you look adorable."

I couldn't remember the last time I had napped like that. Clearly, I was running on an empty tank, totally drained.

"You hungry? Get dressed, I'm taking you out," he said.

A tired yawn pulled my face. I wanted to crawl back in bed but kept the thought to myself. "Where, dinner?"

"You'll see. Go get dressed."

I wore my new jeans and a spaghetti-strap camisole. I'd gone shopping for jeans after the Memphis trip. The platform shoes were a new purchase too. They complemented the newfangled clothing I'd collected over the last year.

It was a short five-minute cab ride from his apartment. As Dale paid the driver, I jumped out and studied the frontage sign, Ike and

Jonesy's. It looked like a party hub, not the intimate restaurant I was expecting. I saw a smorgasbord of characters going in and coming out of the place.

As we walked inside the smoky venue, we were greeted by a massive bouncer/cashier/stamper sitting on a barstool. His wide torso rolled over the sides and front of his belt. He wore a frown of anger.

"Be thirty dollars—cash!" he growled as his massive hand reached toward us.

Dale paid him, and he stamped my hand. We stepped past him and into a dark space that smelled of stale cigarettes and bourbon. I looked over to see a sweating DJ working the excited partying crowd with his upbeat music. "Now, here's a slow one for you folks to enjoy," he said.

He belted the name of the next song spinning: "Please Remember Me" by Tim McGraw. As the somber lyrics filled the room, thoughts of Boone filled my mind.

Overserved couples with drunken smiles danced across the floor, holding their lit cigarettes.

"I'm getting us drinks," Dale said as he headed toward the bar.

"Cosmopolitan!" I shouted to his back.

I found myself warming to the bar scene despite my unfamiliarity. I loved this new adventure watching the happy, wild, happening crowd. None of my Tallahassee friends would believe I was in this place.

In my previous life—when Boone and I were married—bars and nightclubs were nonexistent to us. The only dancing would be at a fund-raiser or a benefit for a nonprofit organization. This nightclub scene was out of my league. I felt like I was back in college—young, foolish, and carefree. Except in college I never was any of that.

I never once partied after I met Boone. He was five years older, already enrolled in law school, and I was majoring in speech pathology and audiology. We were a disciplined, ambitious couple

studying every night. So many of my college friends said Boone overprotected me. I didn't care.

But when I stepped inside Ike and Jonesy's with Dale, I stepped outside of myself. I was awakened, as if I'd been in a deep sleep. I was standing in a room filled with smoke, but it felt more like fresh air.

Could this blissfulness discovered with Dale be fleeting like Boone? Unexpected loss can make a sane person fragile, skeptical, and fearful. It's only normal, I suppose. But I so wanted to guard my heart, lest it be broken again.

As Dale walked back to me from across the room, I watched his familiar gait and warm smile. His blue eyes locked with mine as he handed over my drink, our hands brushing. Chill bumps crawled up my arms inside the steaming, overheated room. A sense of peace surrounded me.

Maybe I could be happy again. And it just might be with the boy I once loved.

Chapter Nine

Still Me

When the blaring sun blasted through the window and woke me up, I had a well-deserved headache. The window was naked. No shade, blind, or curtain to cover the sun's bright glare. It felt like I was in a hospital operating room.

I always slept in total darkness, with no light coming from anywhere or anything. Heck, I even covered up all the tiny red electronic lights with masking tape: televisions, clocks, and alarm keypads. Those little lights came right through my closed eyelids.

After a bathroom visit, I headed to the kitchen for coffee. There was a love note on the counter beside the pot.

I glanced to the microwave and saw the time as I scooped the Folgers grains into the filter. Ten o'clock already. It was much later than I usually slept. I was a tiny bit ashamed, but my guilt was eased when I remembered it had been Dale's idea to party until two o'clock in the morning. That part of him I knew nothing about.

I grabbed the steaming mug and hurried to shower and dress. We were meeting his mother and siblings for lunch. I prayed the coffee would calm my headache but had little hope my prayer would be answered.

❧

We pulled into Steak and Ale, a restaurant chain near his mother's home. She still lived in the same house I'd visited as a girl.

I flashed back to three decades earlier when I had met his family. I had shared a bedroom with his sister, Mary Ann, who was eleven years old at the time. I remembered her braided, strawberry blond hair cushioned against a pillow as she watched my every move from the twin bed next to mine. She was enamored with me because I shaved my legs and curled my eyelashes. I let her play with my eyelash curler, a contraption she had never seen before.

I wondered if his family blamed me for our breakup. Remembering that did nothing to comfort me as we walked inside the restaurant where his entire tribe was waiting.

"Ready?" he asked.

"Sure!" I said. *No!* I thought.

We entered the private room, and I walked around the table, giving a Southern hug to each one of them. Marcia, his mother, wore a lovely navy dress, cultured pearls, and a beautiful smile. She pointed to the chair to her left, where I should sit. Lordy…I was at the head of the table.

As soon as I sat down, it was as though I held court. My mouth never shut, and not from chewing. The Elrods were the quietest people I'd ever met. They chewed their food without running their mouth. They were comfortable eating in silence, with no chitchat whatsoever. My family meals were the complete opposite, everyone always talking at once. I thought I should keep the conversation going. And I did. For two hours. When I finished, they knew more about Dale than they ever could imagine. And everything about me.

As we were saying goodbye, Mary Ann wrapped her arms around me. The little girl who had played with my eyelash curler had blossomed into a beautiful woman.

"Prissy, I love you," she said. "You just told us stuff about Dale we *never* knew."

"Lord, I don't know what private is," I told her. "He picked the wrong girl." I saw Dale turn with a sheepish smile.

By the end of my first week, I learned what Dale did in business, something I wasn't sure of during those months of our writing. He manufactured pneumatic tools (air tools) and showed me how he did it from start to finish. Until that day, I had no idea what the word *pneumatic* meant, much less what it did.

He gave me tours of his other business partnerships: spectator stadium seating for events like the Indianapolis 500 Festival, NASCAR, and tennis matches throughout the country.

We drove to another small town where a new manufacturing building was under construction. It was impressive, even to this girl who knew nothing about manufacturing. I understood something about power tools and felt smarter. And his family knew more about Dale than ever before. It was a win-win for all of us.

Chapter Ten

Bathed in Sunlight

AFTER SEVEN DAYS TOURING, I'd seen most everything: Indianapolis, family, company, even the new manufacturing site. I'd met his friends and partied every night. It was official—I loved Indianapolis. A week earlier, I didn't even know where it was on the map.

It was Friday morning, two days before I was flying back home. "So, what's left to do today?" I asked, chewing through a spoonful of granola.

"Pack," he said, loading his plate into the dishwasher.

"Pack now? I'm not leaving 'til Sunday."

"No questions. Pack your clothes. All of them."

An hour later we were merging onto I-65 south with my same white-knuckled grip hidden from him.

"Tell me what we're doing, where we're going."

"My home. You've just seen where I sleep when I'm tired."

"I don't understand."

"Medora is my home. It's seventy miles away. That's where we're going."

"You commute there? That's just nuts."

It seemed I'd found another workaholic. Boone worked until eleven o'clock every weeknight of our married life. I swore to myself I would never be with another workaholic. I also said I'd never date a man with a pickup truck. Yet here I was with both.

"You need a shade in that bedroom of yours." It was the first time I'd thought to mention it to him. "It's really bright with the sun in the mornings."

"I leave for work early, and it's still dark. I get back at dark. Guess I never knew that. I'll get a blind."

"I'm gone now, so I guess you don't need it."

"You'll be back." He looked over and winked.

"How many years have you had the place?" I asked.

"Six, seven, maybe."

I had no reply for his crazy reality. No blind in his bedroom for years. We traveled the next hour in silence as I tried to figure out what I was doing with another workaholic man. Thirty minutes later we pulled off the exit to Medora.

If I blinked, I would have missed the tiny town, a population of only six hundred people.

"This is the longest triple-span covered bridge in the United States," he said as we crossed it.

He turned on a dirt road and bumped along a mile or so more before he stopped in front of a cow gate. It was chained with multiple knots and a rusty lock securing it.

Dale climbed from the cab of his Dakota truck and unlocked the weathered gate. A squeaky sound echoed through the green pasture as cows mooed nearby. Humid summer heat climbed inside his open door, blanketing me like a wool throw.

We passed the wide-open gate and continued down the dirt road. I gazed up at a cerulean-blue sky that peeked through lush shades of olive and avocado leaves. They loomed high above the narrow, meandering road.

It seemed the road would never come to an end as we drove through the dirt and gravel, the sound of the crunching pebbles under the weight of truck tires breaking the silence inside the forest. We wound two more miles along the canopied road. Finally, the

road ended, and he cut off the ignition. The sight was breathtaking and dazzling all at once.

Ahead sat a small wooden cabin surrounded by two massive lakes that looked like mirrors. A large, outstretched dock loomed over one of them. Forest surrounded the lakes. I jumped from the truck and ran inside to see the modest cabin. It included all the creature comforts one needed but was far from fancy. Dale and his father, brother, and uncles had built it log by log, nail by nail.

My explorative tour of the four hundred acres began after a quick bite to eat. And it was on a four-wheeler. I asked Dale for a helmet, and he laughed.

I flashed back to Boone, his protectiveness and fears. It was only a second, but I felt him watching me from heaven, wondering what the hell I was doing even considering riding a four-wheeler with no helmet. And in a forest. Boone had been fearful, judicious, and protective of everything and everyone, especially his girls and me. He would never have allowed us on a four-wheeler without a helmet. What was I thinking—he would never have allowed us on a four-wheeler, period!

I longed to be reckless and free but wondered if I knew how. I hadn't done anything spontaneous or reckless in decades. The free-spirited Prissy of yesteryear was a different person now. Where was the girl I once knew? What had happened to her? I climbed behind Dale and wrapped my arms around his waist.

As I sat and waited for him to crank the ignition, a strange invigoration caught me off guard. I had this sense of total freedom—the *could* or *should* was my decision alone. Nobody was the boss of me. It was a strange feeling after so many years.

I watched as Dale went through the steps to crank her up. I was intrigued, thinking I might take it for a spin myself later that afternoon. I felt like the once me, the one with no fear of motorcycles, four-wheelers, and fast cars. She had climbed on ATVs so many

times in her youth. And now, here she was, peeking from around a hidden corner within me.

He turned the "kill" switch—that name made me think again—and then actuated the choke by a thumb tab. He squeezed the right brake lever and pressed the starter button with his thumb. The engine started, and I wrapped on to him even tighter. I was ready. But it wasn't. There were more steps.

He opened the throttle to get the gas flowing, and the engine started to pop. And popped again, louder. Dale gave it more throttle. We sat, and sat even longer, just idling. I realized it was way too much work and I would never take that thing out by myself.

With both of us soaking wet with sweat, he turned off the choke. And then, finally, we took off at a snail's pace.

I leaned my face against his neck and breathed in his scent. Perspiration ran down his already-soaked T-shirt. My arms wrapped tighter around his waist.

As we sped through the forest, over the hills, and through the streams, Dale pointed out his red oaks, white oaks, and yellow poplars. He was a forester and loved his woods. I only realized how much as he shouted facts to me over the deafening ATV engine.

"One of every five acres in Indiana, that's four-point-nine million acres, is covered in forest. There are eighty-five different tree species," he yelled back, his cheek touching my nose.

I inhaled the fragrant flowerage, admired the hardwoods, and watched the red squirrels scurry and bounce. Then a branch slapped across my face, and I tasted blood. I wiped it off but said nothing. When we arrived back at the cabin and dismounted, my face was swollen, the cut oozing blood.

"My God, what happened to you?" Dale had an alarmed look on his face.

I had no idea what I looked like. I just knew it hurt like hell.

"I think a branch got me."

"Why didn't you say something, Prissy?"

Later I would learn my not whining impressed him most. Surely every girl believes her shoes, cleavage, or charm scores higher. Now, we know better.

After Medora, our plans changed. Dale had a company he was selling in St. Louis. He got a call from an interested buyer and rescheduled my trip back to Tallahassee so we could drive to St. Louis and meet with the man.

I got the tour of the plant in St. Louis and was introduced to Dale's closest friends, Paul and Mary Kikta. They were instrumental in Dale's flying to London to meet me, encouraging him to take a leap of faith despite his fears. I couldn't wait to thank them for sending him my way.

We shared dinner, wine, and tales of Dale's bachelor life. Sometimes you meet people you know are predestined to be good friends. I loved Paul and Mary instantly.

After two days in St. Louis, we drove back to Indianapolis. We relished our last night there with a sentimental evening at Ruth's Chris Steak House. Since we were in meat country, I ordered a filet mignon again, still pretending I liked red meat. We shared a fine bottle of pinot noir and a spinach salad and slurped Brandy Alexanders for dessert.

It had been only six weeks since we'd met in Memphis. But I felt a change stirring inside of me, cell by cell, breath by breath. An invulnerable peace flowed through my veins.

I relished this awakening, my newfound serenity. Classical music streamed through the dimly lit room as I listened to the murmur of distant conversations from strangers.

Dale reached across the table for my hand. He held it inside both his hands, rubbing my knuckles. "Will you marry me?" he asked with a longing in his eyes. I flashed back to decades earlier when the same boy asked me the same question and I replied, "Ask me later." Only this time, I said yes.

Chapter Eleven

Fragile Strength

FLYING BACK HOME, I was worrying. About everything. Mostly, my two girls. How could I tell them I was getting married to a man they had just met? I began to shake, ignoring the man sitting next to me.

"Where you traveling to?" he asked.

"Tallahassee," I said, reaching for the barf bag and holding it near my chest. He turned away and remained quiet the rest of the flight. I'm ashamed to say I still do that when I don't feel like talking on planes. But this time I really was feeling ill. I was afraid my girls, family, and friends would think I was moving on too soon. Boone was dead; I was in love. It was wrong on so many levels.

First loves are unique animals, leaving footprints on a young heart. In my opinion, if a first love is healthy and nurturing, it inspires a person, enriches their life, and germinates an artistry of affection, devotion, and respect for friends, spouses, and children. Other relationships will be better mannered through life.

When Dale and I were young and dated, there was no drama, fighting, or tears. Our relationship ended only when our schools distanced us. The moment I opened his condolence card about Boone, I knew he still loved me.

I found my car, parked in the long-term parking lot, loaded my suitcase in the back, and climbed into the hot seat of my

Jeep Cherokee. I paid the attendant and exited the terminal parking lot.

It didn't take me long to realize reality had climbed inside the Jeep with me. The ambient setting and romantic arena I'd so enjoyed the previous night was absent. Reality nudged me all the way home from the airport.

My daughters were grieving a father snatched from them. They missed the family of four they no longer had. I gazed up from the road to the pillowy clouds floating above me. "God, what's your plan? I need some direction," I prayed out loud.

I stopped at the end of my driveway and pulled all the mail from my overstuffed mailbox. I had asked the girls to take turns retrieving it during my absence. Clearly, neither one of them gave it a thought. I unloaded my luggage from the car and dragged it in as far as the laundry room, then went upstairs to make a cup of tea.

I pulled a gown from my lingerie drawer, turned on the faucet, and poured in my lavender salts. After Boone died, I remodeled our master bath and put in a whirlpool tub, one way too large. I had to keep my toes pointed to touch the end and even stay afloat. I figured my new tub would be cheaper than grief therapy. I didn't want to sit around a room full of strangers sharing sadness. I figured I would recover better sitting in my tub filled with infused scented salts and swirling water while I listened to music. I'd never had therapy, so I had nothing to base my craziness on—well, except my craziness. I probably could have used therapy. Who am I kidding? I still could. But that's another story.

My spearmint-flavored tea moistened my parched mouth as I soaked. How could I marry him when he lived a thousand miles away? I couldn't move and leave my girls, not when they still needed me. Dale couldn't live in Tallahassee with his business in Indianapolis.

I slid under the bubbles to wet my hair, then squeezed some apple shampoo in and lathered. What was the acceptable grace

period for grieving, allowing a survivor permission to feel pleasure over pain, heartthrob over heartache, elation over despair? I didn't know. Boone was sick thirteen months before he died, and he had been gone eighteen more. The thirty-one months felt like a lifetime. As I lay in the tub, consumed with guilt and confusion, I wondered if my answer to Dale's proposal should have been *maybe*. After all, there were three layers of me. Garrett and Sara Britton being the other two.

Forty minutes later, I was sitting at my desk, writing an email, more like a love letter, to Dale. It was after eleven p.m., so I knew he would be asleep. Even so, there were things I had to say.

Dear Dale,

I asked God to give me courage, strength, and the desire to go on. Then I became greedy and asked for more—someone to share all the love I had inside me. God knew me well and wasn't surprised by my request. He understood what I was asking for. You see, he does listen and work for us each day. He gave me more than I asked for. But now I'm afraid something will happen to impact my newfound happiness. Life is too good—that scares me.

P

I hit send, turned off my computer, and slid into bed, tucking the comforter under my chin.

The next morning came too soon. I climbed out of bed to start my day: coffee, laundry, and thinking about my girls. Wondering and worrying. I picked up the phone and called to invite my daughters to lunch.

Chapter Twelve

Rules Don't Apply

GARRETT, SB (SARA BRITTON's nickname), and I met at Hopkins Eatery, a favorite neighborhood restaurant. It was bustling with the usual lunch crowd, and there were few tables left. I spotted a small booth in the back corner and hurried to grab it.

"Get me chicken noodle soup, please," I hollered as I slid inside the wooden booth, leaving my daughters in the line to order our food. No one cared if you hollered at Hopkins. Maybe that was why I liked it.

Sitting around the table next to me was a group of women of all ages and sizes dressed in matching tennis outfits. Based on their sweat factor, I surmised they had just finished playing.

There was a blonde with thick, wavy hair like mine, another with frizz like mine (poor thing), and one with a tight pixie cut who looked adorable. A brunette was wearing a lime-green baseball cap, and the other two sported damp ponytails.

I loved wearing tennis clothes but not the game. I was terrible even after all the childhood lessons. One day Deborah, my older sister, said, "You just aren't coordinated enough to play tennis, Prissy." It was one of the meaner things she'd said but also one of the truer. It stuck.

I watched my girls moving up in the food line. As I sat waiting, I listened to the women laughing next to me and thought about my

one tennis day. I had taken my leather purse to the cobbler shop to be repaired, and as I walked back to my car, I passed a shop and noticed a mannequin in the window. Rather, I noticed the sensational tennis frock she wore. There was something about her, the way she looked. The mannequin resembled me the tiniest bit. Her curly wig, maybe.

I loved the look of the lemon-and-magenta outfit against the sporty tennis racket she held up, as if ready to serve. I have no idea what I was thinking, why I even went into that store. *I'll take lessons, maybe*, I'd thought. Anyway, I asked the price as the sales clerk climbed in the window and snatched the lemon-and-magenta right off the mannequin. She was wearing my size.

As I stepped out of the small dressing room and stood in front of the shop's three-paneled mirror, the sales clerk coaxed, "That's made for you. It fits so well. You *have* to get it."

"I can't. I don't even play tennis," I confided.

"It looks too good. Who cares? Who would know? You should just get it," she said. She was good at her job. I signed my name on the credit card receipt and left with the lemon-and-magenta outfit peeking from my shopping bag.

"I'm gonna call about lessons," I whispered to my lying self. I wore that splash of color to lunch the next day.

"What are you wearing? Are you playing tennis?" Gayle, my best friend, asked when she saw me.

I studied the menu. "I'm taking lessons," I lied, not looking up. Well, I was thinking about it.

"Those are your colors, and it looks like you." She laughed. I never did take those lessons. I was crazy to let the pushy sales clerk talk me into buying it. Everybody knew I didn't play tennis every time I wore the stupid outfit. I was feeling stupid remembering.

The reason I was afraid to tell my girls I was getting married was because it was ridiculous to have agreed to marry someone after dating him a few weeks. I felt like that stupid girl all over again.

Garrett and Sara Britton interrupted my thoughts and placed a tray full of soup and sandwiches on our table, then slid into the booth opposite me. I was nervous and wasn't sure I could even swallow my soup special.

I studied their facial expressions and moods, mentally rehearsing, running my news through my mind again. *Girls…this may come as a surprise…well…um…we are getting married.* Just thinking it sounded crazy. How could I say it out loud?

I was going to marry a man they hardly knew. Reality whispered in my ear: *Rehearse all you want, silly woman. Feel free…big mistake. They will never understand.* I slurped a spoonful of soup and remained quiet.

"So, Mom, what did you do up there?" Garrett asked with a tang of sarcasm as she bit into her Linda Special. It was one of Hopkins' specialties and named after the original owner.

"Well, let's see…I met his family again. We toured downtown Indianapolis. I saw his manufacturing plant, met some friends." I slid in another spoonful of soup and swallowed. "Then we went to his lake house in Medora for two days—oh yeah, and drove to St. Louis…" I was blabbering away before I realized neither one of them was listening to a word I said. Garrett was asking Sara Britton about her sandwich, and Sara Britton's eyes were flicking between Garrett and me, uncertain whom to focus on.

Forget it. There was no way I was telling them. Not with hordes of people sitting around. I changed the subject and started talking about all their goings-on, not mine. By the time we left the restaurant, my half-eaten soup had intermingled with my unveiled news, rolling around in my gut. A dollop of indigestion thrown in for good measure.

By the next day, I couldn't stand it anymore. I had to tell someone I was getting married, for Pete's sake. I needed help dissecting a major decision in my life. I picked up the phone and started

dialing, inviting those most important for an impromptu dinner party: daughters, mother, sisters, brothers-in-law, nieces, nephews, and my closest friends. I knew my sisters and mother would be allies. After all, they knew Dale from when we dated as youngsters.

The wine was poured, and I served up my low-country boil specialty: Louisiana-style shrimp, red potatoes, Vidalia onions, pork sausage links, and ears of corn, all boiled with crab juice and served on newspaper. It was one of our favorites during the hot summer months and a great crowd-pleaser.

I was holding two plates of my homemade custard trifle to pass out when I heard someone saying goodbye. *What? Oh no!* I almost dropped both dishes on the floor. No way anyone was leaving until I shared my news.

Before I knew what happened, my narrative, the one I'd rehearsed a hundred times, was forgotten. Three words fell from my mouth. "I'm getting married!"

Bang! Just like that. I saw Garrett's lip start quivering and her left eye twitch. Sara Britton jumped from the couch and ran into my shaking arms.

"When? Where?" Gina and Deborah, my sisters, asked in unison.

"I don't know, it just happened." My intuition kept me from sharing anything more. I had said plenty.

Everyone deals with death, divorce, and destruction in different ways. They travel their weary paths in their individual time frames. I naïvely learned—only after Boone's death—there are some who sit and decide what they consider to be acceptable rules of mourning. But there are no rules for grieving. None.

It would have been idyllic for my daughters and me to mourn collectively—as one unit. That's not the way it works. You don't choose how you grieve. It chooses you. Though my daughters and I shared this painful journey, the dynamics of our loss were vastly different.

They were left without a father. A huge loss—pivotal, powerful, punishing. Especially when it happens at such a vulnerable age.

I lost Boone emotionally, intellectually, and sexually before I lost him physically. Thirty-one long months. My grief started the day I learned he was diagnosed with a glioblastoma brain tumor. I saw the shadow of my own mortality that day. I would never be sure about tomorrows again. I birthed a deep-rooted belief in *carpe diem*, seize the day. I began living life more urgently after that. And if I didn't embrace this gifted happiness from Dale, he, too, might be snatched from my life.

I knew in my heart it was too soon for my children to see their mother remarry. But I also knew my chance at happiness was like fresh air I needed to inhale. I was juxtaposed between my happiness and their sadness. How could I be happy at the expense of another's unhappiness, especially when it was my own daughter Garrett? I knew Sara Britton would be fine. But Garrett left me riddled with self-doubt and guilt. I emailed Dale to let him know I'd told the family, turned off my light, and went to bed.

Chapter Thirteen

Proof in the Palm

My eyes were heavy as I tried to wake up. Puddles was walking around in circles at the foot of my bed. She needed to go outside and do her business.

It had been another one of those restless nights. I seldom slept peacefully, tossing and turning all through the night. The bedsheets were tangled around my thighs. I realized I was buck naked, then remembered waking up during the night in a pool of sweat and yanking off my damp gown. Opening my eyes a tiny bit more, I tried to focus on the chandelier above and remember another crazy dream. Nightmares streaming in Technicolor had shared my bed since Boone died.

I reflected on the last weeks: Memphis. Indianapolis. Dale. I stared and thought I saw Boone's face in the shadows on the ceiling. His memory tucked but active. I started counting back the days since Dale and I had reconnected in person.

Dale had proposed exactly eighteen months from the day Boone died.

Puddles started whining, her impatience reminding me she needed to go out. Never a crate puppy, she ran my house and me. We knew the habits of each other like an old married couple. She ignored me when I demanded she come back inside. I ignored her when she begged to go out and eat grass.

I went back to my figuring out the numbers, deciding Puddles could wait a few minutes more. The eighth of November was Boone's birthday. I married Boone the eighth month of the year. His tumor was removed the eighth day of March. Eight. Eight. Eight. The number eight was linked around my life, connecting my past, present, and future. I worked over this significance, wondering if it was more than a coincidence.

Then it came to me. I bolted like a jack-in-the-box. The number eight had been floating in my dream, spelled out and numeric. I wasn't sure how, the specifics, but I remembered it was. Why would I dream about the number eight? What in the world did it mean?

I slid out of bed, pulling Puddles with me. She was licking me all over my face and neck.

"Okay, okay, one lick is enough." She had the worst breath. My mother kept telling me to put parsley in her food, swearing it would cure it. She even sent her wisdom to *Woman's World*, and they'd printed it.

"Come on, let's go outside and do gogo," I whispered next to her ear.

She crawled from my arms and leapt, then raced to the door that led to the backyard. I felt around inside the sheets for my gown. Puddles kept whining and scratching the white paint off the door. She turned to see what was taking me so long.

I finally found my gown tucked between the flat and fitted sheets at the bottom corner of the bed and unpeeled the ball of white piqué that had become a wrinkled mess. It looked like it had aged overnight. I slipped it over my bedhead and hurried to turn off the burglar alarm, Puddles yipping, running circles around my feet, and tripping me as I punched in the security alarm combination.

"Damn it…bad girl!"

When I finally opened the door, she bolted like a puppy and squatted on the first blade of grass, glaring at me as she peed. She

was seventeen in dog years, eighty-four in human years. No wonder. I was ashamed for making her wait.

Feeling guilty, I left her outside to chase squirrels and eat grass while I went to make coffee and ponder the number eight.

I had never been one to believe in magic, voodoo, fortune-tellers, astrology, or horoscopes, any of that hoop-tee-do. A sensible girl knows that if a fortune-teller gives enough generic information, it's bound to reveal something relatable to anyone's life. But that belief changed on a cold January night many years ago, when I met Sister Fay.

Boone and I were at a New Orleans–themed carnival at Maclay School, where our girls had been going since kindergarten. All the parents came dressed in costumes for the annual fund-raiser.

I wore a flammable orange-and-black gypsy frock I'd accessorized with some of my colorful costume jewelry. Boone was wearing a red-and-black pirate costume I'd rented. It had a mask that covered one of his hazel eyes; his flaxen hair was mashed down in the back from the black elastic.

I chatted with girlfriends as I moved through all the silent-auction tables, studying each item carefully, autographing my name under anything I coveted. The local band was playing New Orleans jazz in the background. A few small carnival booths were set up peripherally around the well-decorated gymnasium. Only a day earlier, it had been a stinky arena filled with testosterone-toting adolescent boys shooting baskets after school. The transformation of the gymnasium was magical.

I spotted Sister Fay in the far back corner. I'd heard stories about her. I had always wanted to have my fortune read and convinced myself I would that night. I searched for Boone and found him talking to another attorney.

"Come on, honey, let's go see Sister Fay." I grabbed his hand.

"No way, that's a waste of money." He pulled away.

"Oh, come on, it'll be fun." I dragged him along, ignoring his antics. There was no one in line. In fact, no one was even near her table. Sister Fay had a harsh face and wasn't friendly as she motioned me to the chair across from her. I slid down into the chair. A poster scribbled with marker read $8.00 per person.

"Here, just keep the change," Boone said, handing her a twenty-dollar bill.

Sister Fay slid the money into a small box on the table. Then she reached for my fidgeting hands and pulled them across the table. She turned my palms up and glanced back up at me, stared, then looked back down again. Rubbing her finger over the line on my left palm, she began.

"You have challenges…but I see strong woman. You seek truth. Search hard."

"For what?" I asked over her bowed head. "What am I searching for?"

"Answers."

"To what?" I asked.

"Truth…some you not find."

"What truth?" I asked. *Is Boone having an affair?* I wondered. *That's ridiculous, Prissy,* I told myself. She kept talking, but my mind was wondering.

"I see happy person…you have much courage," she said, then closed my hands, putting my palms together.

I decided this woman was strange and made no sense. There was no mention of me winning the lottery, inheriting money, or having good health, the very things a fortune-teller usually teases you with.

Sister Fay looked up at Boone, implying he was next. I turned around and looked up at him behind me. I could tell he was aggravated, and I knew I'd be hearing about my shenanigans later. I didn't care.

"Your turn," I said. I smiled and batted my eyelashes. He didn't smile but slid into my empty chair. Sister Fay reached out and took his large hands into her plump, wrinkled ones. She rolled his hands over, palms up, and readied herself to read his lines. She looked up and met his eyes and stared for a very long moment. She looked down at his palms again. Quiet, she continued to stare at his lines. I waited for her to speak.

What are you waiting for? The words hung from the tip of my tongue. Yet I stood, watching her head lurking over Boone's palms as we waited. Finally, she folded Boone's hands together and looked directly into his eyes.

I barely heard her words. "I'm sorry, I cannot."

She looked at me standing behind him, then back at Boone, then rose from her metal folding chair. "Thank you for coming," she said and turned and walked out of her booth toward the restroom.

I leaned down to him. "Well, you were right, she's a weirdo, a total waste of our twenty dollars," I whispered in his ear.

Boone was quiet as we walked away from her booth, holding hands. We searched for our table and took our seats for the dinner and live auction. Neither of us mentioned the happening with Sister Fay the rest of the night.

Eight days later he was diagnosed with a malignant brain tumor.

Chapter Fourteen

Deep in the Eight

I FINISHED MY COFFEE, dressed, and headed to the bookstore. I was looking for any sort of book to help me understand what my brain couldn't decipher. Why had I dreamed about the number eight? I gave up after twenty minutes of finding nothing and searched for an employee.

When I found one, I leaned over the counter so the lady behind me couldn't hear. "Do you have any books that explain numbers? You know, what they mean?" I asked him.

I followed him to a section in the corner of the store, one I had somehow missed. He immediately pulled a book from the shelf. I was amazed. Other people wanted to know about numbers, too, I was relieved to find.

"This might be what you're looking for." The lanky boy proudly handed me *The Complete Illustrated Guide to Numerology*.

I paid and left the bookstore in a quickened pace. I was going to spend my Sunday afternoon finding the significance of the repetitive number eight. I was psyched to have discovered the study of numbers and their meanings but planned to tell no one about it.

I skimmed enough to discover the number eight was considered a special number. In the Bible, it represents a new beginning. That alone kept me studying into the afternoon. Plus, let's face it, Sister

Fay had messed me up by, in her silence, predicting Boone's impending doom. She had been right, so why wouldn't I be digging?

I turned on some music, read the thick volume, and learned every number has a certain power expressed in two ways: the symbol denoting its representation and the connection to universal principles. It's believed numbers have relationships with all things in nature, thus making them powerful symbolic expressions. To sum it up, numerology connects our lives and our life experience, helping one understand a single event or a string of events. There is a spiritual meaning for every number, and each person can derive their number through a given formula. I was determined to find my number.

I turned the thermostat down to chill the air. It was still brutally hot outside, despite being September. My poor air conditioner was working overtime and had been all summer. I nestled myself in the middle of the living room couch with my second glass of mint iced tea, classical music streaming in the background. With my pen and paper in hand, I readied my brain to understand more of the whole process, or rather what the number eight had to do with my life and the previous night's dream.

The book gave me the formula to follow: add numbers for each letter of my name together, then reduce this number to a single number with more addition. Honestly, it was more challenging than bridge, Scrabble, or any crossword puzzle I'd ever done. Who knew math could be fun? I was pumped. I poured myself another glass of mint iced tea. And then I found my number. The wrong number.

What the heck?

PRISCILLA MONICA LANDRUM didn't add up to eight. I was *three*. How could that be? But I wasn't finished. I still had to tackle my birthdate, which also had a singular number. *Maybe that's eight.* There was more assigning, adding, and condensing. Two hours later I sat staring, confused. My two numbers were perfect

matches—my name number was three and so was my birthday number. I was a three and not an eight!

I threw all the papers on the coffee table and went outside for a walk. Mosquitoes, heat, and humidity tagged along with me. It was far too hot to be walking, so I stripped down to a jogging bra and shorts.

When I got back home, I was soaking wet in sweat. I drank two bottles of water and decided to wait until I cooled off to shower. I had to find out Boone's number from his full name and birthday. If he was an eight, maybe he was sending me a sign.

"You're ridiculous, Prissy!" I said out loud, just in case Boone was listening.

Chapter Fifteen

Good, Bad, and Ugly

AFTER SHOWERING, I TACKLED my wet hair with the blow dryer, wondering if cutting it short would be less trouble. I remembered chopping it off a year earlier only to discover it wasn't faster or easier but rather twice as hard. The reality: the shorter my hair, the curlier. Everybody wants what they don't have. I wanted straight hair and tiny boobs but got curly hair and big boobs.

I was still thinking about my dream and the stupid number eight. It was ludicrous, a total waste of time. But I tried to convince myself numerology was scientific; it wasn't like astrology, looking to the planets and stars for answers to your destiny. Besides, I didn't dream about the number eight for no reason. That just wasn't possible.

Nancy Reagan was ridiculed for her association with Joan Quigley, an astrologer who frequented the White House during the Reagan years. More than one headline blasted stories of the Reagans that claimed Joan ran the White House with her astrology charts.

The Reagans came from Hollywood though, and astrology was a very hip thing. The astrologers were social equals and mingled at the same parties as the believers. It didn't seem so strange to me that they would have practiced it. Heck, even Franklin Roosevelt quoted horoscopes. Theodore Roosevelt was also an astrology buff. For heaven's sake, these were smart people. I was simply studying numbers and their meanings.

It was six thirty p.m., and I was starving from my walk and blow-drying workout. I couldn't remember if I'd eaten lunch, which happened to me often. I lived on Ensure from the time of Boone's cancer diagnosis until his death, and even afterward. I never regained the lost weight, and my appetite never did return.

I made a plate of hummus and chips and added a green apple with peanut butter. I really didn't care what I ate. I needed to fill the hole in my stomach and hush the growls. Puddles circled her bowl and whined dramatically. I pulled her dog food from the fridge. Piling food in her bowl, I warned her she was getting fat, then removed a big scoop and shoved it back in the can. "It's for your own good," I said.

I wanted some wine but thought twice before opening a new bottle. Red wine was such a waste of money, since I usually stopped after one glass. I tried every gizmo advertised to remove the oxygen from my almost-full bottles. Nothing seemed to work. The next day I tasted the vinegar and would pour it out or make spaghetti just to use the wine. Even so, this was one night I needed a fresh glass. My next numerology assignment was waiting. I opened a bottle of Wild Horse pinot noir and settled in.

"Okay, Jonathan Daniel Boone Kuersteiner, you're next! What's your cosmic number, wherever you are now?"

Puddles looked up, cocked her head, and stared at me. She was smart and wanted an explanation when she heard Boone's name.

I went through the process again, assigning numbers to the vowels and consonants of his name, adding, and then reducing to a single number.

I did it again, once more...three times. I sat stupefied. Boone was number eight. On some level I knew it before I even started. He was eight. I was three. Draw a line down the center of the number eight and it looks like a three. It was me without him. I knew I was acting a tiny bit coocoo and should give the mess a rest. *Prissy, you are a weird wombat widow...stop it!*

The phone rang just as the grandfather clock chimed eight o'clock. Ever since our meeting in Memphis, Dale called every night at eight sharp.

"Hi, sweetie!" I answered in my sexiest voice.

"How was your day?" he asked.

There was no way I could tell him I was trying to find Boone's cosmic number. Or that I'd found it. Or that I had dreamed of the number eight. Or that this person he was talking to was studying numerology for no reason a rational man would understand. Or would he? He was a mathematician. Maybe I would tell him. No way.

I would tell no one and just get on with my uncharted life. Maybe. I could decide later. Tomorrow. I was too tired from figuring all the math. Worse, I was more confused than ever.

After we hung up, I threw all the papers, charts, and my newly purchased book on the glass coffee table. I tried using my latest contraption to suck the air from my almost-full bottle of wine and slid it inside the refrigerator. I turned off the lights, set the alarm, and headed to the bedroom. I climbed in my bed and turned on an episode of *CSI*. I fell asleep before I discovered if the kidnapped boy was ever found.

The next morning, I made the decision to forget all the number mumbo jumbo. I had bigger things to worry about than threes, eights, or anything in between. Dale was flying back to Tallahassee at the end of the week, and Garrett wasn't answering my calls.

I needed to find out what was going on behind her silence. I wanted to help her understand that Dale wasn't taking her father's place. I wanted her to believe he was reassembling pieces of my broken heart so I could live again. If only she could be happy, understand, and accept him.

Prissy, it's too soon to marry him; you should wait. It was the first time the thought ran through my head. It wouldn't be the last.

I poured myself a fresh cup of coffee, buttered a piece of toast, and went back to my desk to do what I did best: write down my thoughts, what I had to say. I did it with Boone throughout our married life when he refused to listen to my opinion or cut me off. Most lawyers know how to argue but seldom know how to listen. It wore me down.

I would write my thoughts to Boone and slip the note, two-page letter, or dissertation inside his briefcase. He would find it, call me, and always apologize. I was a good arguer, but only on the written page. I could write what I couldn't say. Words he *read*, seldom words he *heard*.

I composed my thoughts as I gazed out the window, watching the changing leaves dance in the trees. Summer was almost over. Fall was tiptoeing in ever so quietly. I began to tap my letter to Garrett. Basically, I was begging for her support, or rather her blessing. Once again, the circularity of life took hold.

I hit send and prayed. I was sitting at my desk, second-guessing, when AOL binged "You've got mail." I opened it to find an email from Dale blind copied to me. He had sent an email to my daughters. I inhaled then read it.

Dear Garrett and Sara,

By now you have heard your mother and I are planning to marry. Both of you should know I love your mother just as I did when we were together in the '60s. It was then she taught me what love is, and I never, ever forgot how I felt. Since loving her, I never met anyone that made me feel that way. For thirty years, I never compromised my feelings by accepting less. That's why I remained single all these years. It's also why I am certain about my love for your mother.

Girls, I hope both of you are happy because she truly needs your blessing. Furthermore, she deserves to live happily ever after with someone that loves her as much as me. I promise both of you I will love your mother and will always love both of you, as to me…you both are her.

Written with love,
Dale

I was so touched by his well-written, thoughtful email. I hoped they would agree. I read it again to see if there was anything upsetting. Nothing.

I began sorting bills from junk mail, the stack of bills getting higher and higher. I was feeling anxious, still questioning my decision, my marital judgment, when AOL binged again. I hoped it was Garrett. It was, but not in response to my email; rather, it was in response to Dale's. I was copied.

Dale,

I am very happy for both of you. If she is happy, then I am happy. I don't want her to be alone the rest of her life — I will sleep much easier at night knowing she isn't sad and alone. I must admit I am rather shocked at the abruptness of the announcement, but as she has probably told you, change is not my specialty. It would have been nice if she had talked about it with us — not "ask our permission" but talked with us. If she likes you, then I like you. If I seem standoffish, it is not because I am being childish, but rather it takes me a while to get to know people, and, having a new stepdad that I hardly know would probably be a bit strange for anyone. I have not seen my mom this happy in over two and a half years (my dad has been dead a year and a half), and everyone

deserves to be happy…nobody more than Mom. So again, I know you will make her happy in a way that her children cannot, and for that, I am thankful.

Garrett

I had barely finished reading her email when I received another. This one to me from Garrett. And only to me.

Mom,

I am happy for you, but I do not have the energy to put on a happy face for you because that is not how I feel on the inside. I will try to be more participative with the whole wedding thing, but right now I cannot bring myself to do it.

I do not want a stranger in my family. It is hard enough to have a new member of the family—and pushing it on so suddenly only makes it worse. It would have been better if you had waited more than a few months so that we could get to know him better.

So, if you and Dale are in such a hurry to make it official that you be together, then it may have the opposite effect on some, i.e. ME, making it take LONGER for me to "come around."

You cannot expect to tell your daughters, "I am marrying that nice man you met last week and selling the house you have lived in all your life, aren't you excited?!!" That isn't fair. I wouldn't do that to you.

I was just getting to the point of trying to accept Dad's death, and now I must accept a stranger into my life—it is just too much for

me right now, so I hope you understand and can be patient. I know you love him, as do your sisters, but they have the advantage in that they know him already.

He may be nice, but he is a total stranger to me—regardless of how well you may know him. You know that I love you and want you to be happy. You also know me better than anyone else, and I know you know where I am coming from. So just give me some time. I am not making any promises at this point.

I will come around, one day—but it probably won't be by your wedding day.

Garrett

She wrote the raw edges of my reality. I knew what she meant. One day she might accept us...but not in time to come to the wedding.

I read once that a mother is only as happy as her most unhappy child. It was a truth I was living.

Chapter Sixteen

Logical Emotion

On Friday, I drove to the Tallahassee airport to pick up Dale. He was barely in the car five minutes before I mentioned Garrett's email and silent treatment. It was the same thing we'd talked about the night before, and the night before that. Every evening she was the topic.

"Prissy, stop worrying. She'll come around," he said over and over. I glanced to see he looked exhausted, slumped in the passenger seat. I knew he'd been up since three a.m., the time he started his days.

"It'll all work out with Garrett," he told me as he reached over to pat my hand. He believed what I wasn't sure of.

We had dinner reservations with my friends that evening, so once we were back at the house, Dale took a quick shower, dressed, and made himself a cocktail of Jim Beam and Diet Coke.

Sara Britton dropped by out of the blue, which boosted my spirits. She was genuinely glad to see Dale and told him so. Not once had she been negative about his proposal. If she was opposed, she was sharing that with others, not me.

I watched them interact, seeing how relaxed and comfortable they were with each other.

"I'm going to leave you two and take a shower. We're meeting friends for dinner in an hour, Sara Britton," I said. They were still chatting about school as I closed my bedroom door.

Dale and I sat outside Z. Bardhi's Italian restaurant with two other couples. One of the couples—Bobby and Beverly—Dale had met at the convention. Spider and Gayle had dropped by my house unexpectedly on Dale's first visit to Tallahassee. There was no way my friend Gayle was waiting around to meet the man occupying my mind.

Z. Bardhi's had long been a favorite restaurant of mine. The ambience was always flavored with the aroma of garlic, tomato, and fresh herbs growing in pots on the porch.

"Okay, what's the date? Tell us." Gayle had her calendar out on the table across from us. She and Spider, her husband, along with Bobby and Beverly, had nursed me through the dark days with Boone. When Dale came along, they welcomed him with open arms, determined to smooth the way for me.

Garrett was interning in the office with Gayle at Leadership Florida. This closeness afforded Gayle the opportunity to lobby Garrett: counseling, lecturing, urging—everything she could to help Garrett accept my newfound happiness. Everyone needs a girlfriend like Gayle, not just Oprah.

"Everybody is suggesting we have a cocktail party for you two lovebirds. We want to celebrate," Beverly said.

"A party? That's ridiculous, no way," I said.

"You need to set a wedding date, decide where, pick out china and stuff," Beverly suggested.

"China? I don't want china. I have too much already."

"That's old stuff, twenty-five-years' stuff. Boone stuff. Give it to your girls. You need new with Dale. People will give you gifts. Register what you want," Gayle said.

The men carried on with their conversation—stock market, football, politics—as we discussed china, wedding dates, and other people.

"Honestly," I said, "I hate to set a date until Garrett comes around. She's not even close."

Spider turned and looked at me. "Miss Priss, I heard that," he said. Spider always called me Miss Priss, ever since the day he met me when I was twenty-three years old. Never once had I been just Prissy to him. "Listen, those girls aren't kids anymore. Garrett's twenty-two years old. Sara Britton—how old is she now?" he asked.

"She'll be nineteen in November, remember? Her birthday is the day before Boone's."

"For heaven's sake, stop worrying about those girls. They're almost grown. Garrett will do fine," he said, half scolding me.

Men think with such logical brains, while women stay muddled with emotions. Spider, Bobby, Dale—they all made it sound so easy, each attempting to reinforce the belief that Garrett would just come around. I knew better, and worse. Though by the end of dinner, I almost believed them.

That night I couldn't sleep, thinking about what my friends had said. I slipped out of bed to check dates on my calendar. When January 8 landed on a Saturday, the typical night for a wedding, I knew. It was Boone's singular number. It was the "everything" number orbiting around so many events in my life. Maybe all along it was Boone. Maybe he directed Dale to me. There simply could not be any other date to marry. No one knew this except me and the universe. Well, perhaps Boone. Eight meant new beginnings.

❧

As we drove to the airport on Monday morning, I surprised even myself. It was just before sunrise, and darkness was being swallowed by welcoming light.

"What about getting married on January eighth? Would that work?" I whispered as I drove.

"Yes, perfect." Dale slapped his hand on his thigh.

"Okay, then let the sparks fly."

I wouldn't know how much could happen.

Chapter Seventeen

Life Through Curves

I WAS HUMBLED BY the depth of generosity among so many friends. The ones who felt helpless during Boone's hopeless prognosis were calling to congratulate me on the good news. But each call only reinforced my inner turmoil.

I didn't think I could move to Indianapolis and leave my daughters, mother, sisters, and friends. Tallahassee was home, my haven. Too many changes had already happened in my life, not to mention my girls' lives.

It was Friday, and Dale was flying in for the weekend. After our engagement, he began flying at the same time on Delta Air Lines every Friday, then returned Monday morning on the first flight out of Tallahassee at five thirty. He was back at his desk before noon.

As I drove to the airport to pick him up, I convinced myself I would only talk about wedding plans and enjoy our weekend. I wouldn't burden him with my worries. But he wasn't in the car five minutes before I unloaded on him.

"I can't move there with you."

He turned away and looked out the passenger window. I kept driving. Thinking. Waiting.

"How would it work if I flew back and forth, or maybe alternate and we take turns?" I asked.

He stayed silent. I thought about when we used to date. I would be yapping to him about this or that, some farfetched notion I'd come up with. He would listen and not say anything, not one word. I was a teenage girl, full of myself, so that kind of thing irked me then.

"Don't you agree?" I would ask him. But he wouldn't answer or even acknowledge he'd heard me. Back then I didn't understand how his mind worked. But now I did, so I said nothing, electing to lobby for his approval later.

In the months since we'd met again, it was apparent Dale cogitated every question, thought, or opinion before he answered anyone. I was the opposite and rattled my opinion to everyone, even those who never asked for it. Perhaps it was from living with a lawyer for twenty-five years, learning how to state my case and stand my ground on every issue—major or minor. Now I wished I'd let Boone be the winner on the little incidentals, the insignificant details that meant nothing in the scheme of life. I couldn't know what massive loss he would endure later. If only...

After driving in silence for twenty minutes, we pulled into my carport.

"We'll make it work, Prissy, don't worry," Dale said. He had cogitated.

That night we ordered pizza, drank a bottle of wine, and both fell asleep before nine o'clock. The next morning Dale suggested we take Garrett and Sara Britton to breakfast, and so we did. Dale was still trying to win Garrett's approval. I watched her mannerisms as Dale talked and she listened. She seemed to be better around him, or maybe I saw only what I wanted to see.

Later that day we decided to see a movie I'd heard about. It was called *The Sixth Sense,* starring Bruce Willis. The theme was ghost-driven. Frankly, since Boone was haunting me, it was the last thing I should have seen. After that mistake, the rest of our weekend was less festive, more somber, no fun at all, truth be told.

❧

Choosing the wedding venue scrambled my brain. I wanted to get married at St. John's Episcopal Church. I felt safe within its ancient walls, the familiar scent, the patinaed beauty, and all the history encircling me.

My children had been baptized and confirmed inside that church. Boone was an acolyte there as a boy and had taught Sunday school there as a man. I was reaffirmed there as an adult, after being baptized and confirmed in the Catholic Church as a child.

But in a blink, I knew I could never marry there. We would be standing in the front of the church, exactly where Boone's casket had been placed. My daughters would watch us, reflecting on their father's funeral, him, and his death. I eliminated St. John's.

Everyone said I should register for gifts as a new bride, but it seemed indulgent and unnecessary to me. My belief changed two days later when I opened the front door to our first wedding present. It was wrapped in glossy white paper and crowned with a huge bow. The invitations had yet to be mailed.

I knew then my girlfriends were probably right. In Tallahassee, if you're getting married, you register for gifts at My Favorite Things, the local gift shop. I needed support and guidance through this awkward situation. I picked up the phone and dialed Garrett's number at the Florida Chamber of Commerce, where she was interning with the Leadership Florida program. She answered as I was hanging up.

"Are you busy, honey?" I asked.

"Not too busy. What's up?"

"Would you want to meet me?"

Garrett and I hadn't been talking much. In fact, we had talked only twice since I'd read her email two weeks earlier. I knew she needed space, and I was trying to give it to her.

All the wedding plans—guest list, invitations, flowers, caterers, photography, et cetera—would be made with the help of my closest friends. I elected to leave both my daughters out of it.

"I need help registering for gifts." I held my breath and waited for her answer.

"What…for china…really?" She sounded surprised.

"I know, it's silly, right?" I was embarrassed I'd called her.

"No, I think it's smart. What time?"

"Really? Great. Can you get off by four?"

"Yeah, probably. Want me to call Sara Britton?"

"Absolutely. She may have class though. I can't remember."

Sara Britton was a freshman at Florida State University, a few miles across town. She had pledged the same sorority, Pi Beta Phi, and lived in the same house as I had, even the same room. 519 West Jefferson Street. I still remembered the address and phone number of that house almost three decades later. Numbers were maybe my thing after all. When the sorority house closed during the summer months, Sara Britton elected to move in with Garrett. She had no curfew living with her sister. But she sure did with me.

I could hardly contain my joy when I hung up the phone. I scooped Puddles up into my arms and kissed her little neck. "Garrett might be coming around, sweet pea," I said.

The temperatures were starting to drop, with rain predicted for later. I needed to change from sandals to rain boots, maybe grab a sweater.

I walked into my closet and was caught off guard.

It had been hanging there two weeks. Still, I was jarred every time I opened the closet door. The crepe gown had a shaped silhouette with a high-front neckline. The back was sheer and netted to the waistline with a sweeping, graceful train. It was simple and sophisticated, and quite stunning.

I had found the dress by accident. It happened when Beverly suggested we make a day trip to Pensacola. "They have such unusual wedding invitations at this little shop," she said. "When you do set the date, you can just order the invitations we've picked out."

"You know I like quirky ones, right?" We both laughed.

"And there's a fabulous shop called Sarah's. We might find a wedding dress there," she suggested.

I did find a perfect invitation, different than most. It was long and rectangular with a unique styling. But it was the dress that captured my day. I really had no intention of dress hunting, especially since we hadn't set the date. But when the shop owner pulled out the first dress and urged me to try it on, I did.

I slipped on the chosen frock. Sarah zipped me up, then fluffed and fussed with the material, getting it just right. When she finished, I turned around to face the dressing-room mirror. I stared at the refection and imagined a room filled with people I loved. Dale was standing front and center, smiling and waiting for me to walk to him. The vision was as clear as day. "I'll take it," I said. I received the dress by mail a few days later.

But every time I saw the dress hanging there in my closet, I had the same reaction. It finally dawned on me why. It was hanging next to the dress I wore to Boone's funeral. My white, happy dress next to black sadness. I yanked the black dress off the hanger and shoved it in the bottom drawer of my dresser.

❧

Garrett, Sara Britton, and I circled the tables around the gift store. The salesclerk followed with her pad, scribbling the girls' selections. I kept muttering how ridiculous I felt.

"If you don't register, you'll get hodgepodge," the saleswoman said. She was probably sick of listening to me.

"What about this, Mom?" Sara Britton asked, pointing to an Italian platter centered on the bridal table. It was offered in three different colors. A Vietri piece—I loved it.

"Yeah, get the mustard one," Garrett said.

"No, I like the green better," Sara Britton told her. I liked the paprika best but said nothing to either of them. I left the two of them to debate the best color and wandered over to the stationery section to look for some thank-you cards.

I was mulling them over when I overheard a young bride selecting her wedding invitations. "Mom, where does Dad's name go? First, with yours, or second line?" she asked, turning to her mother with a confused expression.

I stood behind the shelf of cards, watching the mother and studying her weary face. She appeared to be accepting something she'd never expected or planned for—her daughter's wedding, when she and her husband were no longer married. I could only suspect it was the *Mr.* and *Mrs.* on separate lines that accounted for her mother's pause in answering.

A new bride, so fresh and innocent, seldom thinks of the unexpected happenings in life while dancing to the music of love. The mother sat still, her eyes fixed on the card stock.

I slid away before she answered. I wondered how I would word my own daughters' wedding invitations. Would Boone's name be left off his daughters' invitations because he was dead? I shivered as I walked back to Garrett and Sara Britton, who were now deciding which glass size I needed. My eyes unexpectedly misted with tears. Seeing the bride and her mother was a reminder of the loss, pain, and sadness my girls felt.

I stood watching them, remembering how they snuggled on the couch with their daddy as they watched *Father of the Bride*. He promised them the wedding of their dreams. But the unexpected happened. Broken promises, death, a mother remarrying—these

weren't things they had ever dreamed would happen. But they did—they do. Every bride has a unique story. Age and circumstances are irrelevant.

The girls finished selecting all *my* items. In the end, there would be three platters registered: Sara Britton picked the green one, Garrett chose mustard, and I stepped up to the plate—no pun intended—and picked the paprika.

My heart was full, and the platters had nothing to do with it. If Garrett elected to help register for wedding gifts, she must be coming around. Which meant she *must* be coming to our wedding.

Chapter Eighteen

Seized Opportunity

SARA BRITTON'S BIRTHDAY, NOVEMBER 7, was a week away. Boone's birthday would have been the next day. Their birthdays had always been a shared celebration with cake, ice cream, song, and cheer. After Boone died, all her birthday celebrations were over, as it only reminded her of her loss.

I wondered how I could make it better for her this year. Her last real celebration was when she turned sixteen, before her daddy was diagnosed with cancer. Now she was turning nineteen. We missed celebrating her seventeenth and eighteenth birthdays. Cancer had sabotaged our family through two of my child's birthdays. It was not going to happen again.

I still carried guilt after missing so much of my girls' lives during my futile attempts to save Boone. I dragged him and my optimism everywhere, so certain of myself. But this year, by golly, Sara Britton was having a birthday celebration. Period.

The phone rang, reminding me of Dale's ritual call. Always eight o'clock.

I held the phone between my ear and shoulder as I kept loading the dishwasher. Dale picked up on my lackluster mood immediately.

"What's wrong?" he asked.

I told him about SB's upcoming birthday, my guilt, and how I'd neglected her last two birthdays.

"Let's do something special," he said.

"Like what?"

"I don't know, go someplace, get out of town. Chicago maybe. Ever been there?"

"Once." I didn't elaborate.

"How about the girls? Have they been?"

"No, never."

It was the perfect time of year for Chicago, chilly but not yet freezing. I flashed back to the one time I visited Chicago two and a half years earlier, which was still a fresh memory. I was in the throes of chasing that cure for Boone. I'd read about a brain tumor symposium for renowned physicians, scientists, and scholars from around the world. I pestered every doctor I knew, lobbied for admission, and finally got in. I was sure someone there would have a miracle cure in their back pocket. Of course, they didn't. I decided not to share the Chicago story with Dale.

"It's a great city. Let's take both girls, give 'em a chance to get to know me," he said.

"Chicago?"

"Yeah, Chicago. Let's do it. I'll make the flight reservations. I can drive from Indy. How 'bout this weekend?"

I didn't want to burst his bubble, tell him Garrett would *never* go and that I wouldn't if she didn't. I wasn't taking a trip with one daughter and leaving the other behind. I decided not to mention it to Sara Britton until I called Garrett at work early the next morning.

"Listen," I said. "Dale has a good idea." I waited for her to ask what, but she didn't. "He suggested we celebrate Sara Britton's birthday—the four of us—in Chicago. He thinks we would all have lots of fun." My tone was half apology, half plea.

"I've always wanted to go to Chicago," she told me. "Cool, that'll be fun."

I almost fell off my chair. *Thank you, Lord.* "Great, that's great, honey!" I managed to conceal my shrill and thrill until we hung up. My world lit up as I dialed Sara Britton's number.

"That's *so* sweet, oh my God, yes, yes, yes!" Sara Britton shrieked. After we hung up, I emailed Dale one sentence: *Yes, yes, yes…they both said yes.* Then I slipped into bed and fell asleep full of hope.

Three days later Garrett was helping me pull my suitcase off the baggage carousel in Chicago. Sara Britton was flying up after her last exam and arriving before dinner. I really didn't think I'd over-packed; sweaters and coats just made my bag heavier. Well, that was what I told myself.

"I'm so sorry they're so heavy," I apologized to our cab driver as he hoisted the suitcases into his trunk. He didn't answer, so I just climbed in the backseat with Garrett. As soon as he was behind the wheel, I started apologizing again. "We decided to pack one big bag each, you know, rather than two little ones. That's why they are so heavy. My younger daughter is flying up later, and there'll be three of us in one room. That's way too many bags to be stepping over, you know, if we each had two…" I babbled to the back of his head.

"Mom, he doesn't even understand what you're saying. Stop telling him all that," Garrett whispered.

I pulled the slip of paper from my purse where the name of the hotel was scribbled in ink, reached over, and handed it to him. "This. Is. Where. We. Are. Going," I said as though we were visiting another country.

"Ah, yes, the Sutton Place Hotel, very nice," he said.

I whispered to Garrett, "See, he does understand me."

She put one finger to her lips, meaning I should button mine. I did.

After years of traveling, I had discovered some of the most interesting people while riding in the back of a cab or car service. It happened by asking questions and listening. The drivers may seem invisible with their quiet persona, minding their own business, but these unassuming drivers have shared some amazing stories with me. It always kept my curiosity on high alert when riding with them.

But this time, I listened to Garrett and decided to forgo my chitchat: where are you from, what brought you here, and so on. Before I knew it, we were traveling along Michigan Avenue.

The Sutton Place was located on East Bellevue Place, right in the heart of Chicago's exclusive Gold Coast neighborhood. Our driver pointed out—in perfect English—our hotel was only two blocks from Lake Michigan and walking distance to the Magnificent Mile.

He pulled our bags from the trunk, and I handed him a generous tip for his *labor*. Literally.

We walked inside, where we found Dale waiting in the lobby, welcoming us with an excited smile and open arms. Garrett accepted his hug and returned his with her usual one-arm wrap. I winked at him. He gave the bellhop our room number and key. He could see how heavy our two suitcases were and handed the bellhop a nice tip.

Dale was clever enough to book his room on a different floor. For a bachelor, with no experience raising children, he was intuitive enough to know Garrett wouldn't like his room on the same floor as ours.

"You two settle in, then we'll grab lunch. Is an hour good enough?" he asked.

"Perfect." I pecked him on the cheek. Garrett was already following the bellhop toward the elevator.

We had a large corner suite with a picturesque lake view. From the adjacent window, I could see bustling activity on Rush Street:

quaint shops, landmark restaurants, and a few residents walking dogs in the open green space. It had the flavor of New York City without the honking horns. It was everything I *didn't* remember from my last visit to Chicago. I was so relieved.

Garrett was spreading her stuff around and hanging her clothes in the closet. "You know, Mom," she said, "Sara Britton will have all her clothes crammed inside a backpack. She probably won't even bring a suitcase."

Having spent years riding horses, mucking stalls, and traveling to horse shows, Sara Britton knew how to pack light and travel with next to nothing. Unlike Garrett and me, she was a minimalist, a trait I envied.

"Surely she won't cram the whole weekend in her backpack," I said.

"She will. Watch and see."

An hour later we were back in the lobby, meeting Dale.

"Okay, it's across the street. We can walk," he said.

I could tell he was hungry, knowing he had probably been up and going since three a.m., as usual. The three of us sat at a small table inside Hugo's Frog Bar & Fish House. When I saw the name of the place, I was skeptical, but that was short-lived when I saw the fabulous menu. It was a newer restaurant—just over two years old—situated next to Gibsons, a famous steakhouse. The same owners had opened both, and the reviews for Hugo's were astounding.

After we ordered, I excused myself, leaving the two of them with the waiter opening a bottle of wine for us. I slipped inside the ladies' room. I couldn't know Garrett was blasting Dale without taking a breath. She had seized the opportunity in my absence. Here I was reapplying my lipstick inside the bathroom, believing all was wonderful.

I returned to the table with an empty bladder and fresh lipstick and found them sipping wine in silence. I was oblivious. Worse, I was unaware what was about to happen very soon.

Chapter Nineteen

Birds of a Feather

WE FINISHED LUNCH AND headed back to the hotel. Dale and Garrett said nothing as we maneuvered around tourists on the sidewalk. I broke the silence, pointing out cute shops and suggesting we check them out when Sara Britton arrived.

"I think I'm heading to the airport," Dale said out of the blue.

"What, now? She won't be here for three hours," I said.

"I'm taking the train; it's faster getting to the airport today."

He knew more about city living than me, so I let it go. I knew Friday was a horrible day for traffic in any city, especially Chicago. I was clueless as to what had happened between Garrett and Dale at lunch.

Dale hailed a cab when we reached the hotel. We embraced as Garrett walked away from us and went inside. It was getting colder. I waved goodbye as Dale's cab pulled away for the train station, then I headed up to the room to grab my warmer coat.

Garrett and I strolled Rush and Oak Streets as our leather boots crunched the fallen leaves on the cold gray pavement. I listened to the autumn sounds with each step. The richness of fall's colors—bright yellows, robust oranges, and mahogany browns—were everywhere. I was infused with a sense of joy and a belief that life was good again. I was happy. It felt tangible.

Three hours passed before we knew it. We were exhausted and headed back to finish unpacking and rest before dinner.

Garrett hadn't mentioned Dale during our afternoon together. I decided I wasn't going to spend time lobbying his good qualities. The weekend was going to be about her and Sara Britton, not Dale and me. But I hoped by spending time with Dale, Garrett would see his warmth, kindness, and generosity firsthand. Only then would she understand why I loved him, I reminded myself again and curled up for a nap.

I was startled awake by a loud knock. Garrett opened the door as Sara Britton bolted inside, Dale trailing behind, carrying her backpack. She had *no* luggage. Garrett and I burst out laughing.

"Why are you laughing?" She looked down, thinking we were laughing at her outfit.

"Garrett bet me you would come for the weekend with just a backpack."

"Whatever, Garrett!" she said with a snarl.

I forgot what rooming with the two of them was like. I hadn't done it since our last trip together right after we lost Boone. That trip lasted three *long* weeks.

Their arguing and picking were still imprinted in my brain... *Girls. Sisters. Grief. Tight quarters.* I realized it was the same ingredients I was looking at for the weekend.

It was six o'clock, and we had dinner reservations at seven forty-five. "You girls will need three hours with just one bathroom," Dale joked as he walked out the door.

In no time we were talking, laughing, deciding what to wear, and listening to Sara Britton share stories about college and life at FSU.

I got first dibs for the shower, so I grabbed my stuff and headed there.

Sara Britton and I were putting on our makeup in the bedroom while Garrett finished the last bath shift. I glanced at my watch and noticed she had been in there almost an hour. We were running late.

"Sara Britton, go tell her to hurry up, please."

She tried, but the door was locked, and Garrett didn't answer. I went over and knocked again.

"Are you okay, honey?" I leaned my ear against the door. She didn't answer. "Garrett, can you hear me?" I began to panic and knocked again, harder. Still no answer. But then I heard heaving sobs.

"Open the door now. Don't make me call maintenance."

I heard a click, but the door didn't open. I turned the knob and went in. Her face was swollen and red. She was sitting in the tub, her arms wrapped around her knees. She looked away and buried her face between her knees, sobbing.

"What in the world…what's wrong?"

And then, the screams, her tears, and the raw, exposed pain from grief-stricken eyes glared at me. Garrett began purging *everything* buried inside her broken heart. It poured out with scarcely a breath between crying and shouting. Honestly, I didn't recognize her. I stood speechless, frankly, scared to death, as words rolled from her mouth like a tsunami.

"You can't marry him…I'm not coming…never…I'm not…how can you marry someone else…what about Dad…remember him…get out!"

I was blindsided, unable to form a coherent sentence.

Sara Britton came running in and intervened. "It's okay, Mom, I've got her." She pushed me out of the bathroom and shut the door.

I couldn't say a word or even speak. They screamed back and forth, louder and louder, while I sat mute on the bed, shaking.

"She deserves to be happy. You're a selfish bitch!" Sara Britton screamed.

When I heard *that*, I lunged for the bathroom door. It was locked, and Sara Britton, my protector, refused to open it.

"Mom, you don't need to listen to this. Go downstairs. Now," she yelled through the door.

But I had to get in there and explain what Sara Britton couldn't know. Garrett wasn't being selfish. She was grieving her father, the man she cherished. The wrong person was sitting in the chair across from me at lunch. It wasn't because it was Dale; it could have been *anyone* sitting in *that* chair. In Garrett's eyes, it belonged to Boone.

As I listened to my girls in that bathroom, I knew I had failed as their mother. I should have insisted on grief therapy, been a better role model. I had concealed my pain. I believed if they saw my strength, it would make it easier for them. Now I realized it was just the opposite. It did nothing to help Garrett navigate her pain. In fact, the circumstance was proving it had only made things more difficult.

Chicago fell in the "painful detail" category I had buried. Boone was Garrett's rock, and she lost him days before her twenty-first birthday. She was at the crossroads in her adult life and now was adrift, lost, and afraid of the unknown. As I listened to her anguish coming through the bathroom door, I realized Garrett was like me. She wore a cheerful mask despite any torment beneath it. Her mask was too heavy, so she removed it. In a bathtub in Chicago.

❦

I looked at the time. Dale had been waiting in the lobby twenty minutes. Our dinner reservations were in ten minutes. I threw on my dress and ran downstairs to tell him we wouldn't be going.

The minute he saw me, he knew. He just let me cry. Sara Britton came down fifteen minutes later, dressed for dinner.

"Garrett's coming, just give her a few." Her eyes were blotched from crying.

"How is she?" Dale asked.

"She'll be okay. I'm sorry, she had a bit of a breakdown."

"Hey, it's okay. I knew it was coming," he said.

I turned to him. "What are you talking about?"

"Well, at lunch, when you went to the bathroom, she pretty much told me."

"Told you what?" Sara Britton asked.

Dale looked from me to Sara Britton, then back to me. "You actually hadn't even made it to the ladies' room yet. She said she didn't like me, you weren't marrying me, it would never happen, she would never come. There was more. I should have said something to warn you. I needed time to think. I'm sorry."

"What did you say to her?"

"I said I'd never loved anyone but you since I was a boy. I told her I would always love them because they were part of you. I said the wedding was happening…and hoped she would change her mind and support you. I said you deserved to be happy and I could make you happy." His eyes began to water.

"God, I can't believe her. What a brat!" Sara Britton looked like she was going to explode with anger.

"No, please, please, don't say anything to her," he told her. "Nothing, no criticism. Please, Sara, trust me."

Finally, Garrett walked into the lobby. Her lips quivered as she tried to smile, her eyes locking with mine. I jumped from my chair and wrapped her in my arms, stroking her hair. I knew the courage she had mustered, masking her pain, strapping on armor for the sake of me. She learned just how to do it from me. Maybe I was the master of something after all, but I wish I hadn't been so good at it.

After we held each other, it was as though nothing had happened in that hotel room. I don't know what was said between my girls, but the rest of our weekend was unmarked with controversy. We celebrated Sara Britton's birthday at Spiaggia and devoured a gastronomic masterpiece dolloped with decadent chocolate cake and vanilla gelato.

It was a rollercoaster of emotions over the weekend: anger, tears, laughter, even laugher through tears. It wasn't the weekend

I envisioned—blending Dale with my girls. But when the week-
end was over, there seemed to be a sense of peace, understanding,
acceptance, and harmony among us. I prayed the girls may have
grasped what I finally came to understand. They'd never reach their
destination driving backward. Perhaps they would start looking
out the windshield (Mom and Dale) and not their rearview mirror
(Mom and Dad).

On Sunday, we strolled down Michigan Avenue after breakfast.
The girls were a few paces behind us. I heard Sara Britton laughing
and Garrett screaming like a crazy person.

We turned and saw Garrett doubled over with laughter.

Out of everyone walking on the sidewalk, a single bird had found
Garrett and crapped all over her head and coat.

"That's what you get for being a pill!" Sara Britton screamed
through her laughter.

We flew back on November 8, Boone's birthday. *Eight* weeks
until the week of our wedding. I closed my eyes and fell asleep
wondering. And yes, still worrying.

Chapter Twenty

The Me in She

DALE FLEW IN FOR Thanksgiving. We celebrated with my entire family: Garrett and her boyfriend, Mike; Sara Britton and her boyfriend, Matt; my mother; my sisters and their husbands; and my nieces and nephews. Everyone cooked something and hauled in their home-cooked offerings: a twenty-three-pound turkey, oyster dressing, regular dressing, corn pudding, squash casserole, fresh snapped green beans, broccoli casserole, sweet potato pie, and pecan and pumpkin pies, just to name a few.

Dale blessed the food with prayer and continued with his words of thanksgiving. His voice cracked as he shared his love and his gratitude for reuniting with me and joining the family. There were a few misted eyes by the time we all sat down.

As I passed the green beans over to him from the smorgasbord of selections, he whispered in my ear, "Where're the noodles?" Honestly, I thought he was kidding. But I would learn everyone has their own version of Thanksgiving traditions. In the South, it's sweet potato pie. In the Midwest, with the Elrod family, it was noodles.

It was December, and Christmas was approaching. Our wedding day was getting closer. Truth be told, I was unnerved. My life as I knew it was about to change drastically.

Going through both holidays with the pre-wedding jitters, not to mention orchestrating our wedding, had taken its toll. My "getting married" enthusiasm was ambushed by what I had left on my to-do list. I worried I'd never get everything done.

I was dragging through a stifling Banana Republic with other last-minute shoppers. We were a family of stressed, hurried, and unhappy procrastinators. I didn't see any Christmas joy as Burl Ives sang "A Holly Jolly Christmas" through the store's sound system.

My arms ached from carrying layers of clothing piled high, in multiple styles, sizes, and textures. I yanked one more piece from the ransacked shelf of depleted inventory. Score. It was just what I was looking for, a black turtleneck for Garrett.

Beads of sweat collected in my cleavage and were dampening the front of my red silk blouse. I chewed at the inside of my cheek, berating myself for being at the mall during the Christmas frenzy. A root canal would be better—at least I'd get drugs.

Before Boone's cancer diagnosis, my Christmas shopping was always finished the day after Thanksgiving. I would have gifts bought, the house decorated, and coordinated wrapping paper to match our themed Christmas tree. We put the tree up early—Thanksgiving afternoon—to get our money's worth. That girl was no longer. Instead, here I was, trapped in the shopping madness with everyone else. Despite my tardiness, I was determined to make this Christmas for my two girls—we three musketeers—memorable. And I'd spared no expense.

It started with purchasing a bigger tree (massive), then some new decorations (ridiculous), and now, last-minute shopping (overindulgent).

I flashed to Christmas the year before, our first one without Boone. By then he had been gone nine months. In the store I felt a

chill crawl over me, and I became clammy. The room began to move in waves, and tiny specks of black drifted in my vision. I looked around for an empty table, found one, and dumped the armful of clothes with my heavy purse and angora wrap in a heap on the table. I leaned forward over the stack, my hands on each side of the pile, and braced. My mouth was dry, and I tasted bile.

Please, no...don't let me faint, I silently whispered to God. *Inhale, Prissy. Blow. Inhale. Blow.* I was counting the inhaled and exhaled breaths and trying to regain some calm. I had to get out of there and escape the smell, the clothes, the people, and my panic before I went down. Strangers pushed by, unaware of me or my turmoil.

I stood staring, watching, breathing, counting. Finally, my breathing became more normal. I leaned back against the table, steadying myself, and began to study the faces of the shoppers. In that moment, it felt important I remember our last Christmas. *Did I even shop?* I had no recollection. How could that be?

All that despair a year earlier and here I was getting married in a few weeks. Moving on with a new life. Prissy gets to be happy. Poor Boone...dead.

Garrett was right. What right did I have to be happy when she was so sad? She didn't even know the man I was marrying. He was a stranger to her, living in Indianapolis, running his company, and only in Tallahassee on weekends. And he and I were in our own world, planning our new life.

During the week, when he was away, my joy would circle the drain. I'd go from smiling to crying. It came from nowhere and happened anywhere, anytime. And Dale had no idea how this fragmented family that we were creating was stressing me.

He was fifty-one years old and had never been a groom, husband, or father. But he was willing to become all three in one ceremony, rescuing me. I was the luckiest woman alive. Well, until my self-doubt

weaseled in and made me feel worthless for choosing this man over my child's broken heart.

I picked up the pile of clothes and got in line to pay. I still felt nauseous as I watched the worn-out cashier fold the stacks of nothing special and place them inside three glossy white bags embossed with gold Christmas trees.

A blast of cold air slapped me in the face as I exited the mall. I welcomed the frigid wind. The parking lot looked like a mass of graffiti, multicolored cars packing every space. *Where the hell did I park?*

Still feeling light-headed, with stars afloat, I walked in circles, searching the lanes, shifting the heavy bags from one arm to the other, finally carrying all of them like a newborn cradled in my arms. *Click. Click. Click.*

The remote button to unlock my car was working overtime, coming up with nothing. Finally, I saw headlights flashing almost a football field away. By the time I reached the Cherokee, I was freezing cold, numb to my very bones. I tossed the Christmas bribes (gifts) in the backseat.

I drove home, analyzing what could be wrong—what had happened to me in the store? Was I getting sick or having a panic attack? I'd never had one, so I couldn't know. I was in love. Dale adored me, and we had found each other after thirty years. I could still have half my life in front of me. Everything would be new…a love, the town, my life, even my name.

And bam! Just like that, I knew. By the time I turned onto Carriage Road, my street, I recognized, maybe understood, my fear. It wasn't just my disappointing Garrett. It was more than that. I was going to be someone else. Another name. Again. Once, Prissy *Landrum*. Then, Prissy *Kuersteiner*. Soon, Prissy *Elrod*. And what could that mean…again?

When a woman captures a man's last name, it defines her. It had happened when I married Boone. Prissy Landrum, the bohemian,

free-spirited girl, was encapsulated and camouflaged with pearls, lace, and Southern traditions. Poof! Prissy Landrum had evaporated.

The transition of my persona was subtle. I never knew it was happening, this movement of change. A different girl making herself at home, a *permanent* resident. Prissy Kuersteiner was seeded on an August day (my wedding) and birthed within a year and soon swallowed up the once authentic girl who, being a people pleaser, never objected.

I watched and learned from my more sophisticated Southern girlfriends, copying their tastes, mannerisms, and hobbies. I joined the Garden Club though I didn't care a hoot about flowers and landscaping. My mother-in-law suggested I join the Junior League, though I didn't even know what it was. Soon I was a homeroom mother and became a gourmet cook.

In my early years of marriage, I mentioned to Boone that I wanted to return to work, have a career. He said, "You already have the most important job—raising our children." Of course, he was right. But he was also a lawyer, and I had no defense against that kind of statement.

And then Boone died, and I was left alone, clutching my pearls, wondering who I was and where I belonged. He created me, or rather the image he wanted me to be. And when he was gone, I was left with who I had become.

And now, Dale was another person with a new name to brand me, or perhaps define me. Would I morph into yet another person? By the time I pulled into my driveway, I had dissected my struggle. There was only one person who would understand. He knew me before and met me after. Now he was about to marry me. We had to talk.

My question came out of the blue and caught him off guard as he was untangling a string of lights for the Christmas tree. It had been delivered to us earlier that morning from the Tallahassee Nurseries

crew. It stood tall, almost touching the ceiling. "What do you expect from me after we're married?" I asked, almost in a whisper.

"Expect…? What are you talking about?" He dropped the still-tangled lights and pulled me into his arms.

"I don't know. Do you see me changing, being different than I am now? Never mind, I don't know what I'm asking you, how to explain what I mean." I pulled away and began sorting through ornaments.

"I think you're perfect. Why would I want to change you? And for the record, be whoever you want. I loved you as a girl, and I love you now. Nothing will ever change that."

He wrapped his arms around me again, lifted me into the air, and kissed my smiling lips, untangling my emotions. The lights didn't fare as well. He threw them away and bought new ones for the tree. The man had no patience for Christmas tree lights, but he did with me. And that's what mattered most.

Holidays can be the happiest of times. Or the saddest. It depends on the movement of the pendulum, the rhythm of life. There were nights when vivid memories of the past—Christmases spent with Boone, for instance—ambushed me, stealing the tranquility from my life. The next day I would walk around with black circles framing my eyes.

But that Christmas when Dale came back into my life was different. It was seamless and magical. Not just for me, but for everyone in my family. He showered thoughtful gifts on the girls, my mother, and my sisters and their husbands and children. Two of my nephews scratched off a $200 prize from his gifted lottery tickets. To this day they still talk about the first Christmas with Dale.

When I had returned from Chicago and all the drama with Garrett and Dale, I had a board meeting with myself. I'd listed my options. I could postpone the wedding and consider Garrett's plea, massaging her sadness, fear, and struggles. *I should do that*, I'd thought. But would she ever be happy with anyone I married? No one could replace her father.

The second option was to move forward and have faith Garrett would come around. After all, faith had always been my light through the darkness in the past.

I liked to please and simply hated confrontation. There had been many moments in my life when I'd discovered my pleaser personality was a far cry from an attribute. For a pleaser to choose her own happiness over another's—especially her own child's—well, it's fractious, piercing, and painful.

I made a unilateral decision that day. I picked me. My happiness. Looking back, I think it was a brave choice, and the right one.

Branches of the Vine

It was New Year's Eve, and a momentous one at that. It was the Y2K, the turn of the millennium. Rumor had it the world might be coming to an end, fueling widespread hysteria around the globe.

In a nutshell, the hype started over computer programmers using the two-digit shortcut to denote the year, for example, "99" to mean "1999." But what would happen with the year 2000?

So, many feared that when the clock struck midnight on January 1, 2000, computers' math would freeze, their equations whacked out. *Time* magazine's cover read "The End of the World?!?" The possible disaster was made into a television movie by NBC and depicted sheer horror for those not already living in fear.

"Let's celebrate New Year's Eve, especially if it's our last day to live," I joked to Dale.

"Okay, you make the plans," Dale said. I called the Governors Club, located in the historic heart of downtown Tallahassee, and reserved a table.

❧

We brought in the New Year with glitz, glitter, and way too much alcohol. The bright sunlight streamed through my opened blinds and woke me up.

My head throbbed from a restless night's sleep and a hangover. I could barely keep my eyes open. Peeking through my lids, I saw Dale on the other side of the room, his back to me, staring out the window.

I glanced at the clock next to the bed—only 7:47 a.m., and way too early for me to get up. We had stayed out into the wee hours. I propped myself up on my elbow and started to feel more awake, at least enough to see that Dale was already dressed. I sat up and pushed my back against the headboard, then reached over for the water bottle next to me. It was almost empty. I gulped the last few ounces.

"Well, I bet newsrooms are embarrassed and scrambling, trying to justify all those stupid predictions of doom, gloom, and panic," I said.

He didn't answer or turn around. He was still staring out the window.

I kept talking about this and that. The bounty of indulgent and decadent foods the Governors Club offered on last night's buffet, how many desserts my sister Deborah tasted, the blister on my foot from dancing in new shoes. He still hadn't said anything.

"Are you hearing me? What's wrong? Why are you dressed, anyway?"

When he did finally turn around, I felt my posture stiffen, my muscles tighten. He looked dreadful. His skin was pasty and pale.

"I think I better go to the ER. My throat's swollen."

"You mean sore?" I jumped from underneath my warm comforter and bolted to him, pulling open his mouth as a mother would her toddler. "Say 'Ah!'"

I couldn't believe what I saw. My knees grew weak. His uvula, the fleshy thing that hung from the palate above his tongue, was three times its normal size. And instead of hanging, it rested on the back of his tongue, and his airway was barely visible.

He pulled my hands from his face. "I'm okay, just get dressed." He was calm. I turned crazy.

"Oh my God, have you seen that thing? How can you say you're okay?"

I rushed around, trying to control my hysteria, pulling my jeans up with one hand, brushing my teeth with the other. He stood calmly, watching my mania.

Unable to find matching socks, I pulled on one navy and one black, slipped my feet into my leather boots, then pulled the scratchy angora sweater over my uncombed hair.

All those premonitions I'd kept secret, shared with no one, were swirling around in my head. All my fears would be validated. Namely, something bad was going to happen, something to destroy my newfound happiness.

Dale would stop breathing then die…eight days before our wedding.

"Let's go!" I was afraid to call an ambulance, terrified to wait any longer. With drunk partiers, the flu season, and probable firework accidents, I knew the ER would be a nightmare, the absolute worst day of the year, but we had no choice.

I sped through the Tallahassee streets, taking the fastest route my brain could remember. I watched both Dale and the road, looking back and forth between blinks. He seemed fine and wasn't having trouble breathing. How could he be so relaxed with that thing lodged in his throat? I almost gagged remembering it.

It never occurred to me the streets would be empty at eight thirty a.m. until I remembered it was New Year's Day. Nobody would be out this early after partying so late. I pulled in front of the emergency room entrance in eight minutes. I was crazy enough to time it.

"Hurry, go! I'll park!"

He got out and walked inside. I drove around the crowded parking lot, searching for an empty space, and slowly pulled into the first spot I found. I put my Jeep in park, turned off the ignition, looked ahead, and sat.

What transpired after, well, I write with shame. I couldn't make myself open the door. I tried once, twice, three times, even more. I can't explain. I really can't. Dale startled me, knocking on the window twenty minutes later.

"What are you doing?" he asked.

"Waiting…out here."

"It's crowded. You can't wait here in the cold. It'll be a while."

"That's okay."

He stared, waiting for some explanation.

"I didn't get my flu shot. I can't go in. What if I get it? With the wedding next week, in eight days, and the airline tickets, and honeymoon…" The words were spilling out and sounded insane, ridiculous, even to me.

"You're kidding, right?" He chuckled.

I shrugged. Finally, he turned around and walked back inside the hospital.

One hour turned to two, then three. Soon, four had passed. I prayed, worried, and wondered if he would ever come out. Worse, would someone come out to find me?

It's okay to not like me. I don't like me either just remembering that day.

I have all kinds of pathetic excuses: PTSD from Boone's illness, my hospital fears, and the thought of having to relive bad news. Excuses are *never* good reasons though. I should have found the courage, gotten my fanny out of that car, and gone inside that stupid ER to check on the man I loved. Instead, I listened to the radio, wiped down the car interior, and added more to-dos on my list for a wedding I felt pretty sure wouldn't happen.

My relief was clouded by dread when he climbed back inside the Jeep. I expected disappointment, angry accusations, even reprimands. Why should he marry someone like me, a person who hadn't even bothered to check on him?

"Let's go find a pharmacy," he said. He was shaking his head, smiling, then laughing out loud. He handed over his discharge sheets and a prescription. I was a pro at reading scribble, deciphering doctors' lousy handwriting. I had worked in my dad's medical practice and spent part of my teen years forging his messy signature: *Please excuse Prissy. She's not feeling well today.* You get the picture.

I read what the attending physician had written, his diagnosis. Uvulitis, etiology unknown. *What the...?* Uvulitis sounded nasty. I drove to Walgreens, making more excuses for my behavior.

"Stop, please," he said. "It doesn't matter. I'm fine."

I pulled into Walgreens and reached behind the seat for my purse, still holding his prescription. I was half out the door when he grabbed it. "You wait here. I'll get it." He shut the door before I could argue.

My stomach growled, reminding me we hadn't eaten since the night before. I checked the time, already one o'clock. The day was half over. I heard my cell phone ringing inside my purse and grabbed it. My mother's number showed up on the caller ID, and I remembered we were supposed to be at her house to celebrate my aunt's birthday. My mother was having everyone over for cake and ice cream. *Crap!*

"Hey, Mama, happy New—"

She cut me off midsentence. "Helen's not answering her phone." She sounded alarmed. "She was supposed to be here an hour ago. Where do you think she is?"

If she only knew what I, or rather Dale, had been going through, and she was worrying about punctuality.

"I don't know, Mama...outside, on the toilet, who knows? Big deal. She's late. So are we."

"Why doesn't she answer her phone?"

"How would I know? She needs a cell phone."

Helen was the youngest of my mother's six siblings in the litter of Cajun/Creole relatives from New Orleans. She was a very tiny

woman with big brown eyes magnified behind lenses as thick as Lake Michigan in January. Standing only four feet four inches tall, she wore children's clothing and shoes, the only things that fit her.

When my mother married my father and left New Orleans, Helen followed her. She climbed on board the Greyhound bus with a beat-up suitcase and took a road trip to Lake City, Florida, to visit the newlyweds. She moved herself in with them and never left. My father was the new doctor in town, so he hired Helen as his file clerk. Of course, she had no office skills and no idea how to file.

After a few years, she moved out of my parents' house and into an apartment. This happened to be inside a building my father had bought. I suspect that purchase was to get his sister-in-law out of his house. I mean, she had been there for years by then.

At any rate, thanks to both my parents, Helen, a spinster, was always taken care of. Which was why she had just moved to Tallahassee from Lake City and my mother was supporting her, and now calling about her.

"Listen, we're running late too. I'll explain when we get there. Helen's just late, so don't worry about her."

If she only knew the drama I'd been through. Geez, worrying about Helen being late for her cake and ice cream was ridiculous. I hung up as Dale climbed inside with three bags of filled prescriptions, one an EpiPen.

I was sharing my mother's call, our plans, and Helen's birthday and asking Dale if we should cancel based on his uvulitis diagnosis when my phone rang again. I answered as I pulled out of the Walgreens parking lot. If I thought things couldn't get any worse, I was dead wrong. Literally.

Chapter Twenty-Two

The Bright Side

It was Karl, my brother-in-law, on the other line. "I hate to tell you…she's dead," he said.

"Who is? Who's dead?" I asked, pulling the car over to the side of the road. I turned to Dale and mouthed, *It's Karl*.

He was inside Helen's apartment. My mother had called and asked him to go check and see why she wasn't answering the phone.

Karl happened to be a first responder. When Helen didn't answer her doorbell, he forced the front door open by snapping the chain. There she was, propped up in bed, her head slumped to the side, her right hand frozen in rigor mortis, holding the TV remote. Newscasters were blaring from the television across the room.

"It looks like she's hoarded flashlights, batteries, cartons of cigarettes, gallons of water, canned food, and umpteen rolls of toilet paper—it's stacked everywhere, you should see it in here."

I was trying to register what he was saying. "Does Mama know yet?"

"Your sister went to tell her."

"Oh God. We're coming." No one knew we'd been at the ER for the last four hours. I hung up and told Dale what Karl had said. We sat staring at each other, neither one of us knowing what to say.

I pulled back onto Capital Circle with my sweaty hands gripping the steering wheel. A clammy chill enveloped me, followed

by a stabbing, pulsating pain between my shoulder blades. First Dale, now this.

I turned off Meridian Road and into Helen's apartment complex. Dale's right foot swung out before I turned off the ignition. "Which apartment?" he asked.

I stared out the windshield and never answered. My left hand was on my door latch, frozen. I couldn't bring myself to open it—again. I began to sob.

Dale came around to my door and knocked on the glass. I looked at him and rolled down the window. I saw no judgment in his eyes. He leaned in and wrapped his oversized hands around my face and kissed my trembling lips. "Stay. It's okay. You don't need to go in there."

"Give me a few minutes. I'll come."

I watched from inside my Jeep with a racing heart and parched mouth. My sisters, mother, and daughters arrived, then the sheriff and coroner. Everyone was going in and out of the apartment like they were in a NYPD crime show.

Sitting alone watching the scene triggered memories of the horrible day Boone died. My mind was back inside my Carriage Road house, where I watched faceless strangers circling our family. I saw Boone being lifted onto the gurney, the strangers removing a part of me from the home we had shared most of our lives.

I couldn't breathe. I blinked to snap myself out of it and back to the present. My behavior outside the ER—leaving Dale to fend for himself—disgusted me. *Who does that?* I was a gutless, lily-livered chickenshit. I opened my door, climbed out, and wiped my face with a tissue.

Inside I listened as my mother kept repeating the same sentence over and over. "I made a birthday cake. She never saw my cake." My poor mama was in shock.

Mama, she's dead. She'll miss more than your damn cake, I wanted to say to quiet her but bit my tongue.

We spent the next two days discussing, dissecting, and debating Helen's death ad nauseam. The coroner speculated Helen's time of death was around midnight. Helen had believed the worldwide newscasters' speculation of impending Y2K doom. In my opinion, she had literally been scared to death. Her combination birthday and death made it even more tragic.

A few days later, I was in the middle of blow-drying Puddles, who was shivering from her bath, when the phone rang. It was the third time my mother had called that morning. I tried to remain patient.

"We need an autopsy," she said. "Don't you want to know? How can she have a heart attack with no previous symptoms?"

This statement, coming from my mother, a doctor's wife, baffled me.

"Mama, she smoked three packs of cigarettes a day. We need to talk about burying Helen, not her autopsy."

Our conversation shifted from autopsy to funeral plans and back to autopsy.

"She smoked like a chimney, didn't exercise, hadn't been to a doctor since Daddy died, and don't forget, she was seventy years old. Mama, she's dead. An autopsy won't change that."

She hung up and called my sisters to lobby the autopsy case. Dale and I talked, called my mother back, and offered to postpone the wedding until after Helen's funeral.

"That's ridiculous," she said. "Your guests bought the airline tickets already. Anyway, we're taking her to New Orleans, burying her with Mama and Daddy."

"When are you doing that, Mama?"

"In a few weeks, maybe a month, when I can get to New Orleans."

Now, if you're wondering where Helen's body was those weeks before her burial...so am I.

Chapter Twenty-Three

Jubilance

DALE'S FAMILY AND FRIENDS flew in to Tallahassee from Indianapolis and other parts of the country. I was surprised by the numbers who replied yes to our invitation. The wedding day was on top of the holidays and only a week after the big millennium. I think his friends had to see it to believe it.

"He's never been married, Prissy. Let him invite everyone he wants," my girlfriends had said. And so we did.

The Governors Club was the venue for everything: the rehearsal dinner, the ceremony, and the reception. Boone and I had been inaugural members, two of the first one hundred who joined and helped start the club. It seemed fitting to begin my new life there, especially since it held only happy memories and not the memories of Boone's funeral.

I pulled in front of the club an hour before the rehearsal dinner on Friday night. Dale was at the hotel with some of his out-of-town family and friends.

I handed my keys to an energetic young valet with steel-gray eyes. I gave him my first name and spelled my last name—Kuersteiner—the one I'd been spelling for almost thirty years. In twenty-four hours it would be different.

"You the bride?" The valet's aura of joy slapped a few of the butterflies swirling around my belly.

"Yep, I sure am." He was bundled up for a cold evening parking cars and grinned through a hoodie wrapped around his face.

The hostess greeted me inside the festive, decorated foyer. Tomorrow morning it would be transformed from holiday red and white to my cream and green. My friends would be overseeing all the flower arrangements.

The Capital Room on the third floor was elegant and striking with a Ralph Lauren–type décor. A huge table dominated the small but grand room. It was draped with a linen cloth, and the centerpiece was themed with natural outdoor elements: moss-covered orbs, succulents, twisted branches, and freshly cut winding twigs. Flickers of candlelight danced around them.

Cream ribbons fastened the silverware, and dripless white candles filled the table already set for twenty-seven. The place cards were tucked inside my purse. I'd spent my afternoon writing each name on the place cards in calligraphy with a newly purchased gold pen.

Garrett was introverted and shy. Her comfort level around strangers, especially Dale's people, would be challenged. I knew she would gravitate toward our family and not Dale's. So, the place cards were my trick to prevent that from happening. I placed her card next to Dale's mother and put Sara Britton next to Dale's sister.

I heard voices coming from down the hall and looked at the time. I put the last card on the table and inhaled the lingering scent of cognac and cigars.

"Dear Lord, please let this night be good," I whispered.

Only those about to be seated in the dining room were invited to our nuptial exchange the next day. Dale's family was very anxious to meet my two daughters. And Sara Britton was anxious to meet them after hearing Dale talk about them so much. She wanted to match faces to the names. Garrett was trying. She was but was still standoffish about the entire event and all the festivities surrounding it. She hadn't known Dale very long, and she no

longer recognized the mother she knew all her life. That woman had fallen off Garrett's pedestal and landed on the floor. But I had the rest of my life to make it up to her. And I would.

Still, I knew her well enough to know she would not disappoint me on such a special day. She would front her beautiful smile despite any turmoil.

Dale's mother had suggested I choose the menu and work with the chef. Although he prided himself on French cuisine, I catered the menu for the Midwesterners: prime rib, potatoes, salad, rolls, and dessert. Our siblings shared stories, and good-luck toasts were bestowed on us.

It was after the dessert dishes were cleared I noticed Garrett and Sara Britton laughing, engaged, and happy. Perhaps it was because of how I'd seated them, next to Dale's mother and sister. Maybe they saw Dale in a different way, not just as my suitor but part of a wonderful Midwestern family. Garrett meeting Dale's lovely mother softened her. It was a turning point. Simply put, a perfect wedding gift she'd given me without even knowing it.

By night's end, a trio of emotions filled me. I was uplifted, thankful, and full of pride in equal measure.

The guests moved from the dining room to a next-door bar for music, dancing, and partying. I said goodnight and tipped the valet as I jumped inside my warm car. I was elated but exhausted. I needed some alone time. I was reflecting on it being my last night as one person—Prissy Kuersteiner. Tomorrow, I would become another being and belong to someone else.

I turned off my house burglar alarm and flipped on the kitchen lights. I'd been wearing my heels since midafternoon, and my feet ached. I kicked off the new shoes and made my way to my closet, rummaging inside my lingerie drawer for my warm pink-and-yellow-rose-patterned flannel gown. I unhooked my bra, slid off my panties, and pulled the gown over my head. It

felt like heaven, especially when I slid my cold feet inside my fuzzy poodle slippers.

It was ten thirty p.m., hours before the day my life would change. My brain was busy. Writing always had a way of helping me. I made some herbal tea and settled on the couch with a pen and paper and began. I thought if I wrote it down, I might relax. It was a love poem to Dale as my wedding gift. I sealed the envelope and slipped it inside my overnight bag. I looked around the bedroom I'd shared with Boone for so many years. I studied the décor, our furniture, reflecting on how each piece came to be.

The rice-carved mahogany bed, the weeks it took to decide queen or king. Boone wanted queen, now I lay in the middle of his queen. The nightstands he loved but I hated. The French Impressionist painting I bought at auction, waving my paddle number only seconds after Boone slipped into the bathroom, my eye darting between the auctioneer and the bathroom door. I remembered feeling brave, defiant, and proud, making a unilateral decision to buy something I wanted without his permission.

"Sold to the lady in the third row." I stared at the painting, remembering Boone's gibes, and felt a pang of guilt. We don't know how irrelevant things are until we're smacked in the face with something relevant. Good health for one.

I had a plethora of thoughts and emotions—sadness, joy, endings, beginnings. My past, future, and entire life swirled inside my tired brain. I drifted to sleep as Prissy Kuersteiner for the last time.

Chapter Twenty-Four

Chiseled Humor

I AWOKE TO A BITING, arctic freeze on January 8. I turned on the television to the weather station. It was twenty-three degrees. The high was expected to climb to only thirty-five degrees. I was so disappointed for all Dale's friends flying in from Indiana's frigid weather thinking warmth awaited them. It was a mentality for anyone visiting Florida, no matter the month. Sun. Surf. Sand. But our beautiful city was far from the tropical parts of Florida. We lay only twenty minutes from the Georgia line. Florida had let me down, and I was bummed. I might be wearing a parka over my wedding dress.

The ceremony was to begin at three o'clock. Only our immediate family members were invited inside the Plantation Room at the Governors Club, but we were expecting over two hundred guests at the reception immediately following the ceremony. They would all be waiting for us to join them in the main dining room and lounge on the other side of the double mahogany doors after we exchanged our vows.

With the time for our nuptials nearing, I waited in the back of the room, listening to a three-string quartet playing Mozart. The minister was standing between Dale and my two girls. I met my daughters' eyes and wondered what they were thinking. Dale's eyes were already misting as he stared at me.

Through my rapid heartbeats, I heard the cackling and yatter-
ing coming from the next room. Guests behind the closed doors
had already started arriving for the reception. I could even hear the
bartenders shaking martinis and cracking ice cubes. I knew hors
d'oeuvres were being passed around to our early-arriving guests:
shrimp cocktails, bacon-wrapped shrimp, and roasted tomato and
artichoke skewers bathed in basil pesto sauce.

I watched Kelly, the soloist, singing "When You Believe."
Everyone in our room was quiet, listening, sitting motionless in
upholstered chairs as her soprano lyrics filled the space six rows
deep on each side of the room, with an open aisle down the center
for my bridal processional.

My eyes wandered to the mammoth mural on the opposite wall,
a landscape hand-painted by Joe McFadden. In a blink I was over-
come with nostalgia, reminded of all the previous Easters, Mother's
Days, and Valentine's Days we enjoyed inside this very room. Boone,
the girls, me. Who could have foreseen the future?

As life would have it, I didn't reflect for long. Because the un-
thinkable happened only moments before I walked down the aisle.

Earlier, when I was home getting ready, I slipped on my wed-
ding dress only to remember it was backless. Holy Mother of Geez!

Just then I remembered what the saleslady had told me when I
bought the dress. "Remember, buy a backless bra to wear with this."

I'd forgotten. So, I did the only thing I could think of and went
to my kitchen and found some masking tape. I lifted my D-cup
twins in a saluting position and taped them. By golly, it worked.
Or so I thought. Now I felt my right breast escaping from the tape.

As I stood in the back of the room, I started to sweat, which only
made it worse. The heat blasted from the vent above me. I kept one
eye on the crowd as I tried to slip my hand down the neck of my
dress. It was too tight, and we had no bathroom. I wasn't about to
walk through the crowd waiting in the other room to get to one.

I pushed, shifted, pulled, straightened, and pressed the wilted tape hard through the fabric against my breast. I kept checking to see if I was being watched, but thankfully all eyes remained on Kelly. *Keep singing*, I prayed.

I finally got my breast back where it belonged. I looked up to see my groom's smiling eyes watching me, and my heart filled.

As the quartet began playing Bach's arioso, I took one deep breath and blew out my fear. I moved forward and straight to the boy I once loved and had fallen for all over again. The man who wouldn't care if my boobs landed on my waist.

✦

After the minister declared us husband and wife, I lifted my creamy taffeta train and turned around to walk back down the aisle. The string ensemble lit up the room with Handel's "Hallelujah" chorus.

It felt surreal, as though I were dreaming and should pinch myself to wake up. I realized, up until that very moment, I'd been sure something bad would occur and the wedding would never happen. It would all be over. I'd expected it. Now, my heart began beating so fast I felt light-headed. Dale gripped my hand and met my eyes. A huge smile spread across his face as he pulled me into his arms. "I love you," he whispered and kissed me.

Everyone was clapping, cheering, and crying. My own cheeks were damp with happy tears. Then, out of nowhere, a woman gripped my shoulders and pulled me into her arms.

"That was so beautiful!" The strange woman said while sobbing and hanging on to me in an uncomfortable embrace. I looked over at Dale, my eyes pleading for him to rescue me from one of *his* people. He shrugged; she didn't belong to him.

"You look so happy. Are you happy?" she asked.

"I'm ha-p-p-y," I stuttered.

"I'm so glad."

I was glad she was glad, whoever she was.

"You're very sweet," I said, trying to pry her fingernails from my shoulders. She leaned in with one last sweep and sniffed deeply, and I saw my crepe wedding dress was damp from her snot and tears. My boobs suffered even worse, having escaped from my failed tape attempt once again.

Only later did I learn my mother had invited the strange woman to our *private* wedding ceremony. My mother always walked to the beat of her own drum, and my wedding day was no exception. The stranger she'd invited was the girlfriend of my mother's tile layer, who was the brother to my brother-in-law Chip, who was married to my younger sister, Gina. Yet my very best friend for more than four decades wasn't even invited to the ceremony.

When I confronted my mother, she said, "Well, I thought she might enjoy it."

❧

Dale had started planning the honeymoon the moment I said I'd marry him. After all, the man had waited a long time. I knew how extravagant he was, so I offered *my* suggestions to rein him in. He cut me off. "I'm in charge of the honeymoon, you the wedding. I don't give a rat's ass what it costs. I haven't had a real vacation in thirteen years."

Dale and Boone were as opposite as an atheist would be to a priest. Boone was conservative in his spending. I never realized Boone was that conscientious of money until *after* we were married. Boone and I had dated for three years, and not once had he indicated it to me. But a week after we returned home from our honeymoon, I became *very* aware of it when he bought me a present: a thin red accounting ledger from the local drugstore.

I was cooking dinner, music playing on my record player, when he walked into the kitchen of our tiny rental house and asked for me to sit at the dinette table. Right there he spread out that ledger and started explaining what it was, how it worked, and what I needed to do. I laughed. Out loud. I thought he was kidding, but he wasn't. "I'm not your daddy—I can't support you like him." My data recording started that night and lasted the first two years of our marriage. Every penny spent—on groceries, personal items, clothes, entertainment, maintenance, insurance, rent, hair, feet, toes, even tampons—was penciled in a categorized column.

If I missed a day or two, I would spend hours trying to remember where, what, and when. Accounting for what was gone and where, attempting to justify the scraps left in our measly bank account. Looking back, I don't know that girl. It never occurred to her to say, "No, I'm not doing that anymore."

Like I said, Boone and Dale were opposites. Since Dale had worked all over the world, he'd been exposed to a variety of people, places, and things. I was sheltered, let's face it, and a bit naïve. That was probably why—when Dale planned our honeymoon—he decided to expose me to something far outside the boundaries of my narrow little world. A place he was confident I'd never been.

Chapter Twenty-Five

Fairy Dust
and Fairy Tales

A DRIVER STOOD AT the baggage claim, holding up a sign that read "Mr. and Mrs. Elrod." I walked past the man twice. Mrs. *Elrod* wasn't registered in my brain. I had been Prissy Kuersteiner for twenty-five years, Prissy Elrod for one day.

Never in my wildest dreams would Las Vegas have been on my bucket list, but it was first on Dale's itinerary. Las Vegas suited this new husband. If he wanted to shock me by taking us there, he did. This man knew me better than I knew myself. Las Vegas had me at hello.

When the driver pulled up to the Bellagio, I lifted my dropped jaw just to get out of the car. The AAA Five-Diamond hotel was inspired by villages of Europe and sat at the edge of a Mediterranean-blue lake. Inside the lobby, the *Fiori di Como*, a multimillion-dollar sculpture, the pièce de résistance, covered 2,100 square feet of the ceiling. It had been designed by Dale Chihuly for the Bellagio's opening and was a representation of Italian fields in spring. There were two thousand hand-blown blossoms with a vivid complexion of a palette colors. It was brilliant, almost unimaginable.

After we checked in, the bellhop accompanied us to our room, thirty-six floors up, and opened the door to a view overlooking the iconic Bellagio fountains. I looked over to Dale, the boy who once

pulled his living quarters behind a car. He took me in his arms and wrapped me into his chest. "Happy honeymoon, Mrs. Elrod."

We stood gazing at the fountains. Classical music began playing inside our suite as the fountains danced a ballet in sync to the music. Only later would I learn Dale held the remote control hidden inside his pocket.

Our first night we saw *O*, the original water show from Cirque du Soleil. Dale was excited as we were escorted to the front-row seats, proud of his ticket capture, but not so happy when we got soaking wet in the middle of the show.

I roamed the hotel's conservatory and botanical gardens by day. By night I became friends with the croupier. He and I were on a first-name basis after hours of my sitting at his table, playing War, the only game I understood. I kept winning so kept sitting.

Dale played bigger and better cards than I. I left him alone, letting him enjoy himself. He left me to roam the hotel. I kept thinking of Boone, how he would *never* have allowed me such freedom. Loose in a Vegas hotel, with all the shady men surrounding me. Hell, what am I saying, he would never have allowed me in Vegas, period.

I discovered I really loved my newfound liberty, the chance to explore the nooks and corners here, there, and yonder. I studied everything and everyone. There was a smorgasbord of international individuals spilling from the corridors and decadent casino. I was curious about them. Who were they? Where did they come from? What was their story? I wanted to hear theirs and tell them mine. But all I did was watch these strangers as I stood on the sidelines, captivated.

Looking back, remembering my wandering and freedom, I think it was the beginning. It sparked my creative intellect. Just exploring the cornucopia of creatures inside that hotel stirred something. I just wouldn't know what yet.

Our last afternoon in Vegas, Dale found me sitting with my buddy at the War table. By then I had drawn quite the crowd, what with all my winnings.

"Come on, let's find you a slot machine. Give War a rest." He laughed and took my hand. I gathered up my chips and poured them inside my purse.

We walked around the casino until Dale found just where he wanted to plant me. I settled into a comfy chair in front of a slot machine. He showed me the workings of the machine after slipping in a hundred-dollar bill. He pecked my cheek. "Have fun. I'll be back," he said and left for the restroom. I pulled the handle, watching the apples, bananas, and cucumbers tease. So close yet so far away. I liked War better.

I looked around for Dale, only to see him sitting down at a card table nearby. I wondered if he ever made it to the bathroom. I didn't want to know if he was losing. I was too busy trying to figure out the stupid slot machine.

I was twenty minutes into watching apples, chatting freely with the lady next to me, and pulling the handle while my banked money dwindled. Suddenly the lights on top of my machine started blinking and buzzing. My handle was frozen. "My machine is broken and stole my money," I said to the lady next to me.

"You won, it's not broken," she said calmly.

"Won!" I swung in my seat from left to right, not knowing what to do.

"Sit tight, they'll come." She was unaffected.

A serious-looking attendant holding a chart hurried up.

"How much did I win?" I asked her.

"Two thousand five hundred dollars. Want cash, voucher, or chips?" she asked without a smile.

"Cash." I was giddy.

She nodded. "I need your driver's license." She walked away with

my license. I waited, hoping Dale would look over. He was too busy concentrating on losing money.

I studied the screen until the attendant walked back over. She was holding a wad of money and began counting hundred-dollar bills and placing them on the palm of my outstretched hand.

"Can I ask you a question?" I asked. "I've been trying to figure out where it says how much I won, you know, on this machine."

She was still stacking the crisp, clean bills on top of my palm and counting.

"Let me finish, and I'll show you," she said. She plopped down the last bill and bent over me. Her hair, smelling of stale smoke, brushed my face.

She straightened and started pulling money out of my hands.

"Wait, what's wrong?" I asked.

"I thought you were playing ten-dollar slot. It's just a dollar!"

"What...what did I win-n-n?" I stuttered.

"Two hundred fifty. Sorry, my mistake." She wasn't as sorry as me as I watched her walk away. Don't even get me started on Dale. He's still talking about my mouth running in Las Vegas. "Prissy, you don't make friends or even talk to the dealers and staff." That's easy for him. I'm Southern.

❧

San Francisco was the next stop on Dale's itinerary. We checked in to our hotel on Nob Hill and walked around the nearby shopping district. We passed Urban Outfitters, and he stopped to gaze in the window.

"You can't like that," I said as I grabbed his hand to keep walking, but he pulled me back. The mannequin was wearing black leather, layered with black, then accessorized with more black—a Harley-Davidson gangster look. I thought of Boone's Brooks Brother suits, his conservative image.

"Let's go in and buy you some fun clothes," he said. And we did. I can't even describe what he picked out for me. It was so far outside of anything I owned. I think you'd call it "clubbing" clothes. We were going to be clubbing all right, right on over to the Castro District.

Dale loved exposing my innocent, naïve self to the real world because he remembered the girl he once knew. She would have loved meeting and mingling with all the people in the Castro. He knew it was a safe neighborhood with effervescent charm. Everywhere we walked were partyers and outlandish merriment. I loved it. Indeed, he knew me better than I knew myself.

On our last night in San Francisco, we were sound asleep in our top-floor room of our high-rise hotel on Nob Hill when I awoke to the piercing shrill of fire alarms. The entire hotel was evacuated. We were ushered outside into the frigid January cold, wearing just thick terry robes and hotel slippers. It took firefighters three hours to sweep every square inch of the hotel for safety. The fire had started from the fireplace on our floor.

When we were allowed back in, it was time to check out and leave. But I had collected more experiences: partying in the Castro district and surviving a hotel fire. I deposited both inside my treasured memory account, right next to all my winnings in Vegas.

While we honeymooned, Aunt Helen was buried. Stacked on top of her mother, my grandmother, like they do in New Orleans. The epitaph on the gravestone read "Worried herself to death." In New Orleans, nobody takes notice of an anomaly. It's the stomping ground of Cajuns and Creoles and all their oddities. And for the record, these are my people. I'm allowed to talk about them.

Life was good, yet I remained suspicious of the universe. Boone's premature death proved I should never take anything for granted.

Chapter Twenty-Six

Something Blue

THE FICKLENESS OF HAPPINESS is exhausting. I arrived home from our honeymoon and stopped by my mother's house to pick up Puddles, my precious poodle. She had missed me, demonstrating her love by trying to lick off a layer of my skin.

Dale had flown back to Indianapolis as soon as we returned from our honeymoon. It was the longest he'd been away from his office. The only day he ever took off was Christmas Day, only because he spent it with his mother and only because she asked him to.

It was a few days later, on a Friday, when I noticed Puddles's behavior. She was more clingy than usual and not herself. I figured she was sad and mad because I'd left her for so long. But good grief, she had been with my mother, who spoiled her rotten. Still, during the early evening, she would whine if I left her side just to make a cup of tea, go to the bathroom, or reposition myself on the couch.

During the night I awoke to hear her crying. I felt around the foot of my bed where she usually slept. She wasn't there. I slipped out of bed and felt mush between my toes, then slid on a land mine. *Oh God!*

I reached for the light switch in my stupor and saw *piles* of algae-green crap speckled with blood. It was everywhere. I counted fourteen piles covering my hardwood floors. My poor baby must

have been exhausted from squatting. I cleaned up the mess while she hid under a chair shaking, watching, and moaning.

"It's okay, sweet pea, I'm not mad. Come to me, baby girl." I picked her up and smoothed her shaking fur, then wiped her tiny fanny with a warm washcloth and soap. We slipped back into my sheets, and I held her close against my breast until morning.

We were at the vet's office when the doors opened. She was diagnosed with dehydration and a bladder infection. They drew blood to see what had caused the explosive diarrhea.

"She's seventeen, Prissy. You need to prepare yourself," Steve, my vet, said.

Steven had been our veterinarian for years, taking care of Sara Britton's two horses (Stitches and Howie), as well as Puddles, Pooh, and Belle. She was his oldest patient at the time. "In my next life, I'm coming back as Puddles," he said once.

"Well, you'd be healthier eating organic dog food and bottled water if you do," I'd told him.

Puddles was seventeen, which equaled eighty-four in human years, if one believes such a notion. My confidence was dimming with the ticking moments as I negotiated with myself: *She is still eating and walking, and her tail wags when I call her name. Okay, she is blind, and cataracts cover her eyes. But she seems so happy.*

"Prissy." I heard my name. "I think it's time."

Is he asking that I grant him permission to let Puddles die?

"Do what you can, please. I've got to think," I said.

I wrestled with the reality of life and death and the rules that governed me. I could end Puddles's suffering and her life but not Boone's. I couldn't wrap my head around the vet's suggestion.

I surveyed everyone's opinion on what to do: friends, relatives, even a shocked stranger in the grocery store line. I was struggling for validation. Almost everyone suggested I put her down—a ridiculous way to say *kill* my dog. But I wasn't ready. I called and told Steve no.

Puddles stayed at the vet overnight for more IVs and care. I picked her up the next morning, stopped by the pet store for doggy diapers, brought her home, then carried my frail girl back inside. But she wasn't the same Puddles. She was unsure of herself, sometimes whined in pain, and remained incontinent.

I decided not to share what was happening to Puddles with Dale. He would feel guilty for being away and worry about me. I wasn't going to start our married life as one of those needy wives who couldn't make her own decisions. He had his own fires to put out, running a company with over a hundred employees. Plus, he was racing back and forth to Tallahassee.

The tragedy of losing Boone had toughened me. But I carried scars, always waiting for the beautiful sky to fall. I hid my feelings behind a toothy smile and humor.

On Monday, I heard the doorbell ring. I scooped up Puddles, and we went to answer the door. The postman was holding a crate full of overflowing mail, two weeks' worth. He carried it inside and laid it on the floor next to the couch.

I pulled out the junk flyers first, then stacked my envelopes in a pile and left the magazines inside the crate. I reached for the new *Southern Living*, then stopped myself, dropping it back in the crate. *Later*, I thought. I took the diaper off Puddles and carried her outside to tend to business. She stumbled across the grass, sniffing each blade, taking her time while I shivered in the cold.

Puddles deserved some dignity. I waited until I couldn't stand it any longer and finally scooped her back into my arms and hurried inside our warm house.

I made a cup of hot tea and headed back to the couch. A return address on the top left corner of an envelope sticking out from the middle of the stack grabbed my attention. It was from one of the pathologists in Tallahassee.

Why am I getting something from them? A dormant memory flashed. The lump I had discovered four days before my wedding

day. I hadn't told anyone. No one except Alex, one of my closest friends and my gynecologist. I had driven to his office an hour after I'd found it and showed it to him.

"What the heck, Alex?" I was waiting, fearing my happiness might be collapsing.

He examined and kneaded the oversized lump on the right side of my right breast. "Let's send you over for a mammogram," he said.

"No way. I'm getting married, no." Fear makes people stupid.

"Let me try and aspirate it, see if I can get fluid out."

I watched the needle filling up, and the lump sank. It was gone—a good sign, I'd read. "That's good, right?"

"Yeah, a cyst probably."

I breathed a sigh of relief and hadn't thought about it again—that is, until I pulled out the envelope. When I opened it and saw the pathology report, I almost passed out.

Dear Mrs. Kuersteiner. Results of your core biopsy reveal atypical/intermediate suspicion of malignancy. Some cells appear abnormal but are not definitely malignant. A surgical biopsy is required for proper diagnosis. We strongly suggest you contact a surgeon immediately.

I pulled Puddles into my arms, and we sat together, both trembling. I was remembering ten years earlier. I'd gone to Jacksonville for my routine physical. My brother-in-law Nelson was a physician on staff at Mayo Clinic. It was a good way to visit with him and Boone's sister Karol Ann. Get our annual physicals and spend two or three nights with them.

But on one occasion, a lump was found in my breast. The same breast I was now reading about. The Mayo oncologist had had difficulty aspirating any fluid from the hard knot and warned me it was not a good sign.

"It could be a mass," he'd said. But what little fluid he aspirated was sent off and proved him wrong. It was benign. That was ten years earlier. But now that same breast was rearing its ugly nipple, trying to ruin my life. I believed it had to be from the hormone Premarin. I'd been taking that stupid drug for years, since I'd had my ovaries removed. They had ruptured with internal bleeding, forcing me to have an emergency hysterectomy when I was only thirty-five years old.

"Your surgery went well," the doctor told me, "but we had to remove both ovaries, I'm afraid."

I was barely awake and trying to understand what he was saying. "You need hormones…thin…small bones…osteoporosis." He went on, "Your skin dry…sex painful…take the pills…prescribing."

My belly was full of stitches, and he was going on and on. I'd had enough.

"You're saying if I don't take hormones, my husband needs an oyster shucker to have sex with me?" I was loopy from the anesthesia. He laughed. I didn't. But I remembered the warnings and took the drug for years. I didn't want to be an oyster.

Then, when Boone was in the middle of radiation for his brain tumor, I panicked. I was afraid I might get breast cancer from taking the Premarin for so long and our girls would be orphaned. So, I stopped cold turkey.

I can't even describe the crazy emotions I suffered. Note to anyone. Never, ever go off hormone replacement therapy cold turkey. Most especially if your husband, lover, or partner is fighting for their life.

Alex came to my rescue when I stopped the Premarin. He prescribed a "natural compounded regimen." I only wished the doctor who had sucked out my ovaries could see me now. I had no dry skin and no wrinkles. And nobody needed to use *no* oyster shucker on me neither.

I lifted Puddles from my lap, ready to face what faced me. I thought back to a conversation I'd had with Dale soon after we reconnected.

"Are you a boob or legs guy?" I had asked. We'd passed a girl with large breasts on the sidewalk.

"What kind of question is that?" he had asked.

"I read an article in *Cosmopolitan*, and it said a guy is usually one or the other."

"Well, if I had to pick, I guess boob guy."

Of course he was. And now I might have only one.

It took me thirty minutes to pull myself together and make the phone call. I asked to speak to Diana, Alex's wife, who worked at his office. I told her about the letter.

"Don't worry, I'll make some calls," she said.

Two hours later I was sitting inside the surgeon's office. I'd been friends with his ex-wife for years. I had confidence in him and his stellar record. He would tell me this was all a great big mistake.

He read the letter and examined my breast. After he felt the lumpy tissue, he said I needed to schedule surgery. "I don't think you need another biopsy; a lumpectomy should be done." He was holding half my right breast in his hand. "This whole area should be removed based on the report." It looked like more than a lumpectomy to me.

He could schedule me in as soon as possible but encouraged me to seek another opinion. And so I did. The next day I visited another surgeon whose nurse was my good friend Robbi. He concurred with the prior surgeon; the breast should be removed. He ordered a mammogram.

I was married only three weeks, and they wanted to cut off my breast. Dale didn't sign up for that. I broke my rule about figuring things out on my own and not bothering him at work. I picked up the phone and called my new groom. He was on a plane to Tallahassee within three hours.

We were in the waiting room of Radiology Associates for an appointment. The surgeon had contacted one of the doctors there who planned to run diagnostic testing and then let the surgeon know what she recommended: lumpectomy or mastectomy.

Dale's pallor was ashen as he listened to my nervous babbling. I was trying to pretend all was fine as I waited for my name to be called. The nurse came out. "Mrs. Elrod," she said.

I looked up, momentarily confused. Still, the new name didn't register in my mind as being mine. I followed her back and met Mary Swain, the physician.

I'd heard about her from everyone in town. She was the guru for anything involving breasts. Everyone requested she read their mammogram each year. She made me relax the moment she spoke.

I lay on the covered table inside a dark room with noisy machines circling. Mary began asking me the normal questions while positioning the machine—when did I notice it? How did I find it? Was it new? And so on. I watched her as she worked the machine.

I told her my history and more. "I buried my husband from brain cancer. I just remarried a few weeks ago…" I started crying. "They want to cut off my breast. I just got married."

"That's awful." She studied the monitor above my head for a moment, then said, "Maybe not. I want to try something." She was calm and spoke in a soft voice. I looked at the monitor showing my breast tissue. It looked full of something bad, abnormal.

She assured me they were just blood vessels. Some scar tissue. I realized I had no idea what normal looked like, so I remained quiet while she studied the screen.

"I'm going to try and aspirate the area they want to resect. I don't think it looks like a mass. The machine will guide the needle. Lay as still as you can."

I waited as she pricked the needle all over the area. I can't re-member what Mary said after it was over, but it went something like, "Prissy, it's okay. You're fine. There's no mass. It's gone. No surgery for you."

As life has it, Mary and I are now good friends. She must get sick of me telling this story, especially when I've had my second, well, third glass of wine at our book club.

❧

Dale flew back to Indianapolis after my breast ordeal was over. I was thinking life was grand. I didn't have cancer, and happiness abounded. And then Puddles's bloody diarrhea came back worse than ever. She lost all control of her bowels. I carried her all over the house, carried her outside to relieve herself. Where was the dignity in that? Dogs have dignity too. I knew it was time. I picked up the phone and called Garrett and Sara Britton.

Twenty minutes later I heard honking and knew the girls were outside waiting. They had been waiting for my Puddles call for days, maybe weeks. I laid Puddles on the couch while I gathered some things. I pulled out my favorite sheet from the linen closet and headed for the garage. I grabbed Dale's new diamond-plate galvanized toolbox off the shelf and emptied all the contents on the garage floor. Then I stuffed the soft sheet and Puddles's favorite toy bear inside the sterile, water-resistant box.

I gathered my courage, the necessities, and Puddles and climbed inside Sara Britton's car, and we headed to the vet. The girls said goodbye to her in the waiting room and waited for me while I took her back to the room where Steve waited. I couldn't let her die in the arms of anyone else.

I held her on my lap and whispered to her, "Daddy is waiting for you." She listened, staring at me with her cataract-blinded eyes,

and Steve gave her the shot. It was painless for her. A peaceful sleep. To this day, I can still see her looking up at me before she closed her eyes for the last time.

"We'll take her, Prissy," he said.

"No, I'm taking her."

I walked out into the waiting room to my bawling girls, carrying my lifeless dog. The three of us climbed into Sara Britton's car. I remained stoic for my girls, as I did when Boone died. Puddles's body lay on my lap in the backseat. We buried her on Carriage Road, wrapped in a sheet inside Dale's new toolbox.

Death is death, loss is loss. My heart couldn't tell the difference between losing Boone and Puddles's death. Never underestimate a person's love for a pet. To this day, I have never had another pet. And I never will.

Chapter Twenty-Seven

Off the Beaten Path

ONE THING REMAINED CLEAR—MY husband worked in Indianapolis, and I wanted to be in Tallahassee. There were a thousand miles between us. If I was with him, I was far from my daughters, mother, sisters, and friends. I wasn't sure how to choose where I belonged, who needed me most, or maybe who I needed most.

Another issue became clear. Dale didn't want to live in the home I'd shared with Boone half my life. "Let's find our own house in Tallahassee, get new furniture," he said.

I understood and agreed we should start fresh. He was living in the shadow of Boone. But I worried how the girls might feel.

"I have Boone's heirlooms dating back to forever," I said, defensive. "The girls want them but don't have the space right now." Some of the antiques were oversized, and the house they lived in was small and stuffed with their belongings.

"We'll store it, I promise," he said.

I started describing each piece, room by room, beginning with Boone's grandparents' baby grand piano and ending with the sixteen stuffed dead heads lining the library walls: elk, moose, deer, bobcats, fish, and fowl. Sara Britton wanted all the heads. She'd told me that over and over. "Mom, please don't ever get rid of Daddy's heads."

"There's so much stuff—you can't want all of it," Dale said. "Look, we can stay if you want. We don't need to sell—don't worry. Whatever you want. I don't really want to stay here, but I will."

It was a moment of truth. I couldn't move forward with Dale if I was still living in my past. He was right. That was where the house belonged—in my past.

I called Gina, my sister, and she became our realtor. She scouted the market and called me daily. A few weeks later, on a Thursday afternoon, she showed up unexpectedly.

"I found one, come on," she squealed.

"Where?"

"Just come on, get in the car," she said.

We left my street and turned right onto Thomasville Road. The house she found was only three miles away. I loved it even before I walked inside. It had a romantic twist, with nine-foot ceilings and hardwood floors everywhere. The master bedroom was a nice size, with his-and-hers closets and a well-designed marble master bath. In the back was a lovely terrace with a retractable awning to shield against the hot Florida sun.

"You're right, it feels like home," I said.

Gina grinned. "I told you. You need to make an offer—right *now*. Two people are looking at it."

"I can't make an offer. Dale has to see it."

"No time. It'll be too late."

Dale was still commuting. My sorry ass was lingering in Tallahassee, not wanting to leave the only place I knew. Not even for the man I loved.

"Call him," she urged. "Just describe it. I'll talk to him if you want."

Dale answered after three rings. "It's perfect and so romantic," I told him.

"What is?" he asked.

"Our new house. I found it. You'll love it. But Gina says two more offers are coming in. Can I make an offer?"

"I'm glad you found something. I'll see it tomorrow when I get there."

"No, it'll be gone tomorrow. Gina is sure of that."

"Prissy, I'm in a board meeting. I'll call you back."

"No. You can't. Trust me, you'll love it."

Gina was poking my arm. She grabbed the phone. "Prissy loves it. She wants it."

He asked her a question or two while I studied more of the details. I heard her yelling for me. When I walked back into the kitchen, she handed me the phone.

"Okay, you're sure it's what you want?" he asked.

"Yes. Yes. Yes. I'm sure."

"Okay, then. Make the offer."

I offered full asking price. Who knew nobody did that? Not me.

We sealed the deal on our *two*-bedroom house. I swear, I thought it had *three* when I first saw it. I also thought Dale could use the room above the garage for his office. After all, it had a darling spiral staircase leading up from the garage.

"Prissy, you can't take furniture up those stairs," he said when he saw it, his neck cocked so that he could look up into the dark room.

"Oh, well, what about through that window?" I stood outside the *one*-car garage and pointed to the *tiny* window above.

"You're kidding, right? Nothing is going through that window, Prissy." He laughed. The perks of having a newlywed husband. Any other man would have already leveled me.

"Your car won't fit in that garage either," he told me. I was driving a Toyota Sequoia at the time, after trading in my last Jeep.

"Yes, it will," I argued. He was right. It didn't.

"Show me Sara's bedroom," he said. Even though Sara Britton didn't live with us, we both agreed she would always have a room

in our house until she graduated from college. He followed me as I led him into the lovely second bedroom. "Isn't it darling? Just look at her bathroom and that gorgeous painted sink."

"Nice. But where's her bedroom closet?"

I turned around in circles. "What…? Where's the closet?" I was baffled. There was no closet. How did I miss that? Or the lack of a pantry, laundry room, or yard. I was married to a man accustomed to living on hundreds of acres.

Now his new adorable home—purchased by his new bride, at full asking price—had a zero lot line. And it was spitting distance from wonderful neighbors.

But I saved the very best for last. I pointed out the instant hot water dispenser at the kitchen sink. It turned out to be my favorite feature.

◆

On moving day, I walked through my boxed-up, disheveled low-country house I'd made into our home for half my life. I stood staring at the packed boxes ready to load, the bare walls stripped of art, portraits, and color. Room by room I looked around, reflecting, wiping a tear trapped inside a laugh from some funny memory. I had lived and loved inside those walls. I'd learned lessons without even knowing I was being schooled.

I'd thought through what to take and then divide between two cities: Tallahassee and Indianapolis. The rest was to be stored in the largest air-conditioned facility I could locate. And those dead heads, Sara Britton's treasures—Dale hired someone to build crates, then paid a moving company to transport them to his plant in Indianapolis, where he planned to store them in his loft.

I remembered the first time I saw this house. Boone had come home in the middle of the day. It was unusual, so he'd caught me by surprise.

"Honey, I want to show you something," he said. "Go get dressed, okay?"

Sara Britton was only four months old, and Garrett three years old. I was feeding Sara Britton her bottle and was still in my nightgown even though it was the middle of the day. Mothers, babies, and toddlers—don't judge until you've lived it.

"Show me what?" I asked, pulling her up for a burp.

"Don't ask, just go get dressed." He took Sara Britton from me and held her up against the burp cloth I'd handed him.

"Okay, but give Garrett a snack, please," I said, hurrying upstairs to brush my teeth and throw on the same jogging suit I'd worn the day before.

At the time, we were living in Waverly Hills, a lovely, sought-after neighborhood in Tallahassee. We'd built a traditional house from plans I'd found and ordered from inside a *Southern Living* magazine. It was the perfect size for our family—three bedrooms and two bathrooms. I was so proud of my apple-green tub, toilet, and sink I'd selected and had installed in the guest bath. I did it before Boone knew and could veto my bohemian choice. It was colorful against the strawberry-veined Schumacher wallpaper.

We loaded the kids inside the Oldsmobile station wagon and drove less than two miles, where he turned on a dead-end street named Carriage Road. He pulled into a driveway and stopped, then turned off the ignition.

I looked up at a two-story brick house with double circular stairs and a black iron railing surrounding them. Glossy black plantation shutters encased the windows on either side of the double front doors.

Boone started rattling off the story of the house while Sara Britton screamed in the backseat. "The original owners built the house, lived here a few months, and left town for a Disney World vacation. While gone, the house caught fire, resulting in major destruction, so they never moved back in."

"What does that have to do with us?" I asked.

It turned out…*everything*. Boone wanted that house. Period. No matter that I didn't.

The kitchen was housed on the second floor. I had to climb sixteen steps from the carport just to get to that kitchen, hauling groceries, babies, and well, everything. Did I say Boone wanted the house? I don't care, I'm saying it again.

We bought it from the builder, who had purchased it from either the bank or the owners, depending on which story you chose to believe. He had performed the restoration, painting the red brick exterior the pearly white color, probably because he couldn't get the black soot off after the fire.

But Boone loved our castle, and of course I soon did too. Our children learned to ride their bikes there, dressed like princesses, and played hide-and-seek. They pretended to be Laura and Mary Ingalls, the characters from *Little House on the Prairie*, after I made them long cotton dresses draped with starched white aprons and matching calico bonnets. In the evening I watched as they captured fireflies, carefully placing them in scrubbed mason jars with ice-picked holes in the lid, then releasing them before bedtime.

Each Christmas I would think, *Only so-many-more Christmas mornings and our little girls will be gone.* Funny how one thinks so much about the future while the present leaps by. How could I know it was Boone who would be gone?

I was peeling away layers of myself. My name. My house. My possessions.

I sorted through my tangled emotions. The pain. The joy. What I wanted to remember tied up with what I wanted to forget.

Crammed. Stacked. Tucked. Closed.

The movers drove away with everything. The house where Boone took his last breath was empty. I never wanted to see that house again.

Henry David Thoreau wrote, "Things do not change; we change."

I was changing, and those who knew me took notice.

Chapter Twenty-Eight

Chivalry

As a young girl, I dreamed of living in a big city. And here I was in Indianapolis living in one. But it wasn't the way I thought it might be, in the fourth decade of my life. We like to believe we're in charge, but we don't make the plan. Life does.

It was March. A warm front was moving through Indianapolis, and temperatures were expected to climb to forty-nine degrees by late afternoon. I was laughing. A warm front. Were they kidding? For me, a lifetime Floridian, it was downright freezing. The meteorologist sharing the forecast flitted around the screen with his arms swinging, fingers and thumbs pointing left and right.

Gray skies, a brown landscape, and the pallor of the Indiana population matched the inside palette of Dale's bachelor pad where we were still living. It didn't take me long to know this colorless home away from home wouldn't work. It had one bedroom, so no place for my daughters, mother, or sisters to stay when they came. And I couldn't be there if they couldn't visit. At least not for a long length of time. It was selfish of me, I know. But Dale agreed when he proposed, and I said yes, there would always be a spare bedroom for my family if we were in Indiana. And now, I was in Indiana, alone while he worked all day. And there was no place for any visitors.

It was the third day of my fourth trip up to Indianapolis since we had married. Like a puppy waiting for her master, I waited for Dale to come home. The minute he walked in, I would pounce and paw; I was so starved for companionship.

It wasn't working for me, a people person. I was accustomed to having my days in Tallahassee filled with friends, lists, responsibilities, and activities. Seldom was I *ever* alone in Tallahassee, unless I chose to be. But when I flew back to Indianapolis, I was always alone—until my exhausted, overworked new husband came home.

I decided I would try and remedy my new life somehow. Find a hobby besides reading, exercising, cleaning, and waiting. I pulled on my lined yoga pants and a silk undershirt from my still-unpacked bag to go for another walk despite the freezing weather. I layered my clothing, ending with my turquoise fleece. I dug through my closet for the crochet band to cover my ears. On my last walk, the wind had whipped inside my ears and given me neuralgia that lasted two days. I didn't want that happening again.

I looked in the mirror and laughed. I was layered enough to climb Mount Everest. I didn't care. No one knew me. I knew no one. I would take a walk and explore my new city.

It didn't take long to get lost. The more I thought I knew where I was going, the more lost I became. All the landmarks were unfamiliar as I walked in circles. Each road turned into a different neighborhood. A few neighborhoods had houses and cars splattered with graffiti.

I'd watched a crime show on television, and the setting was downtown Indianapolis. Recalling the story of gang violence, I waved and smiled at unfriendly loiterers standing against their cars, smoking cigarettes—I wanted to think they were cigarettes. The men looked shady even under the bright sunlight.

"Hey there, how y'all doing today?" I waved and gave a toothy smile.

Maybe my friendliness would discourage any forward movement toward me, I was praying. Two of the six waved back. Still, I worried when a non-waver whistled and hollered something I wished he hadn't.

I sped up my pace then turned another corner, facing another sketchy neighborhood. Holy cow—where were the tree-lined streets like we had down South?

"I trust you, Jesus," I repeated as each block became more and more unfamiliar.

After two hours I knew it for sure. I was lost. Without my cell phone. I stood in front of a bar with barred windows and saw yellow spit on the sidewalk. At least I hoped it was spit. It had a filthy glass door that hadn't been wiped in years.

I second-guessed pushing through the door to use the phone and call Dale. His plant was an hour away from downtown Indianapolis. By the time he would arrive, I could be dead, my body stuffed in a cooler or buried in a dumpster. I kept walking. And then, as if by magic, Jesus arrived. I was standing under a sign that read Walnut Street, in front of a sign that read PEARLY GATES. Well, it really said Open House. But it sure felt pearly.

A chubby man, the realtor, smiled as I walked inside the warm living room with large windows and a fire burning in the fireplace. The living room flowed into a gracefully winding staircase that led to the second floor. I started crying before I could stop.

"I'm okay. It's cold tears from freezing outside," I lied.

The poor man looked distraught and handed me a tissue.

The house was a three-story, Savannah style. Upstairs the master bedroom showcased a view of the downtown skyline. The second bedroom had a door leading outside to a rear upper deck facing the Indianapolis canal and walkway. The canal was dotted with paddleboats and gondolas, and brave outdoors enthusiasts were bicycling and walking the pedestrian-friendly walkway.

That was it. Exactly what every Florida girl needed. Water smack dab in the middle of the city. If that wasn't Jesus. It was more than a sign; it was a match made in heaven. I borrowed the realtor's phone and called Dale.

"Can you come pick me up?"

"Where are you?" he asked.

"Walnut Street. I think I found a house."

The realtor spread a wide grin across his plump cheeks.

Dale came to retrieve his lost wife. He had no idea there were houses next to the canal, and only a mile from his apartment.

"How in the world did you find this place?" he asked.

"Jesus led me here."

Only later would I share with Dale how I got lost, prayed out loud, and suddenly stumbled upon the house on Walnut Street. As it turned out, Dale loved it just as much and made a verbal offer before we left. The bachelor pad—his apartment—was soon relinquished for a house. More important, we now had a spare room for my girls, mother, sisters, and friends. I was luckier than I deserved.

Chapter Twenty-Nine

Something New

IT WAS A WEEK or so later, and I was back in Tallahassee. Mike, Garrett's boyfriend, called and asked if he could come over and talk to me. They had been dating for two years, so I felt I knew what he was going to ask me.

Only the day before, Garrett and I were driving back to my house after having lunch. Out of the blue she had asked, "Mom, do you think Dad would have liked Mike?"

It wasn't the first time she'd asked the question. She wanted to know in her heart Boone would be happy with any decisions she made in life: school, boys, jobs. I knew I needed to be his vessel. "Yes, sweetie, he sure would." I squeezed her hand and kept driving.

Garrett had wanted to be a bride ever since she was a tiny four-year-old. Of course, most girls do. But she was different. The Halloween costume she chose every year had to be the wedding ensemble: dress, veil, shoes, and sparkle. She wore it even during Florida's hottest summer days. When she outgrew one size, I bought a new one.

She pedaled her little pink bike up and down Carriage Road, wearing that frayed wedding dress. The veil, clipped to her blond curls, blew against her smile. Sometimes she crossed the street to marry George, my friend's husband. He was her repeat groom. Like Boone, he too died from a brain tumor.

Garrett and Mike had their first date during the final stage of Boone's life. When he called to ask her out, Garrett was reluctant to leave our house. I encouraged her to accept the invitation, knowing how much she needed a break. More important, she needed a distraction.

She had been sitting next to her unresponsive, dying father for months, seeing few if any outsiders. Her life, *our* living, existed almost entirely inside the house on Carriage Road. Our circle was Boone, the girls, and me—and eventually Cornelius Duhart, or Du, and Sallie Madison, Boone's live-in caregivers who became like family.

The night Mike came to pick up Garrett for that first date, he was met with the unexpected. I was sitting next to Boone while Garrett was readying herself for the date. I could hear music coming from outside just as Du blasted into the room.

"You got to see it, Christy," Du said. He always called me Christy, even though he knew my real name was Prissy.

"What?"

"Come on, you got to see. Come on." Du was practically jumping up and down, his hands clasped together in front of his heart, a huge grin on his face.

I stepped outside the front door onto our porch. There, spread across our yard, were a dozen men dressed in customary Scottish kilts. The sound of their bagpipes drifted across the lawn to me as I stood in gratitude. They played "Danny Boy" for Jonathan *Daniel* Boone Kuersteiner, compliments of Boone's dearest childhood friend, Alex.

At this moment, Mike was climbing the circular stairs to our front door to pick up Garrett, his face filled with confusion.

❧

I heard the doorbell ringing and pulled my mind back to the present and looked at my watch. It must be Mike. It had been an hour

since he had called to say he wanted to talk to me. Where had the hour gone? I wondered.

We made small talk: his school, a part-time job, the weather. He was so nervous. Finally, he stopped fidgeting and looked me straight in the eye. "I want to marry your daughter."

I felt rage in the pit of my stomach. Not toward him but rather toward Boone, which was worse. It was Boone's place to be sitting across from Mike, handing out blessings. He had talked about the day our girls would get married since they were born. Looking back, I know now it wasn't rage I felt. It was guilt.

Garrett's day would be different than the one she'd dreamed of all her life. Once again, I was reminded life is what it is, not always what you thought it would be.

I counted my blessings that Garrett had warmed to Dale over the last several months. They had become much closer. It began the night before our wedding as she sat next to his mother during dinner. Once she met his family and later witnessed firsthand his love for me, for Sara Britton, and for her, she began to change. It wasn't overnight by a long shot. It was over time, as these things tend to happen.

Three days later, Dale flew back to Tallahassee, and I shared their news. Mike had proposed to her as soon as I gave my blessing. After Dale congratulated her, she asked Dale, "Do you think my dad would have approved of Mike?"

"Sure, he would." Dale had never met Boone, yet he knew how to answer Boone's child.

Later, when he told me what she had asked and what he had replied to her, he said, "She needs validation, approval. She's a pleaser, like you."

"I know. I get it." I gazed out the passenger window.

I heard Dale's voice. "What are you thinking about?"

"Nothing, just daydreaming," I lied through blinked-away tears. The familiar landscape rolled by.

Something Borrowed

IN TRUTH, I KNEW Boone wouldn't want Garrett getting married so young. He was adamant the girls get postgraduate degrees before even thinking about getting married.

"A college degree, that's nothing. It's like a high school diploma nowadays," he had preached.

Boone and Garrett had made plans for her postgraduate path in life. Rather, Boone had made them for her. He wanted her to go to law school after she graduated from Florida State University with a business degree. When he was still able to talk, before the brain cancer took his words, he asked that I please make her stay the course.

"I'll do my best," I'd said and swallowed the word *promise*.

After Boone died, Garrett's pleasing gene kicked in full throttle. She graduated and began the law school admissions process—prep classes and such. It seemed more important than ever for her to make Boone proud. Perhaps she'd made promises I wasn't privy to.

Garrett loved fashion, design, decorating, and art as a young girl and through her teen years. She was always drawing fashion sketches, rearranging her room, and creating vision boards. Maybe it was her type A personality and intelligence that gave Boone the impression she should be in the arena of business. Rather, law. His world.

But in my heart, I felt she didn't want this. A mother knows her child. Well, this mother did. Boone coached, encouraged, and planned her life as I watched from the sidelines. I said nothing. Then he was gone, and all she had left was *his* dream. So how could she let him down?

A few weeks after Mike's proposal, Garrett and I were having dinner at a local restaurant when I noticed her right eye twitching. The twitching eye had gotten her into more trouble than I could count through the years. As a young child, when she pinched her sister and denied it, her right eye would twitch. As a teenager, if I questioned her, "Did you really go to the movies or to that un-chaperoned party?" her eye would twitch if she lied. Busted. Always.

"Garrett why is your eye twitching so much?" I asked. I'd been watching her throughout dinner. She'd had little to say, and there were few smiles. She was anxious, I could tell. I wasn't sure what was troubling her—fiancé, part-time job, or hormones, but I took my gut-felt guess. "Garrett, you know you don't have to go to law school if you don't want to, right?"

She laid down her fork and looked at me with tears pooling in her eyes.

"Honey, that was your daddy's dream. It doesn't mean it should be yours," I said.

She stared but said nothing.

"You can't be happy in life trying to live someone else's dream, even if it was Daddy's." I took a sip of wine, waiting for a reply. When she didn't say anything, I continued. "He wouldn't want you going if you didn't want to. I know that. I knew him…much longer than you. All he ever wanted was for you to be happy." She still didn't answer. "He would want me to tell you this. He would, I promise you."

"It's what he wanted so much, Mom," she said.

"Yes, he did. But only because he thought you did. He meant well, but he was wrong to push you that hard."

She looked away, around the restaurant, then back at me.

"Listen up," I told her. "I'm giving you permission to paddle your own boat. Go find your own passion, do what you want, whatever that is."

She whispered under her breath, "Okay."

Law school was never mentioned again. It was off the table. I took the blame for dismantling Boone's law school dream for her. But the wedding he once promised each of his girls as the three of them watched *Father of the Bride* one night, well, that was one promise I would keep. Garrett would have the wedding her daddy always wanted for her. And later, Sara Britton would too.

A year later, on the day after my birthday, Garrett married Mike. St. John's Episcopal Church, a picturesque brick structure on a tree-lined street in Tallahassee, was the setting. It was the same church where she had been baptized and confirmed and where Boone's funeral had been held only three years earlier. Rather than choosing her stepfather or one of Boone's four brothers, she opted to walk down the aisle alone.

"Let me walk you down," I suggested.

"No, Dad will be with me, Mom, even if just in spirit."

The processional song *Prince of Denmark's March* by Clarke began playing as she gripped her bouquet and walked the familiar aisle where her father ushered so many Sundays ago. When she approached the altar, Mike reached out and held her hand. There wasn't a dry eye in the house.

❧

It would be later when Sara Britton's childhood sweetheart, Matthew Jacobs, asked her to marry him. They had been together since she was only fifteen and he was just fourteen.

Dale had become the father she needed and everything she hoped for after losing Boone. It was never more obvious than when she wrote a letter to Dale after Matt proposed.

Dear Dale,

A wise woman once told me "things fall apart so things can fall together." Now that I am wiser in my own skin, I know exactly what those words mean.

It is, in fact, bittersweet. My life has involved three men. My father, Mathew, and you.

While this day is indeed joyous for us all—with that comes sorrow. For this is the day that I know my father would have lived for. Looking and thinking back on the woman's wise words, I know now how my day is supposed to unravel.

You are the wedding gift that my father has sent to me. I will have someone to walk me down the aisle, as my father, as my dad.

I am asking for your hand in giving me away to my marriage to Matthew, to share in this bittersweet moment with me on March 31, 2007.

With Love,
Sara Britton Kuersteiner

When Dale walked Sara Britton down the aisle, there were more tears falling from the eyes of those who loved us all. But they were happy tears from joyful hearts. Each of the girls' weddings, equally beautiful, held different emotions—based on the timing of the loss of their devoted father.

Only later did I ask Sara Britton about her letter to Dale. "Who was the 'wise woman' who told you 'things fall apart so things can fall together'?"

"It was you, Mom," she said.

I never had the heart to tell her I must have read that Marilyn Monroe quote inside a lady's magazine.

Chapter Thirty-One

Jotting Memories

BEFORE DALE AND I reunited, while we were only writing to each other, I shared with him things that had happened during my quest to save Boone's life.

"Prissy, you just have to write this stuff down," my friend Gayle had said more than once.

Gayle is one of those friends who protects, defends, and encourages me. She may be complimenting me one moment then correcting me the next. It depends on my behavior and her courage.

"You can't make it up. It's bookworthy. Write a book, girlfriend," she had urged whenever I told her about the drama and nefarious happenings that occurred when Duhart and Sallie lived with us.

"Like I could ever forget any of what's happened," I would say. "Laughter-through-tears living," we had called it.

"Just write it down, Prissy." And so, I did. She did. Others did. The craziness was documented on a yellow ledger kept on my kitchen desk. Whatever fiasco happened that day was jotted down on that ledger by whoever had witnessed it.

In movies and television shows where someone is dying at home, scenes are depicted with a sense of stillness, quiet whispers inside the depths of sadness. It was the opposite inside our house. Oh, make no mistake, we had somberness, sadness, tears, and anger. But

there was no stillness; rather, we had an electrical current of crazy streaming through our house all day.

I no longer lived my once-ordinary life. I was this strung-out being who was multitasking everyone, everywhere, every day. I wished to be an octopus and have six more arms. Nothing was easy. Ever.

Friends came and went during that dark time. To be honest, I can't recall who. But the ledger reminds me. It's filled with different-style handwritings—print, block, and cursive. The writing depends on which friend came that day. Sadly, I don't even recognize my own letters, words, or thoughts.

~

Dale and I were having dinner at Ruth's Chris in Indianapolis. The waiter had cleared our plates and was running a silver crumb scraper over the crisp white linen cloth.

"I'm sorry about that stain." The ketchup had oozed off my plate, and the waiter was scraping around it. Dale couldn't understand why I was compelled to make conversation with everyone about anything.

"No worry, it'll come right out." He was nice. I decided I'd order a Brandy Alexander just so we could stay longer. I smiled at Dale across the candlelit table.

"I've been thinking," he said. "Maybe you really should write that book like Gayle suggested."

What did that have to do with my spilled ketchup and chatting with our waiter? Dale was leaning back, sipping his Jim Beam cocktail. The suggestion seemed out of the blue to me. But it wasn't the first time he'd mentioned it.

"Are you thinking I'm bored or something?" I wasn't bored. I'd never been bored in my life. But I was homesick, and more so every day. I just didn't want to tell him so. He deserved better than a whiny, homesick new bride who missed her mama, daughters, sisters, and friends.

"I've told so many people they should write a book too. That's just something you say, not what you mean," I said. "Everybody tells everybody they should write a book. And everybody thinks everybody would read that book."

It was such a cliché, and I knew better. Dale and Gayle were wasting their time even suggesting the ridiculous notion. I wouldn't even know how to begin.

The waiter arrived and placed my dessert in front of me. It was a caloric mistake. The icy drink was made with Häagen-Dazs ice cream and presented in a glass bigger than my hand could hold.

"Good grief, why did you let me order this?" I was trying to change the subject as Dale leaned in with his spoon for a shared slurp.

"It might be fun for you," he said. This subject was not ending.

"Fun! Writing is way hard. Where's the fun in that?" I was licking the dripping ice cream off my glass. "Besides, I'm not a writer."

"You are a writer, what are you saying? I read all those letters, emails, not to mention the poems you write."

The man thought I was great at everything. No matter what I did or said. It made me blush.

"If you want a reason, I'll give you two," he said. "Garrett and Sara. Write the story for them, about their dad, about us."

I finished my drink and didn't answer him. Instead I told him about the movie I wanted to see opening over the weekend.

The next day he walked into our new house, toting a computer, a monitor, a printer, and office supplies. I watched him set it up next to a corner window overlooking the Indianapolis skyline. "Here you go, should you ever decide to write," he said, planting a kiss on my cheek as he brushed by. But the computer was seldom used for anything but sending emails to my girls.

There was one day I thought about trying to write the story. I opened my Word document and stared at a blank screen for a good while. But I had no idea where or how to begin. But more

important, I had no idea why. What was the purpose? To write the story meant revisiting the pain, reliving the loss. No way. I never wanted to feel that way again.

I closed the document and shut down the computer. I grabbed my favorite down jacket and left for the coffee shop on the corner of Senate Avenue and Michigan Street. Susie, the barista, greeted me as I inhaled the aroma of fresh-roasted beans.

We chatted as I watched her make my cappuccino. It turned out Susie and the girls at the downtown T.J.Maxx store were the only friends I'd made.

⁓

I was organizing my clothes and packing for my flight home the next day when I heard the phone ringing. I'd been in Indianapolis almost a month, setting up the house and learning my way around the city. I was looking forward to seeing my daughters. I grabbed the receiver and heard Sara Britton's voice.

"Mom, Brad has leukemia!"

I'd missed what she said about who. "Thad who?" I asked.

"No! *Brad.*" I knew only one Brad. He was the son of very good friends, and the same age as Garrett.

"What are you talking about?" I sat down, my noodle legs shaking. Every time I heard *cancer*, my heart skipped several beats and my knees weakened.

"He went in for his law school physical, and the blood work came back abnormal. He was diagnosed after that, with more tests. He needs a bone marrow transplant."

"Who says that?"

"I don't know—everybody."

"My flight's tomorrow. I'll be home around noon, okay?"

The perils of a life interrupted. When Dale came home, I was lying on the couch—lethargic, ashen, and weeping.

"What's wrong? Are you sick?" The color on his face was worse than mine. He hated to see me upset. I told him what was going on, everything Sara Britton had said. He gave me the pep talk I needed, pumped with positivity.

"Leukemia is on the cusp of a cure. There are so many new drugs. It's different than with Boone. Come on, get dressed. I made reservations someplace I've been wanting to take you."

I climbed off the couch and went upstairs to clean up. My suitcase was already packed for my flight the next morning. I pulled out a pair of black pants and my favorite yellow silk blouse. An hour later, after a hot shower, freshly applied makeup, and two coats of lengthening mascara, I was presentable, my puffy eyes camouflaged. A cab picked us up, and as we rode toward his planned surprise, he attempted to calm my fears but failed. I knew way too much about cancer.

Three days later I was standing in line with the girls to be swabbed as a bone marrow match for Brad. We knew how being blindsided by a twist of fate felt. We decided if one of us were a match for Brad, we would donate. But we weren't. As goodness had it, we didn't need to be. And luckily, he never needed a transplant. The miracle drug—Gleevec—came into the picture. It became his savior, even until today.

Chapter Thirty-Two

Confused

With Garrett and Mike's wedding behind us, spring had leapt into summer, and October was here before we knew it. Sara Britton had her own big event. She was turning twenty-one in a few weeks.

"Let's celebrate in Vegas," Dale said. Of course, he would. "Come on, Sara would love it. We can see some shows."

I was thinking about her daddy, a man who didn't even drink. What would he think about me taking our youngest to Sin City for her birthday? The contrast between my two husbands was mammoth, not to mention comical in many ways.

"Okay, let's do it," I said.

Later, I called and shared Dale's suggestion with Sara Britton. She was over the top with excitement. "What about Garrett and Mike? Can they go too?" she asked.

"Sure, if they can get free."

Two weeks later we were Las Vegas bound.

Dale spared no expense. We checked in to the Bellagio, where he and I had honeymooned. By day the girls and I shopped while the boys gambled. The evenings were candlelit dinners and shows. On our last day in Las Vegas, the day after SB's actual birthday, we were standing in front of the Bellagio fountains, watching the water dance and taking our last photos when Sara Britton's cell phone rang.

"Yes, it is. Yes, I did. Yes, I am," she said. It was obvious she wasn't talking to anyone she knew.

"Who is it?" I poked her arm. She didn't answer me. Her confused eyes were fixed on me as I silently mouthed, *Who is that?*

She kept ignoring me.

"Sara, who are you talking to?" I asked for the third time.

"Can you hold on a second, please?" She placed the phone against her chest. "It's someone from the bone marrow place. He says my name came up in their database. I'm the only person in the entire database that's a match for someone."

"A match for who? What are they talking about? What database?"

"They didn't say who, just someone. They're asking me to come in for a blood test to confirm the match."

"You're not donating bone marrow to *someone*. We tested to help Brad—not someone else, someone you don't know."

She stared at me, listened, then looked toward the sky, the person still on hold.

"Listen, honey," I said, "tell them you can't, you're sorry, but you're in the middle of college exams."

She put the phone back up to her ear, and I exhaled. When I heard the words fall from her mouth, I almost fainted.

"Yes, I can. I will."

She clicked off her phone. "I'm twenty-one now, Mom. That means I can make my own decision."

❧

Sara Britton sat between Garrett and me on the flight home. Garrett was just as bad as me. "What are you thinking? Are you crazy?" she asked her over and over.

I was unmerciful. Frankly, I didn't know anything about bone marrow donations, so I made it up as I went along, this-and-that

tactics to scare and discourage her because it scared me. No matter what I said, how I preached, my worst-case scenarios dramatized, she kept reading her magazine and ignoring me.

I gave up and dozed off as the plane continued toward Tallahassee. When I woke up and looked out the window, I saw blue sky beyond swollen clouds. My emotions were a complicated mix of reverence and uncertainty as the humming of the plane's engine soothed my anxious mind. It was in that moment of stillness I began to understand, as if God was responding to the turmoil within me. Sara Britton's reasoning became clear. She was going to save someone else since no one could save her father. "I'm the only one," she had said when she ended the call in front of the Bellagio. Her empathy outweighed her fear, or mine.

As we taxied to our gate, I argued with myself. *How could I discourage benevolence, courage, and kindness, the very things I spent a lifetime teaching my girls? What should I be saying to a child doing such a selfless act?* Turns out—plenty.

Later, at home, I discovered the bone marrow harvesting was done at the same hospital where Boone had his brain surgery and was given a death sentence. Returning to the Shands Hospital in Gainesville—well, it just wasn't an option for me. I upped my game and started lobbying harder for her to retract the offer to donate. She wouldn't listen and had no intention of backing down.

She began the preparation process and prerequisites for donation. It was scheduled for January, only two months away.

❧

Christmas holidays were upon us. Dale's mother flew from Indianapolis to Tallahassee for a short visit a few days before Christmas. I noticed a significant change in her appearance since

I'd last seen her. She'd lost so much weight, and I noticed she was dragging her right foot. I mentioned it to Dale.

"I know, I noticed it too," he said.

Later, when she'and I were alone, I asked her a few questions about her health. I was no doctor, though my friends said I pretended to be. I did, however, work alongside my father inside his medical practice during my high school years. Then later, after graduate school, I worked with a team of physicians as a medical examiner for disability determination.

Because of her symptoms, I suggested to Dale she might have peripheral neuropathy.

"Find the best place to take her," he said. Dale and his siblings, Jeff and Mary Ann, were nurturers and had attended to their mother's needs since their father's death fifteen years earlier.

I researched and found the best specialist in neurology. He was in Chicago, only a four-hour drive from Indianapolis. (I could say "our home," since Dale was still working there and we had a house there, but I was still in denial, even two years later. I considered my home Tallahassee.) I scheduled the first available date: January 8, our wedding anniversary. I confirmed the appointment and canceled our anniversary plans.

❧

The conditions in Chicago on that January day were excruciating. As we exited the lobby's front doors, a brisk wind almost knocked me to the pavement. Dale clung to his fragile mother. The frigid cold coming from Lake Michigan pierced through my bones as neuralgia shot through my right ear.

"Holy Lord, it's colder than a witch's tit," I said. It slipped out with no warning, right in front of Dale's mother.

"Yes, it is, it surely is," she said through a hoarse laugh.

After two days of testing, we left with no diagnosis and the test results pending. We drove back to Indianapolis, and the following day I flew back to Tallahassee. Dale had an important meeting and would fly to Florida on a later flight. We were scheduled to go out of town again in a few days, only this time it was with Sara Britton. She was having her bone marrow collected, I was reminded, at the place where everything had started and where afterward nothing was ever the same again. Thankfully, Dale would be coming with us. I was so relieved.

Chapter Thirty-Three

Falling Sky

THE MORNING SKY WAS hazy with an arctic cold moving down. It was late afternoon as we traveled east on I-10 toward Gainesville. We were returning to the place I said I wouldn't go and for something I said she shouldn't do.

It had been two months since Sara Britton said yes to the bone marrow donation. Even longer since the girls and I had had our cheeks swabbed to see if one of us was a match for Brad, my friend's son.

After our cheeks had been swabbed, I learned we'd also been checked for human leukocyte antigens, which are the proteins in our DNA inherited from our parents. If you have eight out of ten as someone else, you are a match. After being swabbed, you're automatically added to the database of registry. If you're found to be a possible match for someone who needs a donation, you then have a blood test to confirm it. None of us were a match for Brad.

As someone who researches everything to the limits, I learned what Sara Britton's upcoming donation entailed. Only 0.5 percent of those swabbed receive a call saying they're a possible match. And of that 0.5 percent, only 8 percent are a true match. If you *are* a match, then you have an initial medical checkup. It's an extensive examination and includes a plethora of tests.

After Sara Britton's examination, we were shocked, then grateful, to learn she had a high probability for a stroke should she ever take the birth control pill. Evidence indicated either the residuals of a previous, undiagnosed mini-stroke or small clot possibly had been there since birth. The doctor recommended she be put on aspirin and warned her never to take the birth control pill. In exchange for the bone marrow of my twenty-one-year-old daughter, she was gifted lifesaving knowledge. We would have never discovered any of it had she not been screened so extensively for her donation.

But this made me worry about the anesthesia. Who could know the other risks? I remembered my mother telling me how her younger sister, only four at the time, died under anesthesia when she was having her tonsils taken out. Should I have mentioned it? What was my child doing putting herself at risk?

"Don't worry, everything will be fine. I'll be with you both," Dale said over and over. He knew how much I dreaded going back to the place where Boone was declared terminally ill. I felt braver just knowing I wouldn't be alone. But then, at the last minute, two days before he was scheduled to fly out of Indianapolis and down to Gainesville, he received a phone call from the Chicago physician who had seen his mother.

"We'd like to see your mother as soon as possible," the doctor said to him over the phone. Her appointment was set for the same day as Sara Britton's harvesting. Dale was torn, but I encouraged him to choose his mother. I was fine. Sara Britton was fine. We were fine.

A case coordinator was assigned to Sara Britton. She was a robust older woman with an authoritative attitude. She was responsible for the scheduled tests, appointments, precounseling, and follow-up visits Sara Britton would have throughout the first twelve months after the harvesting. Frankly, the woman scared me, so I answered her like a child: "Yes, ma'am. No, ma'am."

It was predawn on a Friday morning when we checked in for her procedure. We'd spent the previous night in a hotel across the street. When the nurse called her name, Sara Britton was stoic, calm, and busy calming me down. "I'll be fine, Mom. Don't worry, please." If she was having second thoughts, she didn't show it. She wiped a tear off my cheek and followed the nurse.

It was stifling hot in the waiting room despite freezing temperatures outside. My body was quivering and sweating with a yearning and emptiness mingled together inside the pit of my stomach. And Dale, why was he not with me? He chose his mother over me because I'd told him to. But he should have said, "No way, I'm going with you." I was angry; he was my mental target. It was so unfair of me.

I located a seat in the corner of the empty waiting room and claimed it. My body craved coffee, but I was too frightened to leave the waiting room. I sat alone waiting, worrying, and remembering Boone. I began making deals with God.

As one hour grew to two hours, and soon, three hours, I drifted to sleep only to be ambushed by memories. I was transported back, once again, to that horrible day I'd spent five years trying to suppress. Boone was fighting for his life during seven hours of surgery. My daughters and I waited, surrounded by a village of family and friends filling most of the chairs in the large waiting room. When the doctor finally appeared, there was a quiet hush as he walked toward us. I held my daughters' hands; we waited for his words. His eyebrows glistened with sweat, his blue scrubs a shade darker from perspiration, the smears of dried blood blotched over blue. Boone's blood.

"He survived. Removed 99 percent of the tumor," he said.

My heart leapt, all three of us crying openly. I was about to thank him, but before I could, he continued. "If you do nothing, he won't

live more than three months, I'm afraid. But, if we radiate, he could live a year. That's the best you can hope for. I'm so sorry. I really am."

He patted my arm and asked if I had any questions, but I was too dazed to ask anything. He turned around and walked away, on to his next hopeless case.

❧

"Excuse me, are you Sara Britton's mother?" a woman asked.

I awoke confused, looking up into a kind face. "Yes, yes, I am." I began shaking.

"She's doing great." She was patting my arm, smiling. "The procedure went really well. She'll be in recovery soon."

I didn't answer.

"You can see her soon. I'll come get you." She smiled again, then turned and walked away. I sat in silence, taking a deep breath, trying to calm my racing heart.

I looked at the time and saw it was noon. Sara Britton had gone back at six a.m. Another hour passed before the nice nurse returned and led me to recovery.

Sara Britton was still groggy. "Her blood pressure was low, but she is good now," the woman told me. "She'll be good to go soon."

"How long will she be this groggy?" I asked.

"Not too long. She'll be more awake soon."

The shifts ended, and the weekend skeleton shift began to arrive. I listened as those about to leave shared their weekend plans with one another: a Saturday concert, the newest restaurant, a blind date. Sara Britton fell back asleep. A new nurse came in, talked to me, explained the discharge, handed me papers, and woke up Sara Britton and helped her dress.

It was four thirty p.m. when we climbed inside our car. Sara Britton, me, and a slew of paperwork.

Then, an hour into our drive home, somewhere between Gainesville and Tallahassee, it happened. Sara Britton couldn't catch her breath and was acting strange, panicked, and then lethargic. I pulled over and began searching the paperwork for the emergency number they'd given me. It took three tries for my hand to dial correctly.

"You need to get her to the closest hospital," the man ordered. But I wasn't sure where. Back to Gainesville? No, we'd been traveling an hour. That was too far. I dialed Alex, a friend and doctor, and as I waited for him to answer, I pulled back on the highway, accelerating to eighty miles per hour in a nanosecond.

It kept ringing as I looked from Sara Britton to the road and back. I checked my speed when I passed the sign that said Tallahassee was fifteen miles away. I sped up to ninety miles per hour, somehow remaining calm. I interrupted my talk with Jesus when Alex answered. I explained the scenario, speeding like a crazed lunatic.

"Bring her straight to the hospital. I'll meet you there." And he did. She was admitted with dangerously low blood pressure and an inability to urinate (not uncommon after surgery). They inserted an intermittent catheter into her bladder. I sat with her in the ER, a drainage collection bag hanging next to my knee on the side of her bed. As I held her hand, I felt the warmth and looked to see the bag filling up.

Once she was stable and sleeping, I went outside to breathe fresh air and find my composure. My stomach was knotted, so I lay down on a bench, not caring about the stains and dirt.

The sky was crystal blue with an artistic abstract of white clouds circling above me. A gentle breeze blew against my face as I watched the variegated leaves dancing on branches of a centennial live oak tree. I lay there until my stomach settled, so relieved my child was safe. Yet I was angry at what had happened. I had to release the fear that had been caged inside me over the last several hours. I sat up,

dug in my purse, and pulled out my cell phone and dialed Dale's number.

When he answered, I barely took a breath as I shared what had happened, ending with, "You should have been here. I was all alone." It felt good to rant and unbottle all my corked emotions.

He listened, not saying a word, then told me, "Prissy, my mother has Lou Gehrig's disease." And I thought it couldn't get any worse.

I sat on the bench, trying to absorb the horrible news about Dale's mother when I looked up and saw Duhart, Boone's caregiver-angel and mine, walking out of the hospital. It was as if God himself willed him in front of me.

"Du! Oh, Du!" I hollered, running to him. A big smile stretched across his face as he swept me into his arms.

"Christy! What you doin' here?"

I clung to him as he pulled back to look me over. "What you been up to? I see you still skin and bones."

"You can't imagine; Sara Britton's in that ER."

I felt my knees wobbling and pulled him over to the bench. I wrapped my hands around his hand, rubbing his knuckles while telling my tale. I started crying, and he hugged me. He made me feel safe, just like he had many years earlier, when my world was crumbling and he held me in his arms.

❧

Together Duhart and I went in to see Sara Britton. He was just the person she needed. He had a way with us. He had pulled the three of us—Garrett, Sara Britton, and me—from the depths of despair to a place of understanding, acceptance, and normalcy during our struggle and grief. He cuddled with humor and made us believe all would be well. He had her laughing thirty seconds into his visit. Nothing new there; I have never met another man like him.

I walked him back to his car while Sara Britton waited for the ER discharge papers.

"Du, I sent you a wedding invitation when I married Dale. You never replied," I told him. "Then I called you. Where were you? Why didn't you come?"

"I just couldn't see you with nobody else, Christy. I loved Mr. Boone so much." He wrapped his large black arm around my shoulder, pulling me in closer. It was enough.

I knew finding Duhart in front of that hospital didn't happen by chance. As Sara Britton and I drove home from the hospital, I felt blessed. She was safe, and Duhart had come back into my life. By the time I pulled into my driveway, I knew why.

Chapter Thirty-Four

Dissecting Possible

As SOON AS I got Sara Britton settled and she was fast asleep, I slipped from the house and drove to Books-A-Million to search for a book about my mother-in-law's disease. I was exhausted from our bone marrow event but didn't care. Dale was flying in the next day, and there was no time to waste. I needed to know what lay ahead for his family. Now, my family.

Dale had probably been told the gravity of his mother's diagnosis. On the phone he'd sounded broken, his voice hoarse and barely audible. I was sure he was sparing me all the grisly details, electing to end our conversation before my inquisitive mind started drilling him. Then I'd known nothing, but after two hours of reading, I knew more than I wanted.

It was a frightening prognosis. I thought about booting up my laptop on my bedside table to search Google but changed my mind. I was already overwhelmed from reading the book.

Lou Gehrig's disease, also known as amyotrophic lateral sclerosis, or ALS, is a progressive neurodegenerative disease affecting the nerve cells in the brain and spinal cord. *Amyotrophic* comes from the Greek language. *A* means "no," *myo* means "muscle," and *trophic* means "nourishment." No muscle nourishment. When a muscle has no nourishment, it atrophies, or wastes away. I read that ALS attacks

only motor neurons, so a person's sight, touch, hearing, taste, and smell are not affected.

But the book said that once the disease starts, it most often progresses, and eventually a person is unable to walk, dress, write, speak, swallow, or breathe. I was stupefied. The average life span postdiagnosis was three years. *Oh God!*

Marcia lived alone. Dale, Jeff, and Mary Ann—her three adult children—worked full-time running their family business not far from the house where she lived, the house where they all grew up. How could they care for her? Especially Dale, who was still splitting his time between Tallahassee and Indianapolis. How could he keep doing *that?* Would he ask me to move to Indianapolis? I'd vowed to be with him for better or worse. Was this the worse?

I had been spending more time in Indianapolis. Two or three weeks there, then two or three weeks in Tallahassee, back and forth. By the time he arrived the next day on the 5:52 p.m. flight, an idea had seeded in my brain. I was anxious to share it, but when he threw his briefcase in the backseat and slipped into the front passenger seat, I read his mood. He was spent, somber, and sad. I swallowed my words as he leaned in for a kiss.

"How's Sara?" he asked.

"Better. She's doing good." I reached for his hand. "You okay?"

"Let's go see Sara. I've been worried about her, about you," he said.

Our usual routine when Dale took the late-afternoon flight was to grab dinner on the way home from the airport. But nothing seemed usual that day. "Let's go home, then," I said.

He was quiet as I drove east on I-10 toward home. I glanced over and noticed the dark circles under his eyes. I knew worry, travel, and too much alcohol on the layover in Atlanta were the culprit. I also knew Dale was pulling inward. He needed to refuel, dissect, and solve the unexpected, catastrophic crisis impacting his mother's life. Not to mention the lives of everyone who loved her.

I was trying to stay quiet, not run my mouth. Noise was my go-to modus operandi to make myself comfortable in an uncomfortable situation.

"I ran into Duhart at the hospital," I said, breaking the silence, and looked over for a reaction. His head was bobbing. He was fast asleep.

~

Dale's persona was something I never understood when we dated decades earlier. Looking back, I realize I was a flighty, immature, self-indulgent young girl. When Dale was quiet, it drove me smack-dab crazy. He would drive for an hour, lost in thought, and not say a single word. I wanted to scream.

My father was the same way. Who, by the way, I adored. But he, too, would sit for hours reading or watching television, not saying anything as I sat beside him. I would try to think of something, *anything*, to talk about. It was exhausting. Clearly, I was the daughter who needed interaction, noise, and intimacy. All synonyms for attention. I got too little from my father and too little from Dale.

Only when I was older would I understand them. My father needed evenings to unwind from working long hours as a physician, listening to his patients all day long, performing intricate surgeries, and worrying about his payroll, our family, and the future. His pleasure was not chitchatting about nothing with me.

And Dale, well, he had the brain of a mathematician, a scientist, an inventor, and later, a technophile. I wouldn't know it until I was smart enough to know it. And that was when we reconnected in Memphis, thirty years later.

They say girls marry their fathers. But I was different—I didn't want to marry my father, or anyone like him. Maybe that was one reason Dale and I didn't end up together when we first dated.

*An introverted boy meets an extroverted girl, which creates confusion,
indecision, fear, and flight of the girl.*

I'm not proud to write this, but nonetheless, it's true.

❧

I pulled into our driveway as Dale woke up. He was inside the house
almost before I'd turned off the ignition. I found them side by side
on the couch, her head on his shoulder. He was asking Sara Britton
about her procedure; she was asking about his mother.

I ordered pizza and poured myself a tall glass of wine, then
joined them in the living room. Since returning from the hospi-
tal the night before, I'd made Sara Britton use an ice pack on the
back of her pelvic bone where they'd collected the marrow. They
warned her it would be tender for several days and probably bruise.
I gave her arnica pellets every hour to prevent the bruising. That
was my Eastern medicine mentality I'd not bothered sharing with
the Western medicine team of doctors at Shands. Our living room
couch, rather than the bed upstairs, had become a lovely little nest
for Sara Britton. She was surrounded by a big-screen television,
her computer, iPhone, college textbooks, notebook, empty bags of
chocolate, glasses, and plates.

When I realized she was recapping everything that had happened,
I decided I didn't need to relive that scene again, so I left the two of
them alone and went to draw myself a bubble bath.

Dale found me floating in bubbles higher than the tub, my
head sticking out. He sat on the tub's ledge and took a sip of
my wine.

"She seems fine," he said.

"She is. I think she's better than fine."

"How are you?" he asked.

"I'm sick about your mother. It's so horrible."

He went into the closet to change into jogging pants and a T-shirt. I waited, trying to decide if I should tell him my idea. I knew I'd never sleep if I didn't.

"Dale, come here, please, will you?"

He walked in from the closet and stood over me.

"I think we should talk to Du about your mother," I said. "Maybe he'll move to Indianapolis to care for her."

He stared at me but said nothing. He just picked up my empty glass of wine and walked out.

I knew the quiet man had to dissect my idea. I understood him better now.

Chapter Thirty-Five

Peace and Friends

IT HAD BEEN SEVERAL months since Dale received his mother's diagnosis. Her condition was deteriorating. I began commuting to Indianapolis from Tallahassee rather than asking Dale to commute.

His family hired home health-care nurses who visited daily. His mother didn't want full-time care, though that was what she was getting with all the family pitching in.

She was still mobile but couldn't be alone at night anymore. So, her three children made a schedule and took turns spending the night with her on weekends; they hired a health-care sitter for weeknights.

Dale decided he was on board with my suggestion to bring in Duhart. Even though he'd never met Duhart, I had sung his praises for so long Dale felt as if he already knew him. Still, his mother wasn't ready for anyone to move in. So, her children continued trying to care for her themselves another month.

I kept comparing Dale's mother to Boone and my father, all given fatal diagnoses. Boone had given up the moment he received his, even though I hadn't and kept chasing the end of the rainbow. But Marcia was different. She accepted her diagnosis and seldom cried or looked sad. She went about her business, enjoying her children's love and attention. Both Boone and my beloved father, who

battled metastatic brain cancer, would stare into space for hours, looking pained and worried. It was hard to watch, wondering what they were thinking. And I never knew what to say to either one of them. Dale's mother was different. She stared into space, but she had a peaceful stare.

What is she thinking? I wondered one day when I looked up from reading my book and glanced her way. Out of the blue, she said, "I'm just so happy Dale found you, Prissy. He won't be alone." And there was my answer. It gave me peace as I watched her grow weaker by the day.

~

It was May and Indy racing season again. I elected to spend another month in Indianapolis, helping Dale and his family any way I could. I hated leaving my own mother, and my daughters hated me leaving them.

My time in Indianapolis became harder and harder. All the painful memories of Boone's diagnosis, disease, and death resurfaced. Soon, I was having this recurring nightmare, waking in the middle of the night in a panic, wet with sweat.

"Wake up, you're having a nightmare," Dale whispered, holding me. He rubbed my back until I fell asleep again.

The next day he asked, "What was your nightmare?"

"I don't remember." I couldn't tell him or anyone then. But it was always a variation of this: Boone was alive and had never died. He was looking for me. When he couldn't find me, he found our girls. They were afraid to tell him I was remarried. Everyone was afraid to tell Dale that Boone was alive. But worse, everyone said I had to choose.

Based on what I've learned since but didn't know at the time, I had some form of PTSD. Just like my terrors that rose over Dale's

health and then Sara Britton's at the hospital, Marcia's diagnosis and deteriorating condition sparked my buried trauma.

How could I tell Dale I was dreaming about my dead husband, with every scene streaming in vivid color?

I hadn't made any friends in Indianapolis. I'd met a few lovely ladies, but they worked full-time, so I seldom saw them. I wanted to find some sort of job or volunteer work, but I was helping with Marcia during the days and spending what free time there was with Dale, then flying back and forth to check on my mother and daughters.

Marcia was always cold and so thin. She kept the house very warm during the day when I visited. Since Mother's Day was around the corner, I decided to buy her a nice, warm, cashmere robe, thinking if she was warmer, I could turn down the thermostat and I would be cooler.

I pulled into the parking garage off Maryland Street and found a spot right next to the Nordstrom basement door. I beelined to the second floor and straight to the lingerie department. It was an easy choice; they had only one style. I paid and was waiting for the kind but very slow salesclerk to finish her wrapping. I wanted to snatch it from her and do it myself, but she was doing such a beautiful job.

I heard my stomach growling. In my hurry to get downtown, I'd forgotten to grab the protein shake I'd pulled from the fridge. A delicious aroma drifted from the Nordstrom dining room, one of my favorite solo hangouts on a lonely day. The thought of their tomato bisque soup with house-made croutons made my mouth water, and I found myself heading that way.

I slipped into the same booth I usually sat in, said hello to the waitress who usually served me, and stared out the same window at the same tree. Another lunch alone. I was so homesick, and there was nothing I could do about it. I signed my credit card receipt that Bella, my waitress, had left on the table. I liked her and left a tip for

more than my soup cost. It wasn't her fault I had nothing but soup.
She was counting on tips, and I liked her smile.

I noticed a group of women hurrying in, laughing, and carrying
gift bags. They reminded me of my girlfriends back in Tallahassee. I
watched from my corner across the dining room, missing my friends,
lunch gatherings, everyone in Tallahassee. I wished I could go over,
say hi, introduce myself, and ask to join them for lunch.

My God, Prissy! It's not middle school, and this is not the cafeteria.
I grabbed Marcia's gift-wrapped robe and left.

Living in Indianapolis was so different. The "friendless" Prissy
was foreign to me. I liked having friends. More important, I needed
to be surrounded by them. They had always carried me through my
darkest days.

I loaded Marcia's gift in my trunk and sat in the Nordstrom
parking garage for a few minutes. I wanted to close my eyes before
fighting the traffic home. Well, the truth, I wanted to give myself
a five-minute pity party. After all, I *was* friendless, lonely, and sad
from watching poor Marcia struggling with ALS. I drifted off for a
moment, listening to the lyrics streaming from my car radio.

By the time I opened my eyes, I knew what I should do. And
right there, on a Friday afternoon, I made the decision. I would
find a way to be happy *here*. How fortunate, blessed, and grateful I
was to have more family to love. To spend more time with the man
I loved. To help him navigate through such pain and heartache as
he watched his beloved mother battle one of life's worst diseases.

*Get over your selfishness, Prissy. Dale needs you, and more than
anyone else in this world.*

I wouldn't know it yet, but it was a turning point in my life.
Funny how that works.

Chapter Thirty-Six

Missing a Screw

I PULLED OUT OF the Nordstrom parking lot feeling better. I decided to stop by O'Malia's Food Market to shop for something special for dinner. I lingered in the market with no appetite, trying to decide what Dale might like. He'd been super stressed and even quieter than usual. I had to cheer him up.

I decided on chicken piccata, his favorite, and gathered all the ingredients and threw them in the cart. I knew Dale would be feeling down after he visited his mother. In the South, comfort food is the best medicine to feed sadness. I planned on giving him a big dose of that medicine as soon as he walked in the door.

My chicken piccata was simmering as the aroma of lemons and capers sifted through the air. I prepared Giada De Laurentiis's recipe, one of her many I'd collected in the last year.

Everyday Italian streamed from the Food Network on the TV in the living room. The sultry hostess, with her revealing cleavage, had become my favorite chef. On her thirty-minute show, she created magic using very few ingredients. Besides, Italian food was also my forte.

I washed the fresh spinach and was watching the day's preparation: summer cocktails and poolside entertaining. Giada was preparing and sipping, preparing and sipping, making me lust for what she was

sipping. She had made the Destroyer, her acclaimed specialty cocktail. It was a tequila-based drink with an Italian twist. The ingredients included tangerine juice, fresh basil, and an orange peel. The crackling, fizzing sound of the ice cubes was the culprit that drew me in.

I didn't have the pool, but I had glasses, booze, and ice. I would make a cocktail and pretend to be Giada. When it came to cocktails, I was pretty much a virgin, preferring wine. I remembered my father teaching me how to make his Smirnoff and grapefruit cocktail. I had that drink down pat…maybe too pat. But my cocktail knowledge pretty much stopped there.

If I ever did order a cocktail, there would be a *too* lengthy discussion with the bartender or server before I ever made up my mind. I annoyed myself, not to mention whoever was dining with me.

I stared at my choices of alcohol neatly arranged on the wrought iron bar against the living room wall. There were four to five bottles of liquor on the bar but no tequila. I would improvise. Two bottles had handles—Jim Beam and Crown Royal. Good grief, they looked too heavy to lift, much less pour without spilling. Next to them was something wrapped in a purple velvet sleeve; it captured my eye. I unwrapped the gold tie around the neck of the bottle and was surprised to see another Crown Royal. But this one looked much easier to pour.

It had never been opened, so I slid my knife through the stamped foil, twisted off the top, and splashed some over the crackling ice. I added sparkling water, lime juice, and cherries to finish it off. It was delicious, so smooth. Maybe I did like cocktails after all. I wasn't Giada, but I sure felt like her.

I was relaxing after preparing dinner, just lounging on the couch and enjoying my second cocktail. The local news was turned low, flashing a mug shot of the latest criminal they were searching for in downtown Indianapolis. I was skimming through the *Indianapolis Star* when Dale walked in.

"Something smells great." He leaned from behind and planted a kiss on my head. "Is that liquor? A drink?"

"Yep, my newest invention—it's really good."

He walked into the kitchen. I kept reading an article about the Indianapolis Art Center.

"You opened it?" he asked.

"Opened what?" I was half-listening.

"This! Did you see the one already opened right next to it?"

I turned around to see what he was talking about. "Yeah, that other bottle with the handle was heavy." I turned back around and kept reading the paper, my back to him. When he didn't respond, I turned back around.

He was still holding the purple velvet pouch in one hand, the bottle of Crown Royal in the other.

"Big deal, we have two bottles opened," I said. *His day must have been worse than mine*, I thought.

"My dad gave me this before he died. It's a 1948 bottle—worth about fifteen hundred dollars the last time I checked."

"Why was it sitting there? I didn't know."

"Why would I tell you? You've never poured a drink from anything on that bar."

"Well, I'm sorry I just did!" I looked down into my glass of liquid gold and took a gulp. "Three hundred dollars," I said. Then another gulp. "Three hundred."

He started laughing. "You better call Nancy and warn her about the bottle I gave Jim."

Nancy was my dear friend whose husband, Jim Giroux, passed away rather suddenly. He and Nancy had visited us in Indianapolis. I learned (only then) Dale had given Jim the other bottle from his father. It was a 1946 and decorated the same: a purple velvet pouch.

"You think Nancy knows how much that's worth? You think Jim ever told her?" I asked.

"Well, you didn't. Why would she?"

I dialed her number in Tallahassee, but it was too late. She had given her bottle to her daughter to take to a Florida State tailgate party. She and I blame both husbands to this day. You can't know what you aren't told, right?

It's a tale for sure. Dale still brings it up in conversations. He has a pleasant disposition, patience, and a logical mind. In his mind, with his personality, what was done was done. There was no changing it. Besides, I knew when he was mad. I'd seen it for myself a few months earlier. Lordy!

It happened when I discovered I needed—or rather wanted—a desk with more drawers since mine had only one.

I called Dale at work. "I think I'll look for a desk today. Where should I go?"

He sounded busy but gave me a few store recommendations, their locations, and directions.

"Get what you want, but make sure I don't have to put it together," he said.

"Put it together…what are you talking about?"

"I mean please don't buy anything unassembled."

"Okay, okay," I said then hung up.

I headed off to the first desk store on my list Dale had given me. I found a desk that worked on the first try. It had four drawers and was nice enough but nothing special.

"I'll take this one," I said to the anxious salesman. "When can you deliver?"

He checked with delivery and came back. "How about this afternoon around four o'clock?"

"Okay, but it'll be this one and not one you have to put together, right?"

"Well, we can't sell you this one, ma'am. They come in boxes."

"To put together?" My heart skipped. "No, I can't get anything to put together."

"The deliveryman will put it together," he guaranteed. "He can be there at four o'clock."

"He needs to come earlier before my husband gets home; he'll kill me."

He made another call back to delivery. "They can deliver in an hour," he said. The man must have taken my "killing" remark literally. It was eleven thirty a.m. I raced home to beat him. Except he didn't show up, not at one, two, three, or even four o'clock. It was a quarter past five when he delivered the stupid desk. And Dale was usually home by five thirty.

I looked at my watch. "How long will it take you to put it together?" I asked.

"Hour thereabouts," he mumbled.

"Absolutely not, there's no time for that. You'll have to come back tomorrow." I was miffed. "Just bring it upstairs, please." I had him place the heavy box in the corner of our closet. It wasn't in the way but wasn't out of sight.

Dale was pulling in as the deliveryman was driving off. "Hey, got your desk, I guess," he said. "How long 'til we eat?"

"Not long, maybe an hour."

He had already sprinted upstairs to change before I could tell him about the desk and the man coming back to assemble it.

Twenty minutes passed, and he'd not come back downstairs. I heard banging and swearing. I hollered up to him, "What are you doing?"

"I'm putting the damn desk together," he yelled down.

"Don't touch it. They're coming tomorrow. Now come eat." He didn't answer or come down. Thirty minutes later I hollered again. There was no way I was going up there.

"The food's getting cold, Dale." No response, just some swearing. A lot.

It was sometime in the second hour I heard a loud crash outside. I opened the back door, and there was my desk I had yet to pay

for splintered in a hundred pieces all over the driveway. Dale had thrown the whole caboodle out the *third*-floor window. He got to the very end, and it was missing two screws.

He came downstairs beaded with sweat. "I told you not to buy anything I had to put together."

Trust me, I never have again.

Chapter Thirty-Seven

The Color of Chance

It was Saturday morning. I'd slept in longer than usual and came downstairs to see Dale sifting through the newspaper. "Morning," I yawned, heading toward the coffee pot.

"I have an idea. Why don't you take a class?" Dale said.

I could tell by his hyper voice he'd already had a pot of coffee.

"On what?" I wiped the spilled sugar off the counter.

He kept chatting through his read. "You always liked school."

I poured my coffee from the fresh pot he'd made and splashed in some organic milk. "Yeah, I always did love school, you're right. Remember that time I took that final for you at FSU?" I asked.

"Oh yeah, you aced it. What was it? I don't remember."

"Sociology, I think…yeah, that's what it was."

When he was at FSU, I didn't need an ID to take his exam. I was an English, science, and sociology nerd. So, yes, I took the sociology test since he hated the subject. A girl does that for the guy she loves, right? Wrong, Prissy. I think they call it cheating.

His voice snapped me back. I heard him going on about whatever he was reading. "It says here they have a writing class at IUPUI…only six weeks long, you should take it."

Did he know I didn't care? I took another swallow of coffee and started reading the book-review section of the paper.

Indiana University–Purdue University Indianapolis was two blocks from the house on Walnut Street where we lived. Last year, after Dale brought home the computer for me, he never stopped encouraging me to write, especially those weeks I was in Indianapolis wandering around the city alone.

"For the umpteenth time, I'm not a writer, honey, and those are all college kids," I answered him between sips. I knew he realized I was homesick. He just wanted to fix it. Rather, me.

"I've had your poems stacked up; you are a writer."

"I'm not. I just like rhyming words with senseless stuff. Creative writing is another animal."

He tore the ad from the newspaper and waved it in my face. "Just think about it."

I skimmed the clip, then stuck the paper inside the pocket of my terry cloth robe. I poured another cup of coffee, hoping this one would dissolve my headache.

On Monday, I called about the creative writing class. The one during the day was already full, so my only option was the night class. That would never work. Dale was gone all day, and I only saw him a few hours at night. Even so, the next morning I walked over to the campus, wanting to convince myself it wasn't a good idea.

The moment I saw the parking situation, I was convinced. It would be way too hard to find a place to park at night. Also, I remembered a few *Cops* episodes that took place somewhere in downtown Indianapolis—at night.

❧

Two days later I was in the middle of brushing my teeth and recalled my pity party—my "you are a loner" moment watching the lunching women in Nordstrom. I'd told my daughters all their lives that happiness comes from within. I would practice what I preached.

I brushed my hair and twisted it into a bun with my favorite clip. I unboxed the new lipstick and complementing liner the Nordstrom salesclerk talked me into buying. I had decided if I was going to miss the party upstairs, I was getting a party favor downstairs at the cosmetic counter. Studying my reflection, I applied the liner and then my lipstick. That salesclerk was right; it did give me more color. I smacked my lips and applied two layers of mascara. With a quick spritz of my Flowerbomb perfume, I was ready to go, at only eight thirty a.m.

I was two coffees down and into my third as I headed north on College Avenue toward Sixty-Seventh Street. College Avenue and Meridian Street were also the names of two major roads in Tallahassee. The roads I frequented most often in Indianapolis were the same as in Tallahassee. It seemed more than coincidental, perhaps serendipitous.

The traffic was moving slower than I'd estimated. I was stopping at countless traffic lights and feared I'd be late. But I was not taking that crazy interstate. No way.

I saw Sixty-Seventh Street ahead and turned on my right blinker. I pulled into the shaded parking lot, with butterflies swarming in the pit of my stomach. I had no idea what I was doing, but no matter, I was doing it anyway.

It was somewhat of a dingbat decision, deciding to take art rather than writing. I was more interested in writing. But the horrible parking at the university, not to mention the class was held nights, well, that just wouldn't work. I barely saw Dale as it was. Art could feed my soul and fill my days when I was in Indianapolis. Besides, surely I would meet some interesting people even if I had no talent.

When I pulled in front of the sign that read Indianapolis Art Center, I knew I'd made the right decision. Their parking was so much better. Art class trumped writing class based on the parking, sort of. The lot was only half-full as I unloaded my supplies. They

had sent me to their website recommending what I needed before my first class. I'd never taken a painting class before. But I loved art and art history and thought I'd give it a try. *Who knows, the worst that can happen is I say I tried, maybe make a friend, and call it a day*, I thought. I took a deep breath then walked through the door.

I counted seventeen other students. Their easels were set up around the room with the early-morning sunlight spilling in from outside. Nobody looked up or even noticed I'd walked in.

There was an empty easel in the second row toward the center of the room. I decided it would be best if I sat right in front of the instructor. The class was called Introduction to Oil, but from looking at everybody, it appeared I might be the *only* one getting introduced to painting.

Everyone seemed to know what they were doing. I was a nobody looking for somebody to teach me something. I'd begun reconsidering the parking at IUPUI when the instructor approached. Little would I know how enlightening our meeting would be. I couldn't know she would help me uncover untapped talent trapped inside of me. Or, one day soon, I would be painting children, landscapes, barns, and pets. Only because they happened to have better parking and morning classes.

Gathering Salvation

DALE CLIMBED INSIDE MY idling car as I waited in front of the airport. He had flown to Tallahassee with an intention other than just to see me. He wanted to meet Cornelius Duhart. Dale's poor mother was worsening at a rapid pace, and the family needed help.

Dale was quieter than usual and had black circles and bags beneath his eyes. The pressure of business and his mother's deterioration were taking their toll. As I drove east on I-10, he started snoring. Ten minutes later I pulled into the parking lot. He didn't wake up, even when I turned off the ignition.

I tapped his arm to wake him. "Okay, are you ready?"

He popped up with bloodshot, dazed eyes. "I fell asleep?"

"Yes, you sure did."

Duhart and Sallie were waiting inside Marie Livingston's Steakhouse. From the moment Dale shook hands with Duhart, their friendship began. It was as if they had known each other in another life.

"Christy, how you been?" Sallie hugged me. "And how you do?" she asked, her right hand reaching out to Dale, but he leaned in to give her a hug.

"Christy done trained you," she said.

I knew Du and Sallie well enough to know they'd probably been rehashing the whole Dale and me story as they drove to the

restaurant. They adored Boone and grieved his death. Much like Garrett, they weren't comfortable seeing me with another man. But I could see a softening when they met Dale.

We ordered our food, and Dale began asking about their families, children, and lives.

After they'd talked awhile, Du said, "Mr. Dale, tell me 'bout your mother."

"It's Dale. Call me Dale, please."

Dale talked about his mother with a guttural rawness in his voice, like he was holding back tears. I listened without interrupting. It was his story to tell. My contribution was introducing him to Cornelius Duhart, one of God's angels. Sallie just happened to be his sidekick. This remains the greatest gift I've ever given Dale.

By dessert, Du and Sallie were moving to Indianapolis. And neither of them had ever crossed the state line. No matter the Georgia line was only twenty minutes from where we all lived in Tallahassee.

Sallie, the family financier, had a few requests before they could leave Tallahassee though. First, she and Duhart needed to secure their property. They planned to do this with a chain-link fence around the quarter-acre property that housed their mobile home. Second, they needed a wooden shed to lock up all the lawn equipment, outdoor furniture, pots, and more. When all was said and done, Dale was $10,000 poorer than when we'd walked inside that restaurant. But he was also much richer. Duhart and Sallie were coming to Indianapolis, and they were *priceless*.

The day before Du and Sallie arrived, Dale and I sat with his mother. She had a favorite rocking chair, so they made a place for it in the dining room. From there she rocked and observed the comings and goings of everyone. As I watched her stare off into space, I wondered if she was worried about the strangers who would soon be moving into her home. Mainly, a man—Duhart. Then, out of the blue, she asked, "What if they don't like me?"

I jumped in before Dale could answer. "Are you kidding? They will gobble you up with love." I started laughing. "I was sitting here wondering if you would like them, and you're worrying they won't like you." Her smile beamed relief as I held her hand.

❧

It was a warm July day when Du and Sallie pulled into Marcia's driveway. Everyone in the family was at the house waiting to welcome them: nieces, nephews, brothers, and sisters. I had shared so many stories about the pair; everyone was eager to see who the characters in my tales were.

We all grabbed something from their overpacked car. Sallie's hats alone took up the entire backseat. I counted fourteen. They had three suitcases each, and it would take us an hour to get them all settled in downstairs. It was a perfect setting for them: living room, bedroom, bathroom, and tiny kitchenette.

As the women in the family prepared the festive food for our welcoming dinner, Dale and I sat downstairs and visited with Du and Sallie. Dale was bringing them up to speed on his mother's condition, what she needed—the whats, hows, and whens of keeping her alive and comfortable.

I wasn't sure what I expected when they arrived. After all, the last time we had all been in our living arrangement, Boone was dying. Then he was dead.

Soon dinner was ready. We went upstairs and sat at the long dining table, everyone laughing, telling stories, and getting to know one another.

After the dishes were cleared and loaded in the dishwasher, I went in to say goodbye to Marcia. I found Du fussing around her, straightening her bed, organizing her medications, and laughing out loud. She was smiling. I felt a sense of relief, something I'd not had in a long time.

I had been going over daily and smothering Marcia with my "What can I do?" every few minutes. Not to mention my babbling when I was uncomfortable.

Now *they* were in charge, knowing what to do and how to do it. Caregiving is so emotionally draining and physically exhausting. This world you find yourself in taxes you spiritually, to say the very least. But if I thought my load was lightened, I was wrong. I was unaware how Du and Sallie's arrival would affect me. I would discover only a few days later. It all started with a phone call.

"Christy, you comin' today?" Duhart asked. I felt guilt crawling up my spine.

It had been several days since I'd been over. It was so hard to go and sit with them as they sat with Marcia. It was throwing me right back to the time when Boone was dying. I wasn't sure if they were calling for themselves or for Marcia. With Du and Sallie now living there and caring for her twenty-four, seven, I planned to pop in every other day for a visit. That was the point of having them, I'd told myself. In hindsight, I was delusional. It was just the opposite. They wanted me with them all day, every day, like when they lived with the girls and me. I realized Duhart and Sallie were homesick, far away from family and friends. They were like me. Only I reminded them of home, while they reminded me of loss.

"I sure am—be there soon," I said. What else could I say? Do? I hung up and called my art class instructor and explained my situation. She offered a refund. I knew what my job was now. The most important thing I could do for Dale, his family, and Marcia was to keep Du and Sallie happy. For them to stay, I needed to change my game.

I told no one how difficult it was for me, being around Du and Sallie. The painful memories deep in my soul were triggered. I was dragged back into an arena of suffering and despair. Déjà vu became my shadow and companion. A different city. A different disease.

A different hopeless being. I knew I needed a distraction if I was going to relive my heartache. I drove to the nearest art supply store and bought myself an easel, several canvases, a set of good-quality brushes, a few palette knives, and a toolbox filled with paint tubes. I threw in a few how-to books on painting, paid, and left.

From then on, I dragged my supplies back and forth each day to Marcia's house. As the rest of the family worked the business full-time, we visited, laughed, and told stories as Du, Sallie, and Marcia watched me paint. Today, as I look around and see some of those very paintings hanging on my walls, I am reminded of those days, the good, bad, and ugly. Yet I know it was part of my journey. Painting was another gift from God, waiting to be discovered and nurtured. When I decided to embrace what was—not what I wished—positive things happened. I became an artist. Not famous, but good enough for admirers to want to buy them. And all of it happened by accident, as many things often do.

Thanksgiving came and went, and then it was almost Christmas. Dale and I decided I would fly back to be with my family for Christmas, while he would stay in Indianapolis with his mother, Du, and Sallie.

When I left Indianapolis, his mother was stable, rocking in her chair. However, on December 30, the unthinkable happened. She died in the arms of Dale while Du and Sallie stood next to them. It was sudden and unexpected. I had watched Boone dying for a year. Marcia had been diagnosed only nine months earlier.

I believe she willed her own death. She no longer wanted to burden her children. I was so grateful I wasn't there to witness it, the setting so like Boone's. I flew back up to Indianapolis. At the memorial service, Duhart was the most popular man around. Everyone over the age of eighty wanted to meet him, asking if he would ever come back should they need care. They pretended to be kidding, but I knew they weren't.

Later, as the crowd thinned, Du strolled over and whispered in my ear, "You got any chicken bones in your pocket, Christy?" We were both hungry.

"If I did, I'd be gnawing on them." We started laughing, and once we started, well, we couldn't stop.

He leaned in and whispered, "Somebody should teach these people 'bout Southern funerals and food."

"*Food and Funerals*, I should start a blog." We stood together, his arm around my shoulder, and somehow, he managed to lighten my heavy heart again.

Chapter Thirty-Nine

Tales to Tell

AFTER SAYING GOODBYE TO Du and Sallie, I stayed another two weeks in Indianapolis. Paul and Mary, our good friends from St. Louis, spent New Year's Eve with us. Chef Paul, as we liked to call him, prepared a fabulous feast, and together we brought in the New Year. Of course, it wasn't celebratory by any stretch of the imagination. But dinner was a delight, and we were grateful for a reprieve from such doom and gloom.

January brought more gray skies and frigid rain. I thought I'd cheer up Dale with second-row seats to a Michael Bublé concert. But it was a total bust. Dale was with me in person but not in spirit.

On my last night before flying back to Tallahassee, Dale said, "Let's go have a romantic dinner somewhere," and mentioned the name of a restaurant I didn't recognize. "I'll do better, be better, have more fun tonight," he told me. "I promise."

"My goodness, your mother just died. You can't have fun. Let's just stay home."

"No, we're going out. Now go get dressed."

I yanked something black from my already packed bag, applied fresh makeup, and slipped the sweater dress over my head. I pulled my suede boots over my black wool socks as the wind whistled outside our bedroom window.

My purple cashmere scarf was thin, so I wrapped it around my neck to give some color to my pasty-white complexion. I grabbed my small black suede purse. It was only large enough to hold my driver's license, lipstick, and hand sanitizer.

As we drove through the vibrant stretch of downtown, my mood was lifted by the shimmering streetlights. The store windows were still bedecked with elaborate Christmas decorations and twinkling trees. It was a relief to feel good, even if it was only for a little bit.

Christmas in January is just as good, I thought.

Dale turned off South Capitol Avenue into the Hyatt Regency and valet parked. He'd never mentioned a restaurant inside the hotel, so I was surprised this was the "romantic" choice for dinner.

The doorman opened my door and helped me out. The freezing wind almost blew me down.

"What restaurant is here?" I hollered through the noise of the wind. Dale was handing off his car key.

"You'll see."

We crossed the lobby and stepped inside the elevator. I watched as Dale pushed number 22.

"Ugh, please no, that's too high."

"It's fast, you're fine," he said. I knew I was a pain but didn't care.

I hated heights and elevators ever since I got trapped inside one when I was eight years old. Here I was with both. The elevator door let us out onto the Eagle's Nest, a revolving restaurant with a 360-degree view on top of the hotel.

"They say it's one of the most romantic restaurants in the country," Dale said.

"Look at our city." I ran to the window. It was amazing. I could see everywhere. "Wow! You did good."

He wrapped his arms around me. "Thank you for everything." He didn't need to say more. I knew what he meant.

When I ordered the herb-crusted prime rib, he shook his head and said, "I can't believe you ordered red meat."

Yes, I had come a long way in my eating since we'd gotten married. He ordered osso bucco.

We ended our meal with two desserts: crème brûlée and espresso chocolate mousse. It was a perfect night—so far.

As we were leaving, I walked over to the window to take one last look at the magnificent view. I laid my cute little purse on the ledge, not realizing there was a gap between the window and the ledge. You know, it was revolving. Seconds later I watched my purse fall into an abyss of blackness. "Oh God!" I screamed.

"It's gone," Dale said.

"It can't be gone; I'm flying in the morning."

"You aren't now."

Like a lunatic, I found and grabbed our waiter. "You have to stop this spinning. My purse fell down the hole."

The man stared at me a moment then said, "We can't, not until we close."

"What? No way. What time is that?" I was borderline hysterical. "I need my ID. It's in there. I'm flying in the morning."

"I'm sorry," he said. "The mechanic will get it when we close. Come back later."

That was when Dale pulled out a hundred-dollar bill and tore it in half, right in front of the waiter. He gave the waiter half and waved the other half in the air. "I'll give you this if you'll get her purse after closing, then deliver it to us."

"Yeah, man. Write your address here. That's a deal." The waiter grinned as he handed over a pad and pencil.

Truth be told, I never expected to see that purse again. I figured I'd be in Indy a few more days and have to get a new ID. But my cynical self was proven wrong. The waiter delivered my purse at two fifteen a.m. I was sound asleep on the couch when he rang the doorbell. He handed me the purse, and I handed him his half of the hundred-dollar bill. I slept two more hours and flew back to Tallahassee the next day.

Looking back, the atmosphere inside the restaurant was excellent, the service and view unforgettable. But it was the Good Samaritan who made it memorable. Well, him plus Dale. He has never let me forget it. It was his favorite story to tell…until he found a better one. And it trumps my purse drop.

It was sometime later—I don't remember exactly when. We'd just checked in to the Ponte Vedra Inn & Club after a full day of driving and a medical appointment at the Mayo Clinic. I longed for a bubble bath with the niceties I'd discovered in the oversized marble bathroom.

I turned on the tub water and sprinkled in the bath crystals. The aroma was lovely. I saw a cream candle on the other side of the tub, reached across the tub, and brought the candle closer so I could light it. The water had a ways to go, so as the tub filled, I went to the bedroom to retrieve my cosmetic bag. I became distracted by an interview on television and stood watching, listening, aware there was water running but knowing it was a big tub.

"I smell smoke," Dale shouted, running toward the bathroom. "Fire!" he yelled. I ran in to see the ceiling on fire and Dale yanking the lovely, *seared* terry cloth robe from the hook above my fragrant burning candle. He threw it and the burning towel into my tub of bubbles.

The bathroom sprinklers came down, spewing more water into my bubbles. Then came the door knock and the fire department. It was a disaster, to say the least.

"Why would you put the robe hook there?" I asked. "Surely I'm not the first person to light a candle and have this happen."

"Actually, you are," the man said.

"Well, how could I light a candle way over there? I couldn't even reach it."

"We will need to move you both to another room. We have a fire damage specialist team en route."

They came. We moved. To a room at the very end of the hotel, away from everyone. And that room wasn't nearly as nice as the one we'd left. Not to mention, they'd removed all the candles.

And that became Dale's favorite story from then on.

Chapter Forty

The Gift(s)

IT WAS SOMETIME IN March, and I was back in Tallahassee for a few weeks. Dale was back to commuting again on weekends. He had flown to Indianapolis earlier that morning, and I was thinking about a conversation we'd had about Sara Britton on the way to the airport. I was laughing to myself just thinking about it.

A few seconds later, I heard Sara Britton calling out. "Mom, you there? Where are you?"

"I'm back here, in my closet," I hollered. She was still living at the sorority house and loved dropping in for a visit.

I was hanging up Dale's no-iron shirts that needed ironing. Those shirt-making people were liars!

"Hey, what's up?" she asked. She was drinking a coffee from Starbucks.

"Where's mine?" I asked.

"Sorry, I should have."

"Yeah, you should…Dale brought you up today on the way to the airport," I said, pulling out the empty hangers off the clothes rod. "You know that emergency credit card he gave you?"

"Yeah, I still have it."

"And you used it at Potbelly's. What kind of emergency happens there?"

I knew all about Potbelly's after Sara Britton dragged Dale and me there one night soon after we were married to hear a local band. To say we were the oldest couple on the slimy dance floor would be an understatement. As Dale twirled me around as I held my drink in the air, I was bumped by someone. I looked over and saw my nephew's bulging blue eyes. "Aunt Prissy, is that you?" he asked, confused. It was one thirty in the morning. I was pretty sure by noon the next day he had shared with Boone's whole family that I was partying with college kids in the middle of the night. Potbelly's. Yep, I knew there were no emergencies in that place.

Sara Britton was sheepish and stammered, "Well, it was my emergency—I was out of money and wanted a beer."

I couldn't help but laugh; it was stupid funny, which probably makes my parenting skills questionable by some.

"Is he mad at me?" she asked.

"No, he laughed when I reminded him Potbelly's is a bar. You have him wrapped around your finger. Shame on you though."

I had been much like her when I was a teenager, a sneaky partyer. I knew how to find fun, or make it, if need be. Dale was a clueless, lifelong bachelor. Only now he was the stepdaddy to my offspring. He wanted nothing more than to be their friend. He wasn't interested in disciplining either of my daughters.

"You and Boone did a great job raising them, Prissy," he repeated so often.

Every parent wants to know they did a good job at their most important job: raising their legacy. But good grief, the poor man cruised into fatherhood without a single 101 class on parenting. You don't give an emergency credit card to a college kid and think they'll save it for an emergency.

Only a few weeks later, I came across an email from Sara Britton on his computer. That was when I knew for sure he was a hopeless disciplinarian. She was thanking him for sending a letter with money

for her spring break with her sorority sisters. *"...you are so generous, kind, always giving to others, the most selfless person I've ever known. I love you so much..."*

I wondered what the letter he wrote to her had said. It had to be about more than the extra spending money for spring break, but rather something memorable. I reflected on Sara Britton's own giving—of herself, her bone marrow to a stranger. She and Dale were both givers. My favorite kind of people.

❧

"Mom, I got a letter yesterday from the bone marrow people."

"Really, what did it say?" I was half-listening to Sara Britton as I was trying to organize Dale's trousers by color.

"Will you stop a minute and listen?"

I looked up to see her holding the letter. "Okay, I've stopped." I reached for it and skimmed. The letter was from the National Marrow Donor Program. It said Sara Britton's one-year anniversary for donating was approaching. Would she like to release her name to the recipient, allowing them to communicate with her? I handed it back.

"So, what do you think? Should I?" she asked.

"Of course, you should. You saved someone's life. Don't you want to know who?"

She hesitated. "Honestly, I'm not sure." It was a no-brainer for me, but she wasn't me.

"There aren't many people who do what you did for a stranger. You wanna know what I think? I say yes."

She filled out the form, left it with me, and went back to the sorority house. I mailed it the next day. Two weeks later, Katie Goettsch, her recipient, reached out to Sara Britton.

Katie was living in California and had been battling acute myeloid leukemia. She was the same age as Sara Britton and also a

sophomore in college. She, too, was majoring in elementary education. Sara Britton was her *only* match in the entire national bone marrow database.

It had been a year since Katie received Sara Britton's bone marrow donation. She was in remission and doing well. They began their long-distance friendship that very night on the phone.

Flash forward another year. Katie and Sara Britton continued to stay in touch via email and occasionally on the phone. And then the unthinkable. Katie's cancer returned with a vengeance. A stem cell transplant was her only hope. Sara Britton was, of course, a perfect match. When Katie called to tell Sara Britton, she didn't blink. "Yes, I'll help you," she said.

I'll be brutally honest—I wasn't on board. I thought donating bone marrow was generous but donating her stem cells…another hospital in another town, well…no, she couldn't do that again. Not after what happened when she'd been harvested for bone marrow. No way.

I researched the drug Sara Britton would have to take to ready herself for donating. The study on it was only five years out. In other words, that was how long they had followed individuals who took it.

"They just don't know enough about it, baby," I told her. "It might affect getting pregnant one day, or maybe the delivery, even your health." Once again, she was mute.

I called my brother-in-law who was a practicing physician at the Mayo Clinic in Jacksonville. "Please talk to her. Explain what might go wrong," I pleaded. But Sara Britton wasn't listening to him or me. She was going to save Katie, and nothing I said or did would change her mind.

Three weeks later Dale and I sat in the waiting room inside St. Luke's Hospital in Jacksonville. Two pilots sat beside me, one of them with a blue cooler between his feet, waiting to take part of my child to California. Katie lay inside City of Hope—one of the country's

largest and most successful bone marrow and stem cell transplant centers—fighting for her life. I was looking at the City of Hope brochure. Underneath the name, it read "The Miracle of Science with Soul." I realized Sara Britton was the miracle, Boone the soul. He was the very reason we were sitting inside that waiting room. Before the new stem cells were transplanted, Katie was given high-intensity radiation therapy to kill the leukemia cells throughout her bone marrow and body. The hope was the graft-versus-tumor effect of the transplanted stem cells would trigger an immune reaction against any remaining leukemia cells inside her body. Thanks be to God, and Sara Britton, the second donation worked.

The beauty of her halo is that she didn't even know she had one. That always comes to my mind when I think of Sara Britton and Katie, only because so few people know what my daughter did. But Katie does, and that's all that matters.

After it was said and done, I learned one of life's most valuable lessons: parents aren't always right. We don't know everything. Sometimes our children are smarter, braver, and more dauntless than we are. I was wrong to discourage Sara Britton's benevolence. Katie is healthy, happily married, and still in remission because of my daughter. Sara Britton couldn't save her father, but she did save someone else. And she did it twice. She's not only Katie's hero, she's mine.

Chapter Forty-One

Stitched-Up Self

IN APRIL 2010, WINTER surrendered to spring, and my birthday was around the corner. It was always a time of reflection for me. I took stock of any difficulties from the previous year, as well as triumphs and blessings. I knew I was lucky to have another year, remembering Boone had lived only to fifty-one. So, April was a grateful month for me.

I was reading *Toward a Psychology of Awakening: Buddhism, Psychotherapy, and the Path of Personal and Spiritual Transformation* by John Welwood. He was one of my favorite self-help authors, a clinical psychologist with a twist of Eastern spiritual wisdom. I had read his books for years. He helped me think in ways no one else did.

I took a break from reading to make a cup of hot tea and grab a nibble. I found a piece of bittersweet chocolate in the freezer. I slipped it into my mouth, retreated to the couch again, and went back to reading Welwood. It was in that moment, savoring the melting chocolate, I came upon a passage that served as an awakening: "Awareness born of love is the only force that can bring healing and renewal. Out of love for another person we become more willing to let our old identities wither and fall away."

I read it again, and once more. My eyes were watering. I closed the book and rubbed the cover, analyzing. I shut my damp eyes,

flashing to thoughts of me, past and present—who, when, and how I'd changed. More important, why. It was as though the passage was written for me.

In the aftermath of Boone's death, I retreated within my own being to search for answers—mainly, how to find joy again. I elected to pull out my combat boots and go to work rediscovering my original self, the girl who was forgotten. Little by little, day by day, came strength and resurrection.

I gifted all my beautiful, ladylike jewelry to my daughters and began to replace it with funky, one-of-a-kind treasures made by local artisans. I wrote a poem to each of them when I gave away my jewelry from Boone. They would remember my written words more than the spoken ones.

How I love my little girls
I dressed each day with bows and pearls
The years have passed & now you're grown
A gift from me is yours to own
Please enjoy this jewel I wore
It's yours to have forevermore
Pass it down in years to come
As yours grow up from little ones
Should you want to sell for money
I give my blessing, precious honey
As now I know life's true treasure
It's my daughters who give the pleasure

Then I donated all the clothes and shoes that stifled me and replaced them with the boho-chic style I loved. I joined a Tae Bo class and kicked ass three times a week. And after almost three decades spent with one man, I entered the dating world.

When I reunited with Dale, it was easier. He knew the original me, and it was liberating. His encouragement to do what I wanted and be who I wanted was a gift, a blessing.

"What's happening to Mom? Who is *she*?" Dale overheard Garrett asking Sara Britton soon after we reunited.

"She's who she was when I knew her," Dale cut in.

"Well, she's not the mother we know," Garrett snapped.

And she was right. I know it was so hard for her to watch me change before her very eyes, as well as everyone else's. But I was ready to reclaim myself and choose *my* happiness, even if it made everyone else uncomfortable. Dale encouraged me.

I wanted my girls to understand so they might better understand themselves one day. Anne Morrow Lindbergh said it beautifully in *Gifts from the Sea*: "We long, to give where it is needed—and immediately. Externally, a woman spills herself away in driblets to the thirsty, seldom being allowed the time, the quiet, the peace, to let the pitcher fill up to the brim."

I lived as two people. Or maybe I was layers deep, peeling them off in sheets. Could they understand this?

When I enrolled in the art class, I discovered not only painting but also confidence. And with that, my artistic talent emerged. Soon I relaxed into the person I was comfortable being. But to everyone who knew me, I was a foreigner. A stranger unveiled. She looked like me, yet she wasn't.

Many believed Dale changed me, but it was just the opposite. He did nothing at all except let me find my own way. And that made all the difference in the world.

Chapter Forty-Two

The Long Road

It was April 20, my birthday, and five decades of my life had gone by. It was a rather significant one as birthdays go; a new decade was upon me. By then Dale and I had been married ten years.

I stretched my arms behind my head, touching the headboard. It was my usual morning routine. I grabbed the mobile phone next to me on the bedside and opened my *Jesus Calling* app to read the daily scripture. When I finished that, I opened four other apps I always read before my feet touched the ground: *Daily Horoscope*, *Secret Daily Teachings*, *Buddha*, and *Headspace*.

When it came to *Headspace*, I was a bit of a cheat. I knew I was supposed to be on the floor or sitting in a chair, breathing in and out, counting, blah, blah, blah. Still, I never ventured from my flat, horizontal position in bed. If they only knew.

The white noise from my sound machine purred as early-morning sunlight spilled through a small opening in my silk curtains. I slipped out of bed and pulled the curtains wide open. I liked watching the birds and squirrels sweep over the concrete balusters and scurry around the Mexican tiles outside my house.

I looked at the bedside clock. Only 7:12 a.m. I climbed back under the warm sheets and waited for a sign of movement outside. Soon a squirrel and two birds appeared. They never disappointed me.

A tall palm tree towered above the porch, brushing the tiled roof. The lush green fronds contrasted against the clear blue sky, still soft from the early morning.

I watched billowing white clouds move slowly behind the tree. I thought of Boone living somewhere up there. I can't be sure why it happened, but something stirred, a yearning of some sort, as I lay under the covers watching two birds flirt.

To this day, I believe God enveloped me, filling my entire being—heart, mind, and soul—with this invisible gift. In the blink of a moment, I knew I was going to write what had been seeding in my head for years. The urge intensified the longer I lay there, as though the story was sprouting and working its way out, writing itself. I climbed from bed and knew what I had to do.

Dale had been up for hours. He was always an earlier riser than me. He must have heard me, since he was holding my cappuccino in his hand.

"Happy birthday." He wrapped me in his arms and kissed my parched lips as I reached for the coffee.

"You're the best. Thanks," I said.

We liked sitting together in the mornings, sipping coffee, talking, strategizing, and listening to each other. It was the only time Dale was chatty. I'd learned to take advantage of that time of day. We joked it was our morning conference meeting.

"Well, birthday girl, what do you want to do today?" he asked.

I pretended I didn't know what was cooking. He, Garrett, and Sara Britton had a surprise party planned for me later. I had snooped on his computer for the evidence. I mean, seriously, a girl must be prepared with lipstick if hordes of people are showing up to surprise her, right? My conscience was clear.

"I think I'm going to the bookstore."

"The bookstore, really?"

"Yeah, well, don't faint. I might start writing, really writing. We've talked about that since we met, right?"

"That's great. About time."

I drove to Books-A-Million, wondering if I would find what I needed. I had no idea how to begin, stringing words into sentences, paragraphs, pages, chapters, a book. But I figured, how hard could it be? I had a story to tell. But the only writing class I'd had was in high school. And frankly, I didn't remember it.

Saturdays at bookstores are always the busiest. The parking lot was packed, so I drove in circles waiting for someone to leave. Finally, a mother with her two whining children came out. I waited for them, my blinker blinking to turn into her spot, everyone going around me.

I watched as she strapped both children into their car seats. She looked so frazzled. I envied her and those wonderful days, the very ones a mother thinks are so miserable as they live through them.

That April was colder than usual in the panhandle of Florida. When I entered the store, the heated air inside swept over me. I walked straight to the coffee station and ordered a large cappuccino. I watched as a girl with dozens of tattoos blanketing her flesh worked her magic.

I paid and tipped her, then began strolling the aisles one by one with my steaming cup. I was sipping, stopping, and scanning the shelves for inspiration, instruction, anything that would show me the way.

As I studied the rows of books on either side of the aisle, I asked myself, *Who is the most successful author?* Stephen King came to mind right away.

I didn't like the horror genre. But he was one of the most successful authors for sure. Maybe he had a book telling me how to write a book. I walked over to his section of the bookstore. I'd been through several rows, one scary cover after another, when I came to one called *On Writing.* It was as though God put it right in front of me. I pulled out the equivalent of a lottery ticket and tucked it under my arm.

I kept walking, thinking, and analyzing all the shelves. *Who do you like to read, Prissy?* asked a voice in my head. Anne Lamott came to mind. I loved her voice and had read most of her books. I found her section and thought, *Well, if Stephen King wrote one, then why wouldn't she?* I was an eternal optimist.

I scanned the shelves and recognized most of the titles as those I had read. Then I came to one I hadn't. I'd never heard of it. It was titled *Bird by Bird: Some Instructions on Writing and Life.* I skimmed the first pages and almost cried. It was too good to be true. Two out of two choices were going to tell me what to do and how to do it.

I knew I would never get a second chance to make a first impression. So, I kept looking for more books, just in case there were some.

By the hour's end, I had a total of five books in my shopping bag: *On Writing* by King, *Bird by Bird* by Lamott, *The Year of Magical Thinking* by Joan Didion, *You've Got a Book in You* by Elizabeth Sims, and *The 90-Day Novel* by Alan Watt. I'm still laughing about that last one.

I began my self-taught learning the next day. There would be forty-eight books by the end of four years, each one read more than once, with yellow highlights and dog-eared pages, the books marked up, bent, and worn. I had a yearning to tell my story, but only if I could tell it right.

I enrolled in a memoir writing class at Florida State University. I attended writing conferences in Los Angeles, New York, and Atlanta. I joined a writing group composed of four older, wiser women from different cultures and different stations in life. Their stories of loss and despair equaled mine, and they inspired me even more.

We were guided by a retired journalist from the *Washington Post* who drilled us like soldiers, showing no mercy with our dangling modifiers. The group soon dissolved, leaving only one writer: me.

And I was no quitter.

Chapter Forty-Three

The Magic of Side Roads

Two weeks later, when I was the only one left with Barbara, the journalist who led our writing group, I was intimidated, overwhelmed, and confused. She was older than me and had a short fuse, and her style of writing vastly differed from my own.

But she was well read and brilliant, a wealth of knowledge. I was happy to pay her to share that knowledge with me. If she'd only had a smidgen of warmth. Even so, I stayed with her another year, allowing her "voice" to swallow mine.

"Write longer sentences. Use that word. Don't abbreviate, Prissy." Most times I didn't recognize my own sentences by the time she'd finish.

It was a Saturday morning, and I had read late into the night. I was half-awake, opening my eyes, trying to focus on the clock next to my bed. It was already after nine a.m.

I rolled over onto my back and stared at the tray ceiling. I liked studying the irregular pattern of the bronze-painted strokes inside the tray. When I hired my painter, I was surprised when he asked, "Do you care if I do something different with that ceiling?"

"The ceiling…um…okay, go for it."

I figured if it turned out crazy ugly, I would paint it after he left. I wasn't going to hurt his feelings or cramp his creativity. But when he finished, I was happy.

"Look what you've done. I so love it."

He gave me a crooked smile. "Thanks so much."

The littlest things in life make such a difference. Compliments are one of those little things. If only my writing mentor had known. I sat upright in my tumbled sheets to take a sip of water. Outside, I saw a red cardinal watching me, peering inside my opened curtain I'd not closed the night before. I watched her watching me. People watching. Bird watching.

She was feasting on tiny bits scattered on the Mexican tile outside the French door. She looked down, grabbed another something, fed her tiny being, and looked back up at me. I looked beyond her to the manicured greenery and my serene water fountain inside our circular drive.

I lay back down in my bed, remembering how I'd tossed and turned during the night. I'd had a dream. It seemed real at the time. But as dreams go, it was gone. I watched the cascading water splashing from the fountain, the dream running in and out of my head, becoming clearer. Soon, it began reeling in vivid color. My past colliding with the present. I turned my eyes to the crimson cardinal. Ten minutes turned to twenty, and soon thirty, while I interpreted my dream. It seemed *so* real. I could see myself, my surroundings. I saw Boone.

I was inside a bookstore sitting cross-legged on some plaid carpeting, with a stack of books in my lap. Boone was still alive, I remembered that. I was searching for something, a book, a pamphlet maybe, anything on how to watch Boone die. What I should be doing, saying, being. I found nothing.

There were plenty of books for after it was over: death, grief, surviving the loss—the psychology, religion, and self-help books. But I didn't want to know how to survive *loss*; I wanted to know how to survive *losing*. The difference was huge.

There had to be a book written by someone who had lived through the arena of dying. *How did they do it—step by step, minute*

by minute, day by day? Please, someone, anyone, tell me. I pulled one book after another from the shelf and was crying in my dream. Soon, I was crying remembering it.

What do you say to a dying husband or wife, to children, or to the friends who don't know what to say to either one of you? There wasn't a book anywhere on the shelves for that. There had to be someone else who was ambushed by the unexpected, slapped by the reality of a loved one given only a year to live. How did they feel hearing those words, walking out of the doctor's office, driving home in silence to a life taken for granted only hours earlier? Where was a book like that? I had to know. *Please, someone tell me.*

An hour passed before I crawled from my bed and knew what I needed to do. It was as though I had been infused while sleeping. I had deciphered the message.

Reading books, attending lectures and conferences, listening to Barbara spilling her thoughts—all that was over for me. I was sick of the process of how to write. I was going *to* write. I would write what I knew, what had festered inside of me for years.

I had been on the road to nowhere. Now I would mark my own path with my imperfect footprints. A road map for anyone traveling the darkness with no beacon of light or hope. The next day I began writing *Far Outside the Ordinary*, my memoir.

I knew the story was worth writing. I had no idea how to begin, even after all my studying, classes, and money. Everyone had an opinion, each one stronger than the next. Why did it take me two years to get that? I can answer now with only two words: *no confidence.*

I asked myself over and over, *Does anyone care?* Well, if not, then it wouldn't be for anyone else. It would be just for my family. Once I said that, I relaxed, and Stephen King's two thousand words a day became my mantra. My journey began. I started my book with the day it all began, an ordinary Tuesday afternoon folding laundry. The day nothing was ever the same again.

From there it was as though the book wrote itself.

Chapter Forty-Four

Closer to Fine

My story was free flowing with an ease more frightening than flattering. Memoirists and songwriters write from deep within about love, sadness, pain, addiction, joy, happiness, rebirth, reinvention, even destruction—it comes from the lessons endured.

God and the cosmic universe helped me navigate my life and the penning of it. Pieces of conversation were nuggets of gold to me. So, I listened.

Sometimes a conversation wasn't remembered or even understood until much later. Like in the middle of the night, when I was nudged out of sleep by an "aha" moment. Starting the process of writing was a deep-rooted excavation of my soul. I was trying to make sense of my dreams, nightmares, memories, choices, mistakes, regrets, life, and most of all, me.

The act of composing and stringing my words into sentences, paragraphs, pages, and chapters was not only daunting and challenging but also exciting. Occasionally, a thought would germinate, and I would sit staring at my keyboard, wondering, *Where did* that *come from, and more important, why?* I could barely decipher the thoughts, much less their meaning.

Perhaps artists and writers are more alike than one thinks. The artist stares at a blank canvas, holding her bristle brush loaded with

paint, wondering where to begin. She has so many color options, a plethora of paint tubes. But she must choose one color first. She stares, thinks, and waits for her inspiration. Finally, it comes, and she begins. She has no idea where it will lead, how it will end, what it will be. That's the beauty and the madness of an artist.

With a writer, it's much the same as she tries to understand the flow of her words. She blends the edges, fills in tiny corners one seldom notices. She will worry the critics are lurking nearby. Is it good enough? Will it ever be?

She sees the vision with each tap, trying to capture it on the page. Sometimes, she's brave but most days afraid. Still, she refuses to retreat, because, well, she can't. She's compelled.

As I pushed through writing *Far Outside the Ordinary*, I knew I might not make the world better or different, but it would make a world of difference to me. It wasn't easy or fast or even planned. Like everything in life, the difference occurred while journeying into the unknown. I translated my internal thoughts—convergent and divergent—into words. It happened moment by moment, day by day.

The truth is, we aren't born strong, wise, or fully prepared for life. We acquire awareness, wisdom, and strength through the experience of life. I spent thirty-eight weeks dragging my dying husband on a treasure hunt and finding no treasure. Instead, he faced surgery, radiation, foot soaks, medicine men, an FDA-indicted physician from Poland, a scruffy Spanish-speaking stranger who inserted a port in his chest, and probably the worst of the lot—the barbaric treatment infused by me.

I wrote the story with the same rawness I'd felt as it happened, trying to get comfortable being uncomfortable. As strange as it sounds, I pretended an invisible person was piggybacking on me. I invited this invisible stranger inside those closed doors of that terminal diagnosis: seeing, smelling, hearing, tasting, and touching just as I did in those moments.

I traveled back, as if in a time capsule, to the darkest of my days. I let down my guard to write about them honestly, revealing my imperfections, mistakes, and regrets. Otherwise, what was the point? I wrote sad but sprinkled it with the humor lived while suffering. Spoiler alert: there is humor in life's everything: ups, downs, unexpected twists and turns, mystery, scandal, deceit, anger. Even death.

When I invited Cornelius Duhart into our home to care for my husband, a series of extraordinary events began happening, all occurring in a short timeline. Each event was out of the ordinary on its own. When woven together, the events became extraordinary. Southern crazy lived behind our closed doors.

The book wasn't about cancer, though that was the topic. It was about love. There are so many kinds of love, so many ways to love, and such a diverse population of people to love. A heart stops beating, but with medical help, it beats again. The same is true of a broken heart. Sometimes, faith, hope, and second chances heal broken hearts.

I needed to share my story for those starved of hope, perhaps living with despair. I wanted to introduce my charming caregivers and write the story of their love and devotion to my family. Their love was a lesson for everyone in paying it forward.

The story was about me, but it belonged to everyone, regardless of age, gender, or social or economic status. There are identical and universal themes for us all: loss, fear, desperation, heartache, heartbreak, aging, pain, anger, sorrow, and change, whether from the death of someone you love or other blows such as divorce, breakups, job loss, or financial ruin. The list is endless. Beating hearts don't need a category to register pain.

Life threw us some hard, unexpected curve balls. I was left reeling and without answers. I searched for help in unimagined places and discovered so many new facets of love and the real meaning of life.

Honestly, if anybody had told me I would be driving around town with a drunk, stoned man in my backseat while I begged, no…ordered him into my house for the night, I would have told them they were nuts. But sometimes, well, most times, life is what it is and not what you ask for. When unexpected things happened, even catastrophic, I was living proof you could navigate loss and find your way through the darkness. Because I had.

I was a male-dependent woman when married to Boone. When he died, I lost that identity and didn't know who I was. I wanted to go back to that Tuesday afternoon folding laundry when life felt safe. Then I met Dale. He threw my life out of balance even more. I wanted to be with him but hated to choose my happiness over my own daughter's. Would I lose her to have him?

The hard choices provide the lessons.

You miss 100 percent of the chances you don't take. So, I took a leap of faith when I chose happiness. From there I discovered me, the girl left behind, the one with buried talent, undiscovered.

It is simple to write, but it was complicated to live. I loved two different men as two different women. But I was happy being both women.

When I was married to Boone, I was a bird who wanted to fly but was never encouraged to leave the nest and try. Boone wanted his *loved* bird safe from a world of predators.

Dale was a different specimen. He nudged me from my cage and encouraged me to fly. Because he knew I could and had as a young woman. This allowed me to discover my hidden, untapped talent.

It would take two years and fourteen drafts before *Far Outside the Ordinary* was complete. After which, nothing was ever the same again.

Chapter Forty-Five

The Write Me

IT WAS A BEAUTIFUL April night when I launched *Far Outside the Ordinary*. There were 250 generous people gathered at the Carriage House nestled on the grounds of the Goodwood Museum & Gardens in Tallahassee, Florida. The estate is canopied by mature live oak trees, all of them laced with Spanish moss.

The night was beautiful and breezy, but I was as nervous as a chicken running from an axe. *Far Outside the Ordinary* sat like a queen on her throne. It felt surreal after four years of hard work.

Friends, even perfect strangers, were in line to buy my book. It meant they would be reading it—all my thoughts and words splattered under that butterfly cover. I felt totally exposed, almost naked, as they drove off in their cars later that night.

With the food table cleared, the flowers and tables broken down, the lights dimmed, and the staff gone, I climbed into my car and felt like somebody else. My deepest and most private thoughts, carried inside my heart and soul for years, were now released to the world. As a writer, one never knows what will happen once you publish.

On Easter Sunday, three days after the launch, I opened an email from my church's minister, who had attended the book launch and purchased a signed copy. The email read:

Prissy, it is 9:45 p.m. and I have just finished your book. I began about 4 p.m. and couldn't put it down, except for a bite of dinner. My heart was warmed with tears, joy, laughter, hope, and love as I read through each chapter. I shall arise at 4 a.m. tomorrow morning to celebrate another glorious Easter morning! You will hear me say throughout my sermon "hope is stronger than despair; love is stronger than death!" Your book makes the experience of resurrection and new life become even more meaningful. Thank you! You have blessed me.

Rev. Wayne Curry

To this day, his email alone made my work worthwhile.

Within days, I was scheduled for twelve books signings throughout Florida, Georgia, and Texas. The momentum continued when *Far Outside the Ordinary* was selected for a dozen book clubs in Florida, Alabama, Georgia, California, and Maryland during those first weeks.

Then, Katie, my niece who created my butterfly cover for *Far Outside the Ordinary*, called. "I won," she said.

"Won what?" I asked.

"I didn't tell you. I entered your cover in a graphic design competition."

Print Magazine, one of the most prestigious design publications, featured her design, my book cover, in the December 2014 issue, only months after the release.

The story wasn't mine anymore; it belonged to everyone. And it was resonating with readers around the country, selling thousands in only a few months. In my wildest dreams, I never would have imagined it. Especially when my original intent was to write the story for my daughters. The reasons were pure, simple, and nostalgic.

I wanted them to hear Boone's name again, see it in print: Jonathan Daniel Boone Kuersteiner lived. He mattered. He was not forgotten and never would be. I would share stories of his strength, dignity, love, and valued life with the grandchildren he never met, knew, or loved. They would learn he once told me he wanted to be called "Daddy Boone" when he had grandchildren. They could talk about Daddy Boone one day when they read Sassy's book called *Far Outside the Ordinary.*

Last, but certainly not least, I wrote it for Dale, the man who waited thirty years for a second chance to love me. He became the grandfather Boone couldn't be. He did so with such gentleness, love, and devotion. An outpouring of love radiates from this quiet man every moment of every day.

In the end I wrote what I sought but could never find: a book to expose, with transparency, what happens behind the closed doors of a terminal diagnosis. I wanted to reveal how I journeyed through this devastating loss and found my way forward in the aftermath. My story just happened to include comical goings-on and Southern flavor added to an otherwise bitter dish.

Healing comes in unexpected ways. Anguish does soften into acceptance. One will laugh and cry in the same breath. It's okay. It's strange how the universe rescues the desperate at the precise moment of despair. I still carry a message from Melody Beattie that I read on my more horrible days: "Gratitude turns what we have into enough, and more. It turns denial into acceptance, chaos into order, confusion into clarity. It makes sense of our past, brings peace for today and creates a vision for tomorrow."

It is humbling when readers reach out to me with a thank-you, praise, and kind words of affirmation. To realize I've given value to a person without hope, living through despair in their unrecognized life, is a priceless gift. For me there is no greater reward than knowing my journey was not in vain, nor was Boone's life. Together

we help others to brave and travel the unchartered and treacherous road of loss.

I met a gentleman in Valdosta, Georgia, a year after my book's release. *Far Outside the Ordinary* had just been selected by a large book club with a hundred-plus members. I was keynoting their spring luncheon at the Valdosta Country Club. Following that, I was having a book signing hosted by the owner of Mockingbird, a lovely retail shop in the center of town. The two events were close together but doable.

It was going to be a long day though, so I left early to drive the seventy-three miles from Tallahassee to Valdosta. I was asked to arrive by eleven a.m.

As always, I loaded my car with the boxes of books, the table décor, and all the other paraphernalia needed for my book-signing events.

Once I found the club and parked, I began unloading, hauling, and setting up my book-signing table for the after-lunch signing. I had my whole drill perfected and the cut biceps to prove it. Note to self: nothing is easy.

It was a spectacular event, one I will always remember. I was a bit frazzled breaking down the table, reloading the car, and racing to find where I was going next—Mockingbird. I had less than thirty minutes to unload my car and set up there.

I'd never met Pam Atkins, the owner of the store, and wanted to introduce myself before unloading all the books.

"Hello, you must be Pam?" My hand was out, but my eyes were scanning the fabulous items arranged inside the store. I already knew I'd be trading profits for products.

"Prissy, I'm so glad you're here," she said.

I looked at my watch. It was a few minutes after three. "Am I late? It's at three thirty, right?" I asked.

"No, you're not late. It's just that man over there has been waiting an hour for you."

I looked to where she pointed and saw him in the corner of the store staring at me. My heart skipped. He looked like one of the men from the *Duck Dynasty* television show.

"Who is he?" I asked.

"I have no idea."

"Your store is amazing, by the way. Thanks so much for having me." I looked down at my watch. I had fifteen minutes, and my car was full. But he'd been waiting an hour, so I walked over.

"Hi, I'm Prissy." I extended my hand and felt his dry, calloused skin as we shook. "Have we met?" I stared into his bloodshot eyes, studying the wrinkles lining his pale face.

"No, we haven't," he said with no emotion, smile, or warmth. "I want your book. I read about you in the paper this morning."

"I'm sorry, what paper?" I asked.

"*Valdosta Daily Times.* They ran a full page about that book you wrote."

"Clearly, they need real news." I chuckled. He didn't smile or respond. I became uncomfortable, aware of the ticking time and my car still loaded down.

"Do you have one?" he asked.

"Sure, okay, just let me run outside and get you one and set up my table. Be right back."

I'd eaten little to nothing at the luncheon, so I was running on fumes. The heat and humidity slapped me when I stepped outside. My blouse was already damp with perspiration. I opened the trunk to my SUV and began pulling the heavy box of books toward me, trying to lift them.

"Let me get them for you."

I turned to see the man from inside the store, his calloused hands lifting my burden. "Thank you so much...how kind!"

He unloaded everything. He even offered to set up my table. Afterward, I had my pen and book in hand, ready to sign his book first.

"I'm sorry, tell me your name again," I said.

"Make it to Kathi, with an *i*," he told me.

"Oh, I thought it was for you." I began personalizing, writing *Kathi*. "You're so sweet. For a birthday or something?"

"No, nothing like that. For later."

I was way too tired to ask what he meant.

"I'm dying," he said. "I got 'bout another six weeks or so, they say. She'll be needing it, I suppose."

It was one of the few times in my life I had no words. Maybe because there were none to have.

There would be more like the gentleman from Valdosta, too many to list, even count. A letter from the husband of a friend killed in London; a call from the husband of a woman dying of glioblastoma profiled on two separate *Dateline* episodes; a friend whose daughter was diagnosed with terminal cancer; a friend of my daughter's whose husband was given a terminal diagnosis; my friend who succumbed to cancer. It was endless. It still is.

In the words of William Shakespeare, "Tears water our growth."

Chapter Forty-Six

Full Circle

I WAS A SOUTHERN housewife when the book was released. Then it grew. I somehow sold thousands of my books with no agent, publisher, or staff. This happened by the power of two. Two people told two people who told two people. *Far Outside the Ordinary* took on a life of its own. It propelled me from the shadows to the spotlight.

Bloggers from California to New York reviewed and shared the book with their readers. Newspapers in Florida and Georgia profiled the book and me. I was interviewed and broadcast on multiple syndicated radio programs throughout the country. *Tallahassee Woman Magazine* featured me on their cover. I was spotlighted in *Writer's Digest* and featured in the national Pi Beta Phi *Arrow* magazine.

Soon, I was invited on stage and entered the speaking circuit: SunTrust, Merrill Lynch, the Florida Transportation Builders' Association, Altrusa, DAR, and Friends of the Library in Thomasville, Georgia, to name only a few.

My purpose was greater than the fear consuming me. I mustered my courage and braved my white-knuckled self. There would be hundreds of book clubs I visited or Skyped.

And then the day came. I slipped on my favorite dress, and with a splash of Flowerbomb perfume and a dollop of courage, I headed for the recording studio. I felt like the little engine that could.

With my Southern accent and all the critics awaiting, I decided I would narrate *Far Outside the Ordinary*. A committee of everyone I asked, along with my research, revealed the author of a memoir should be the narrator.

It was harder than writing the book. When I was composing my narrative arc, the content, the characters, and everything encompassing my story, I had to analyze and weave it together with careful planning. My brain was in charge. But when I isolated myself inside the recording studio and read my written words out loud through the microphone, well, it echoed a reminder of those painful and dark months I'd written about. And it was brutal. This time I was sharing my story from a different place: my heart.

There was more than one day I had to stop early. But I returned determined I could do it. I knew my children's children and theirs would hear *Far Outside the Ordinary* being read by me. As I pushed through narrating it, Boone's handprints were all over my heart.

❧

Two years after the book's release, I was seated next to the president of Flagler College inside their breathtaking dining hall filled with exquisite murals. I awaited my introduction as keynote speaker for an audience of more than 350 women. It was my first time back in the room after forty-eight years.

I had first arrived at the Spanish Renaissance palace as an eighteen-year-old freshman, wearing new tweed slacks with an invisible zipper below the waistband. I'd made the pants from a Vogue Paris Original pattern and installed the difficult zipper myself, in perfect symmetry, with my new Singer sewing machine. I'd spent more money than usual for the required two-plus yards of fabric. But as I took in my new surroundings, I was happy I did.

A boy I loved had driven me to Flagler College from Florida State University, the school where he was enrolled. I couldn't know it then, but one day this boy would change my life. Dale would become my second husband and part of the journey that brought me back to that stage and to the place where it all began.

I climbed the stairs to applause inside the Ponce de Leon Hall, and my heart skipped. As I stood at the podium and looked down at Dale's smiling eyes from where he sat in the second row, it seemed nothing had changed. Yet everything was different.

I locked eyes with the boy I once knew, the man who knew me best. I had come full circle from where I'd started. The only difference…a life lived in between.

The End

Epilogue

CHASING ORDINARY SHOULD HAVE been released two years ago. That was my *plan*, anyway. But life jumped in and spun me around. I couldn't think, much less write, or come close to finishing the first draft of *Chasing Ordinary*. Everything that could happen…well, it pretty much did.

I lost my beloved mother. It plummeted me into grief for months. Then my husband had spinal surgery in the middle of a hurricane and hospital evacuation. Two more hurricanes came along, then another evacuation. But the real test of my strength and faith came with a murder.

I had been mentoring a boy and his disabled mother for eight years: music camp, Christmas gifts, bikes, books, clothes, and friendship. The boy I thought I knew so well (ever since he was fourteen years old) slipped into the hospital where his mother lay critically ill. He stabbed her to death. It's hard to tap my painful memory into those words. Love and hate juxtaposed. It was also difficult for me to write anything after that. But I mustered up the courage to keep going, because, well, that's what we do. All of us.

I try and find humor where I can and when I can. I discovered it just this week as *Chasing Ordinary* went through the publishing process: content editing, copyediting, proofreading, and formatting.

After it came back from Jennifer, my copyeditor, I found a question in the margin in my numerology chapter on Boone. "I get nine when I follow the formula listed on this website. Is this the same formula you used?" she wrote.

Say what! I pulled out my numerology book, grabbed a pad and pencil, scribbled Boone's full name, added once, added twice, pulled out my calculator, and stared. What the heck, Prissy!

Boone's number wasn't eight after all. It was nine. All that "signs from the universe" mess in my head I'd blabbered about. Getting married on the eighth day of the month because it meant *new beginnings*. I was certain Boone was sending signs to me all along. Heck, I dreamed the number eight. What?

After Jennifer's discovery, I sat up restless almost the entire night. I had added up Boone's letters and numbers wrong following that formula. Well, I would just delete all the numerology craziness from the manuscript the next morning. But then it occurred to me…the humor…my imperfection. It was way too funny not to share it with my readers. All the thoughts, writing, and pages and my beliefs were marching to the beat of adding up his numbers wrong. Memoir is truth and here it is: I can't even add right.

Jennifer also wrote, "Do you want to say which birthday it was when you decided to write *Far Outside the Ordinary*? The reader doesn't know exactly how old you are when this happened, and age might help some readers identify/connect with you."

Clearly, my Jenn is young and doesn't know Southern women don't like to reveal age. But I gave her suggestion a lot of thought. I decided to just get over myself and become a cheerleader for a team of everyone who has a story to tell. So, I sprinkled my age inside the manuscript (ever so lightly). I wanted to share what I had learned and what my takeaway was from a life I'm fortunate to have. And my takeaway for you is this: age is irrelevant when it comes to dreams, talent, and potential.

I picked up a paintbrush and became an artist at fifty years of age. When I was sixty, I began writing *Far Outside the Ordinary* and became a published author. This afforded me a column inside *Flamingo Magazine*, a well-respected, award-winning, Florida lifestyle magazine. My column was named "Panhandling," since I live in the panhandle of Florida.

I believe everyone has some untapped potential within. Everyone has something they long to do, or be, or maybe create. Yet they sacrifice this discovery by sabotaging themselves with self-doubt. *I'm too old…no time…no talent.*

A few years ago, I met Elizabeth Gilbert, author of *Eat, Pray, Love*. We were at a private cocktail party in Tallahassee. What a kind, gentle being I discovered her to be. After the reception, she spoke to an audience attending Florida State University's Seven Days of Opening Nights. I've never forgotten what she practices most days. She will ask everyone she meets *one* question, from bellhops to taxi drivers. "What are you most excited about in your life today?"

She shared with us some of the stories from those who have answered her question. That night, sitting inside the Ruby Diamond Concert Hall, her message became my mantra for the rest of my life. I've discovered it's a gift when I take notice of the joy and excitement in someone else's life by asking that one question. Thank you to Elizabeth for this gift.

So, I ask you, what are you most excited about in your life today? Write me a note and let me know, because I would love to hear it. And if you should long to write that story festering inside of you, just do it. You will never know what might happen when you do.

Acknowledgments

To MY READERS OF *Far Outside the Ordinary*, thank you for reaching out to me with your generous words of affirmation. You made revisiting the pain to write my story worthwhile.

I've been asked repeatedly, "What happened at the end?" To me, stories never end. But I decided to march to the beat of my readers and write a sequel I never planned on writing. *Chasing Ordinary* was birthed to satisfy all of you, dear ones. So, thank you for that.

Steve Adams was the first to read *Chasing Ordinary*, just as he was the first to read *Far Outside the Ordinary*. I appreciate and thank him for always reeling me back in with his oh-so-gentle words: "Remember the story you're telling, Prissy." Yeah, okay, I know, I know. But I do so love those other tales you say I *can't* tell. Rats!

Jennifer Zaczek is a jewel and rock star. A big thank-you for the detailed editing and dissecting with those keen literary eyes of hers. And to Amanda Kruse and Vinnie Kinsella—thanks for climbing aboard my production team this round. As every author knows, it takes a village to publish a book.

To Jamie Rich, editor in chief of *Flamingo Magazine*, my heartfelt thanks for welcoming me into your *Flamingo* family. I love being surrounded with creative minds and artistic talent. And I'll be forever grateful for the privilege to write my heart for others to

read on your pages with my "Panhandling" column found inside each sensational issue.

A big thank-you to Katie Campbell, senior design manager of publications at Warner Bros., who happens to be my beautiful niece. Once again you designed a dazzling cover. Clearly, you gave the same amount of love, talent, and dedication to your auntie this time as you did with *Far Outside the Ordinary*. I'm humbled you squeezed me into your Harry Potter life. Move over, Harry.

And to my extraordinary family, who keeps my heart beating—I couldn't love the whole lot of you more. Truth be told, without your support, love, and encouragement, my writing life wouldn't be possible. Thank you!

I have discovered a thing or two while writing my two memoirs. When the unexpected in life happens, it sure can uproot the soul. There are times we think we can't bear the tragedy, loss, and suffering. And yet, we do. We have this courage that sits at the center of our sorrow. Time, patience, and prayer encircle this courage and soften the raw edges of our pain. It isn't easy or fast. But eventually, the unbearable does become bearable, gratitude blossoms, and the colors in our world become bright again. It's a simple truth inside a very hard lesson. But it is the universal story of life.

Book Club
Discussion Questions

1. Were you surprised Prissy invited Dale to meet her in Europe after spending only two days together in Memphis? Would you have done this?

2. After Prissy and Dale reunited, do you think the relationship moved too quickly? If so, why do you think it happened this way?

3. Was Prissy selfish to choose her happiness and Dale over Garrett's disapproval and unhappiness? What would you have done?

4. Do you think Prissy should have waited to accept Dale's marriage proposal, to give Garrett longer to get to know him? If so, why?

5. Do adult children ever support second marriages of their single parents? If so, what is an acceptable time frame to them?

6. Did Prissy spend too much time asking the universe for answers, believing in signs, numbers, and fortune-tellers? Have you ever put your faith in the unknowns in life?

7. Should Prissy have relocated to Indianapolis after she married Dale?

8. What might Prissy have done differently to acclimate to life in a new city?

9. When Puddles, Prissy's seventeen-year-old poodle, was ill, do you think she made the right decision to end the dog's life? What would you have done in this situation?

10. Did you agree with Sara Britton's decision to donate her bone marrow and later her stem cells to save someone she'd never met? Have you ever considered donating, or would you?

11. Do you think bringing Du and Sallie back into Prissy's life when Dale's mother had ALS triggered a form of PTSD for Prissy, or was it something else?

12. Should Prissy have shared her nightmares with Dale rather than keep them to herself to protect him from worrying about her in addition to his dying mother? What would you have done?

13. Why do you think it took Prissy so long to begin writing after Dale bought the tools needed early in their marriage? Was it procrastination or fear? Have you ever wanted to write your own story? If so, why haven't you?

14. Do you think Prissy's discovering her love for painting happened by chance, through default, or was always there waiting to surface? Have you ever considered taking lessons in painting, writing, dancing, music, or acting?

About the Author

PRISSY ELROD IS AN artist, a humorist, a professional speaker, a columnist, and the author of *Far Outside the Ordinary*. She is a graduate of Florida State University and the mother of two daughters. She lives in Tallahassee, Florida, with her husband, Dale, and divides her time between writing, painting, and chasing her tail.

Follow Prissy
www.prissyelrod.com
www.prissysblog.com
www.instagram.com/prissyelrod
www.facebook.com/prissy.elrod